THE FRENCH REVOLUTION AS BLASPHEMY

ABOUT THE DISCOVERY SERIES

*Innovative and generously illustrated, books
in the Discovery Series focus on a single important
work of art, artist, or theme in the history of art.
Each is distinctive for the richness of detail and
insight it conveys in a concise format, and
each is written in prose that appeals to
both specialists and general readers.*

The Publisher gratefully acknowledges the
contribution provided by the Art Book
Fund of the Associates of the University of
California Press, which is supported by a
major gift from the Ahmanson Foundation.

Publication of this book has been aided by a grant from the
Millard Meiss Publication Fund of the College Art Association.

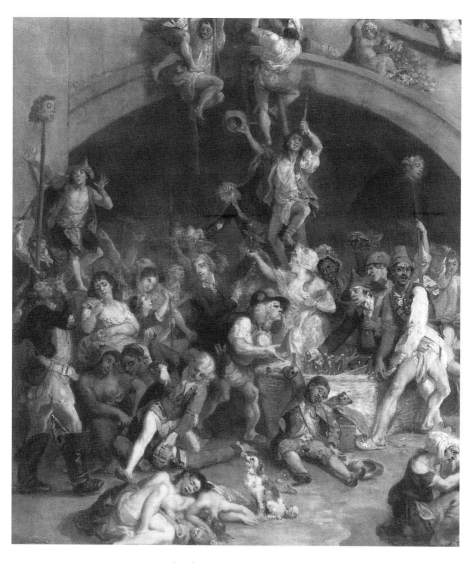

Johan Zoffany, *Plundering the King's Cellar at Paris, August 10, 1792,* 1794, oil on canvas. Wadsworth Atheneum, Hartford, Connecticut. Detail.

THE FRENCH REVOLUTION AS BLASPHEMY

Johan Zoffany's Paintings of the Massacre at Paris,

August 10, 1792

WILLIAM L. PRESSLY

UNIVERSITY OF CALIFORNIA PRESS BERKELEY LOS ANGELES LONDON

University of California Press
Berkeley and Los Angeles, California

University of California Press, Ltd.
London, England

© 1999 by
The Regents of the University
of California

Library of Congress
Cataloging-in-Publication Data

Pressly, William L., 1944–
 The French Revolution as blasphemy :
Johan Zoffany's paintings of the massacre
at Paris, August 10, 1792 / William L. Pressly.
 p. cm.—(California studies in the
history of art. Discovery series ; 6)
 Includes bibliographical references and
index.
 ISBN 0-520-21196-0 (alk. paper)
 1. Zoffany, Johann, 1733–1810. Plunder-
ing the King's cellar at Paris, August 10, 1792.
2. Zoffany, Johann, 1733–1810. Celebrating
over the bodies of the Swiss soldiers, August
12, 1792. 3. Zoffany, Johann, 1733–1810—
Criticism and interpretation. 4. France—
History—Insurrection, 1792—Art and the
insurrection. I. Zoffany, Johann, 1733–1810.
II. Title. III. Series.
ND497.Z6A72 1999
759.2—dc21 98-6424

Printed in the United States of America
9 8 7 6 5 4 3 2 1

CONTENTS

With love to my mother and father

and

to my brother, Paul

ILLUSTRATIONS

Works are by Johan Zoffany unless otherwise indicated.

PREFACE

The subject of this study is a set of two paintings of the French Revolution by Johan Zoffany. Although little known or appreciated outside specialist circles, these pictures are among the most unusual and extraordinary works of art devoted to the Revolution. In them, Zoffany displays a degree of originality rarely suspected in his oeuvre. My task in this book is to reveal what is singular in these works: how they are related to the momentous historical events they purport to treat and to other portrayals of the same and related subjects; how they define, elaborate, and convey particular meanings; how they are related to other pictorial genres of the time, including those drawn from the domains of both "high" and "low" art, and how they nonetheless depart from these traditional pictorial genres. Zoffany's paintings offer an exceptional vision of the French Revolution, one that transcends merely topical viewpoints to address more trenchant issues of human nature and behavior in a time of unprecedented social distress. A close reading of their style and content helps to place them within the larger framework of those social, political, artistic, psychological, and religious attitudes that they reflect and, in their turn, helped to form.

In documenting the complexity of Zoffany's achievement in these two paintings, this book will also offer additional evidence of how his works in general should be interpreted. Although his reputation has never been higher, the full dimensions of his achievement are only now beginning to emerge. Traditionally, he has been seen as an artist who held up a mirror to his world, but both Ronald Paulson and I have argued that his work is far more complex than is usually imagined: indeed, he delighted in veiled allusions, challenging his audience to see below the surface.

In the use of source materials, I have emphasized English texts and images over French ones because these are the materials with which the artist was most likely familiar. In addition, while Zoffany was a world traveler, fluent in German, Italian, and English, he never lived in France and may never have mastered its language.

The titles of prints, inscriptions, and quotations from contemporary authors often contain inaccuracies in spelling, and I have retained the orthography of the orig-

inal, while avoiding as much as possible the use of *sic*. In the case of someone like the English caricaturist James Gillray, the errant French accent marks and spelling may have been deliberate, introduced as yet another affront to French sensibilities. To every rule there is of course an exception. In the case of Earlom's print after Zoffany's painting, which gives an incorrect date in its title *The Tenth of August 1793*, I have, after drawing attention to this error, gone on to cite this work as *The Tenth of August 1792*.

I had long been interested in Zoffany, but this particular focus on his images of the French Revolution grew out of a seminar entitled Art and Revolution that I gave jointly with my colleague Professor June Hargrove in the fall of 1991. I would like to thank the members of that class and the students in other classes I have taught since then for their helpful suggestions. It was in one such seminar at Princeton University that Janet Temos, responding to a lecture by Miri Rubin, pointed out that the Jewish clothesman bargaining with the woman was reminiscent of the story of the Miracle of Paris with its Host-desecration narrative. Others whom I would like to thank for their contributions are David Alexander, Brian Allen and the Mellon Centre staff, Catherine Barne, Lois Berdaus, Stephen Campbell, Kathy Canavan, Jonathan Carey, Anthony Colantuono, Don Denny, William Drummond, Elizabeth Einberg, Billie Follensbee, Kimberly Jones, the Hon. Christopher Lennox-Boyd and Guy Shaw, Beth Lingg, Pam Potter-Hennessey, the Countess of Rosebery, Don Sutherland, Penelope Treadwell, Lee Vedder, and the Marquess of Zetland. The staffs at the Wadsworth Atheneum in Hartford and the Stadt Museum in Regensburg, in particular its director Dr. Peter German-Bauer, have been unfailingly cooperative, and to them I am most grateful.

This study would not have been possible, at least in this form, without the scholarship generated by the celebration of the bicentenary of the French Revolution. The numerous books and exhibition catalogues created on this occasion have proved of enormous value. Modern technology has also made possible a more thorough study than could have been accomplished just a few years ago. Microfilm and the videodisc have occasioned a revolution of their own, giving easy and rapid access to a wealth of material. I am most grateful to the library staff at the University of Maryland, in particular Courtney Shaw, Lynne Woodruff, and Carleton Jackson, for helping to make this information available.

I would also like to thank the General Research Board of the University of Maryland for its generous support. Its grant for the spring semester of 1992 made it possible for me to begin concentrated research on this book. In addition, no matter how sophisticated the technology, in art history at least there will never be a substitute for seeing objects in the flesh, and the GRB grant, along with support from the Department of Art History and Archaeology, enabled me to travel to see these works firsthand. In 1994–95, when a member of the Institute for Advanced Study at Princeton, I was able to make significant progress on this book. I am very much indebted to J. Richardson Dilworth for sponsoring my membership, and to Irving

and Marilyn Lavin and my other colleagues at the Institute for stimulating discussions concerning my work.

I am most grateful to the readers of the various versions of my manuscript, all of whom have offered perceptive suggestions. In particular, I would like to thank my colleagues Vincent Carretta and June Hargrove for their reading of an early version, Peter Paret for his careful reading of the manuscript while I was at the Institute, Ronald Paulson for his insightful reading of the draft I submitted to the University of California Press, and my wife, Nancy, for her reading of the various drafts and for her continuous support. It has been a pleasure working with the University of California Press: in particular I would like to thank Stephanie Fay for her outstanding work as the book's sponsor and project editor as well as Deborah Kirshman and her assistant Kimberley Darwin. Finally, I would like to thank James H. Marrow, the editor of the Discovery Series, for his unstinting support and for his immensely helpful comments and recommendations.

PLATES

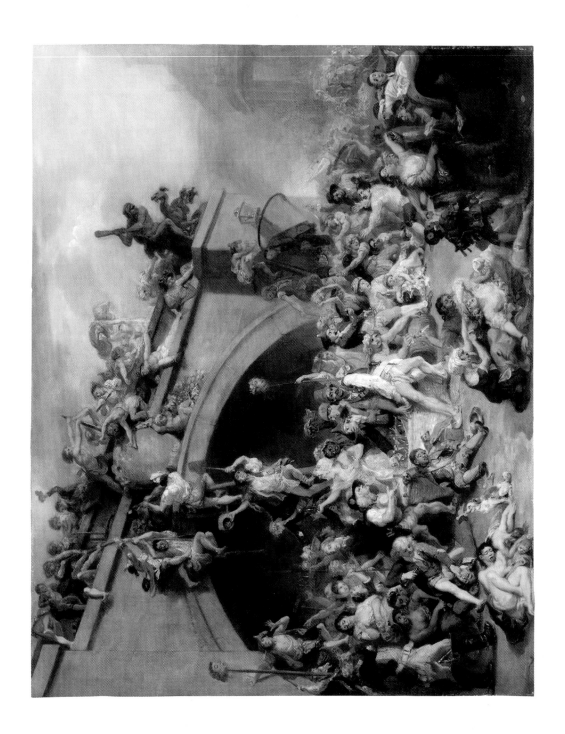

During the eighteenth century, Great Britain and France, locked in global competition, fought one another in several major conflicts. Yet France's declaration of war on February 1, 1793, was more than just another round in this continuing rivalry: the nature of the conflict had changed drastically. In a letter of September 18, 1793, to his friend Hannah More, the aging Horace Walpole, long a perceptive observer of current affairs, conveyed a new sense of urgency: "This is not a war of nation and nation: it is the cause of everything dear and sacred to civilized men, against the un-bounded licentiousness of assassins."[1] The war was over ideology, over which world-view would predominate, and many in Britain saw it as a struggle for nothing less than civilization itself.

Not surprisingly, in light of the magnitude of the events unfolding in revolu-tionary France, British writers churned out reams of material arguing over its mean-ing. In the visual arts, the popular genre of the political caricature also commented on the Revolution and its impact on British life. But in the realm of high art, there is remarkably little direct representation of these cataclysmic events. Using painting as a barometer, the casual observer would be hard-pressed to detect that a political and social upheaval of unprecedented proportions was occurring across the Channel.

Once Great Britain was at war with France, those prominent artists who were sympathetic to republicanism, such as James Barry and George Romney, chose not to espouse unpopular, some would even argue treasonous, sentiments directly. In-stead they refer obliquely to the contemporary situation, choosing, for example, to depict Satan from Milton's *Paradise Lost* as the heroic spirit of revolt. William Blake, who did not enjoy the same stature as his colleagues, was more direct in champi-oning the revolutionary cause, yet he too subsequently found it prudent to veil his allusions.[2] Even Benjamin West, the president of the Royal Academy, may have in-tended that his sketch *Death on the Pale Horse* from the Book of Revelation, exhib-ited in 1796, link biblical prophecy with current affairs, holding out the millenar-ian promise of a new order. That West made his sketch as a study for a painting

commissioned by the king for a proposed Chapel of Revealed Religion at Windsor Castle makes any contemporary political allusions even more relevant and daring.[3]

Although artists who might have been sympathetic to the French Revolution wisely avoided direct representations of its unfolding drama, artists who supported the British government's anti-French policies were free to depict revolutionary subjects without circumspection. Unlike their prorepublican colleagues, however, these painters generally came from the minor echelons of their profession. In addition, uncomfortable with scenes depicting the triumph of the masses, they focused primarily on the tribulations of members of the royal family, manufacturing sentimental melodramas of their unfortunate fate.[4]

Johan Zoffany, a royalist sympathizer, stands apart from his colleagues. He is the only major artist of the British School to attempt paintings depicting scenes of the French Revolution, and, unlike other conservatives, he chose to depict violent mob rule, a subject more suitable to the popular medium of prints than the exalted one of oils. He executed two paintings, neither of them commissioned, that show the victorious Parisian "mob." Perhaps because they are atypical of his oeuvre and were executed late in his career, they have received little critical attention, even though they number among his most imaginative works. This study offers a detailed analysis of his subject matter, the place of these images vis-à-vis pictorial conventions, and the audience to whom they were addressed.

Only one of Zoffany's pictures of the French Revolution was exhibited during his lifetime. This work (Plate 1) appeared in the 1795 exhibition of the Royal Academy under the title "Plundering the King's cellar at Paris, Aug. 10, 1793." In the posthumous sale of the artist's works in 1811, the entry reads, "THE 10TH OF AUGUST—at the time of the Parisian Populace breaking open the King's Wine Cellars; strongly characteristic of the furor of the French Revolution, and the Outrages then committed. This picture is engraved."[5] Richard Earlom's mezzotint after the painting (Fig. 1) was published on January 1, 1795, just a few months before the spring opening of the Royal Academy exhibition, and it bears a similar, though abbreviated, title *The Tenth of August 1793.*[6] The subject of Zoffany's painting is, of course, the celebrated *journée* (day) of August 10, 1792, the bloodiest day of the French Revolution and the one that marked the end of the French monarchy. The artist depicts a French mob, after the successful assault on the Tuileries Palace and the deposing of the king, riotously emptying the royal wine cellar while engaging in other acts of vandalism and barbarous behavior.

Curiously, none of Zoffany's contemporaries appears to have commented on the mistake in dating, either in the print's title or in the painting's title as it is listed in the Royal Academy catalogue. It is also surprising that in 1886 J. E. Wessely incorrectly listed the print in his catalogue of Earlom's works as *Die Erstürming der Bastille* (The Storming of the Bastille), even while recording the inscription in the margin as, "THE TENTH of AUGUST 1792 [not 1793]."[7] Furthermore, as recently as 1990 the print after Zoffany's picture was still being incorrectly categorized: the videodisc *Images of the*

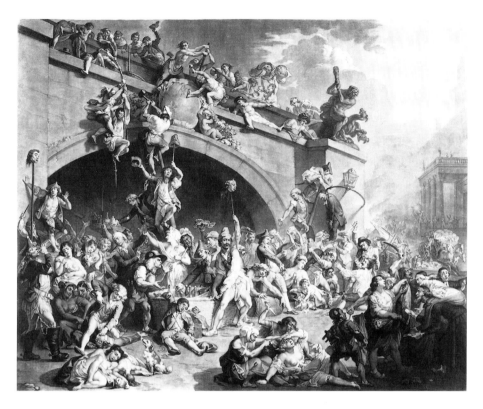

FIGURE 1

After Zoffany, *The Tenth of August 1792*. Mezzotint by Richard Earlom, First
State, 57.1 × 68.5 cm. (22½ × 26¾ in.), January 1, 1795. British Museum, London.

French Revolution, although accurately recording the title in its catalogue, even not-
ing that 1793 should read 1792, places it under the section "The September Mas-
sacres" rather than "The *Journée* of 10 August 1792."[8] *Plundering* cannot date later
than the January 1, 1795, publication date of the mezzotint reproducing it, and, as
will be argued in more detail in Chapter 6, it was probably begun no earlier than
the spring of 1794. A two-year gap between the *journée* and the artist's completed
rendering of it would help to explain the misdating of the year in the title, but, more
important, it is a reminder that Zoffany conceived August 10, 1792, from the van-
tage point of almost two more years of revolutionary activity. Had the Republic that
was born out of the turmoil of August 10 proved a stable and peaceful one, the artist
presumably would not have felt compelled to depict this earlier pivotal moment in
French history. His rendering, therefore, is also a response to such subsequent
events as the September massacres, the execution of the king and queen, and the
Reign of Terror.

A second picture by Zoffany of the French Revolution, a work that was never completed, has also survived (Plate 2). Passages such as the lower right corner (see Figs. 49 and 52) remain unusually sketchy in treatment, and the canvas also appears to have suffered at the hands of restorers. Its subject too has been misidentified in the literature on the painter, beginning with its first citation in the 1811 sale, where it was listed as "A Scene in the Champ de Mars on the 12th of August, with a Portrait of the Duke of Orleans."[9] As recently as the bicentenary exhibition at Paris in 1989 it was exhibited under the incorrect title *The Massacre of July 17, 1791, in the Champ de Mars*. As I argue in Chapter 4, the setting is the Tuileries Gardens rather than the Champ de Mars, and the picture is indeed related to the events growing out of the *journée* of August 10. Its new title, *Celebrating over the Bodies of the Swiss Soldiers, August 12, 1792*, is fully explained in the later discussion. Suffice it to say here that the work shows the Parisian victors cruelly continuing their revels around a pile of denuded Swiss guards who had earlier fallen victim to the mob's fury. In addition, I argue that, close in its measurements to *Plundering*,[10] *Celebrating over the Bodies* was conceived as a pendant to this exhibited picture, and each work can be fully appreciated only in relation to the other.

The sale catalogue of 1811 lists a third work devoted to the French Revolution: "The Triumph of Reason, French Revolution" (lot 59). This picture is now lost, and one can only speculate on what it depicted. Given the nature of the two surviving works, the title "The Triumph of Reason" could only have been meant ironically, the triumph of unreason being the trilogy's real subject. Yet commentators mentioning the three works from the 1811 catalogue have often neglected to point out that *Plundering the King's Cellar* (lot 94) and *Celebrating over the Bodies of the Swiss Soldiers* (lot 85) appear under the heading "Pictures.—By Mr. Zoffany," while *The Triumph of Reason* appears under "Unfinished Sketches." Many of the works in "Unfinished Sketches" are preparatory studies for paintings recorded in "Pictures." Thus, it is possible that *The Triumph of Reason* is not a third subject but rather a work preparatory to *Plundering* or *Celebrating*: its sardonic title would be appropriate to either.

Before examining Zoffany's two surviving paintings of the French Revolution individually and then as a pair, I place them in the context of both the artist's career and the events that they purport to describe. The first chapter provides a brief introduction to the life and work of the artist himself, while Chapter 2 gives an overview of the dramatic history that exercised such a powerful hold on the imagination of Zoffany and his contemporaries, a hold that, as the bicentenary demonstrated, has hardly diminished today.

The brief biographical sketch offered in Chapter 1 suggests the complexity of Zoffany's earlier work, in keeping with his persona as a man of superior talents. Yet Ronald Paulson, who has so effectively championed a sophisticated, multilayered approach to the artist's oeuvre, argues that in *Plundering the King's Cellar*, "probably all that Zoffany wanted to express was the equation of drunkenness, madness, and revolution."[11] This study maintains that late in his career the artist still had the phys-

ical energy and the intellectual vitality to forge a new vision of the meaning under-lying the events of the French Revolution. The paintings offer more than mere re-portage; indeed they willfully ignore factual accuracy. In support of his Manichaean view Zoffany wished to demonize the revolutionaries, and in his efforts to vilify the opposition, he did not hesitate to employ grossly unfair, prejudicial stereotypes that are Francophobic, elitist, misogynistic, racist, and anti-Semitic. In conceiving his two pictures, he was fiercely engaged in visualizing and interpreting the clash of com-peting ideologies, but even if historical accuracy played little part in his agenda, his two pictures offer something more than a simplistic, outraged response to the hor-rifying news coming out of France, providing instead a boldly original and rawly abrasive interpretation of revolutionary "justice."

Zoffany's paintings are important in contributing to our understanding of how the English viewed the events of the French Revolution. They form part of the largely spontaneous outpouring of counterrevolutionary propaganda, and the book's title itself underscores this bias. The French more frequently described the *journée* of August 10 as a revolt, while many of the English were more inclined to view it as a massacre. The echo in the title of Christopher Marlowe's Elizabethan play *The Massacre at Paris,* describing the events of August 24, 1572, is also deliberate, as the Francophobic English often took the long view, seeing the atrocities as part of an es-tablished pattern of French barbarism.

Building on the examples of Hogarth, the political caricaturists, and contempo-rary history painting, Zoffany forged a new type of painting focusing on modern life. On one level his works are indeed about drunkenness, madness, and revolution, but on closer examination, they are masterly translations into paint of a complex philo-sophical argument for traditional values, an argument inspired to a great extent by Edmund Burke's *Reflections on the Revolution in France* (1790). Because both paint-ings operate on different levels of complexity, they require a great deal of the viewer. They provide a political and social commentary on the behavior of the sansculottes and on the roles played by women and by blacks, and they promote as well a con-spiracy theory that had long been cherished by the counterrevolution. At the same time, they place the artist's analysis of what is wrong with the motivating principles underlying the French Revolution within a larger context, one that offers a tran-scendent vision of French and English history in a religious framework.

1

A CHECKERED CAREER

Zoffany was born on March 13, 1733, near Frankfurt. His father, Anton Franz Zauffalÿ, supervised a workshop for carving and joinery for the palace being built by the prince of Thurn and Taxis. Early in 1748 the family followed the House of Thurn and Taxis to Regensburg, where Zoffany studied with Martin Speer. Two years later he left for Rome, the primary destination for artists of serious ambition. After training in the studio of Agostino Masucci, he returned to Regensburg around 1757 and was soon at work for the prince-archbishop and elector of Trier at Coblenz and Trier. Around this same time he married the daughter of a court councillor of Würzburg, and probably in the second half of 1760 he and his wife moved to London, a capital hospitable to foreign talent whose royal family had strong German ties. England was now to become his adopted country, and it was here that he changed the spelling of his name from Zauffalÿ.

Before his arrival in England, Zoffany's oeuvre consisted of history paintings of subjects from the Bible and the classics, the standard sources. Zoffany most often executed these works on a modest scale, although he created larger pieces for the decoration at Trier.[1] Because in London there was little demand for the type of history painting he had undertaken on the Continent, his move there forced him to concentrate on portraiture. Inspired by the example of William Hogarth and soon enjoying the support of the actor David Garrick and the royal family, he became a celebrated painter of conversation pieces and of the related genre of theatrical portraiture. Of the thirty-one subjects he exhibited at the Society of Artists and the Free Society from 1762 until 1769, not one was drawn from the Bible or classical history or mythology. He began exhibiting at the Royal Academy in 1770, having been appointed a member by the king himself shortly after its creation in 1768, but again he made few attempts at the traditional subject matter of high art, exhibiting religious scenes only in 1773 and 1775 and at the end of his career in 1796 and 1800. He showed only one classical subject, a sibyl, in 1773. One surmises, particularly given Zoffany's return to religious subject matter in the twilight of his career, that his

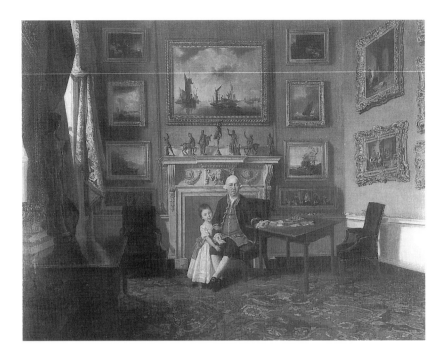

FIGURE 2
Zoffany, *Sir Lawrence Dundas and His Grandson in the Pillar Room at 19 Arlington Street,* 1769. Oil on canvas, 102 × 127 cm. (39¾ × 49½ in.). Aske Hall, The Marquess of Zetland.

abandonment of history painting in favor of portraiture reflected prevailing conditions of patronage more than personal preference.

Zoffany remains best known for his conversation pieces, group portraits on an intimate scale that show the sitters in full length and in a setting reflecting their environment. This descriptive genre appealed to middle-class sensibilities rather than to an aristocratic taste emphasizing grandeur. Zoffany's portraiture was even more in tune with the taste of the royal family than the elevated rhetoric of Sir Joshua Reynolds, the king preferring his brand of realism to Reynolds's high-minded masquerades where a lady could become a Venus, a vestal virgin, or one of the Three Graces.

The painting *Sir Lawrence Dundas and His Grandson in the Pillar Room at 19 Arlington Street* of 1769 (Fig. 2) provides a well-documented example of one of Zoffany's conversation pieces.[2] The artist introduces the viewer to Sir Lawrence, the head of his family, in the company of his grandson, the latest to carry on the family name, in the library of his London home, which had recently been decorated by Robert Adam. The rug, the furniture and curtains, the group of Giacomo Zoffoli bronzes on the chimney mantel, and the exquisite collection of Dutch paintings are all documented as having been in Sir Lawrence's possession. The artist, as sanctioned by convention, made slight adjustments in scale to some of the pictures on the walls to bring them into greater harmony with his overall design and probably took small liberties as well in rearranging the furnishings, yet the painting offers a remarkable

record of a moment in time, for the most part truthfully mirroring the interior and its inhabitants. Some critics feel that in Zoffany's works appearance is reality. Sacheverell Sitwell succinctly sums up this attitude in his book *Conversation Pieces* of 1936 when he compares the artist's work to that of his contemporary Henry Fuseli: "Fuseli composed out of his imagination: Zoffany had wonderful vision, but no fancy."[3] Yet, on closer examination, *Sir Lawrence Dundas and His Grandson* can be seen as more than just a descriptive record. Sir Lawrence sits directly beneath the bronze reproducing *The Faun in Rosso Antico,* a figure that joyously celebrates the grape, and this association with wine is reinforced by the large statue of Bacchus on the Chippendale table at the left. Sir Lawrence invites the viewer (or the artist) to join him by gesturing toward the waiting, empty chair on the other side of the table at which he sits, and this chair is positioned beneath Teniers's *Journeymen Carpenters,* the only picture to show a drinking scene. Thus Zoffany offers more than a catalogue of the sitter's refined taste, wittily alluding as well to his convivial hospitality.

Despite his success in London, Zoffany, whose wife had early on left him to return to Germany, agreed to join the entourage of the naturalist Joseph Banks on Captain Cook's second voyage around the world. When this plan fell through after Banks quarreled with the Admiralty, Zoffany left for Florence in 1772 to paint for the queen of England *The Tribuna of the Uffizi* (Fig. 3), a work documenting masterpieces in this celebrated collection. As Ronald Paulson has pointed out, this picture is "as mytho-poeic as one of Blake's engraved books," forging a personal myth out of the contents of this collection.[4] The hidden personal narrative, which alludes to the death of the artist's son and his own role as suffering genius, has been discussed in detail elsewhere,[5] but to these accounts one might add that the prominent sculpture of the Knife Grinder in the lower left corner helps set the tone for interpreting the painting's content. This marble figure looks intently into the painting's center, as if he is as much a spectator as a participant, instructing us how we too should view the meaning underlying the artist's presentation of the Uffizi's treasures. Since the sculpture's discovery, probably in the late quattrocento, differing interpretations of its identity have been offered, but the one that is most generally accepted was put forward at least as early as the seventeenth century.[6] The figure is most commonly identified as the executioner of Marsyas, the satyr who had foolishly entered a musical contest with Apollo. After the god won, he chose as his rival's punishment that he be flayed alive. The Knife Grinder is depicted sharpening his blade in preparation for this gruesome task.

Since the Renaissance the story of the flaying of Marsyas has been interpreted allegorically as representing the painful shedding of the outer skin to uncover a deeper spiritual truth.[7] The Knife Grinder instructs the viewer that this painting is about the agonizing stripping away of appearances to reach a profounder reality. The bronze oil lamp placed on the sculpture's base beside the blade further alludes to the Knife Grinder's potential as a bringer of light. The ribald nature of the lamp, composed of a figure with its legs in the air and a phallic oil pan jutting out between them (details

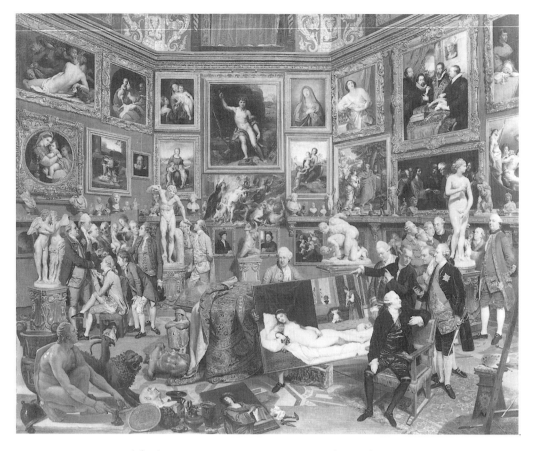

FIGURE 3 (*above*)
Zoffany, *The Tribuna of the Uffizi,*
1772–78. Oil on canvas, 123.5 × 154.9 cm.
(48⅛ × 60½ in.). Copyright Reserved
to Her Majesty the Queen.

FIGURE 4 (*opposite*)
Zoffany, *Colonel Mordaunt's Cock Match,*
1784–86. Oil on canvas, 103.5 × 149.9 cm.
(40¾ × 59 in.). Tate Gallery, London.

not readily visible in the reproduction), indicates that "truth" is not to be confused with social niceties, and rampant sexual desire forms a cornerstone of the picture's meaning. The artist also aligns himself with the Knife Grinder by placing his own easel in the painting's opposite corner with his palette and brushes and, on the floor, his palette knife, which echoes the blade of the sculpture. Queen Charlotte, who commissioned the painting, desired only a record of the Uffizi's finest works, but, as the artist discreetly suggests, there is far more to his account than meets the eye.

In Florence the artist, enjoying the prestige of working on a commission from the queen, did not hesitate to push his advantage. As stated by his biographers, "Zoffany, styling himself the Queen's Painter, gave himself great airs, insisting upon special privileges in the gallery, and especially in the room known as the Tribuna, in which for a time he seems to have claimed almost the entire rights."[8] He was on familiar

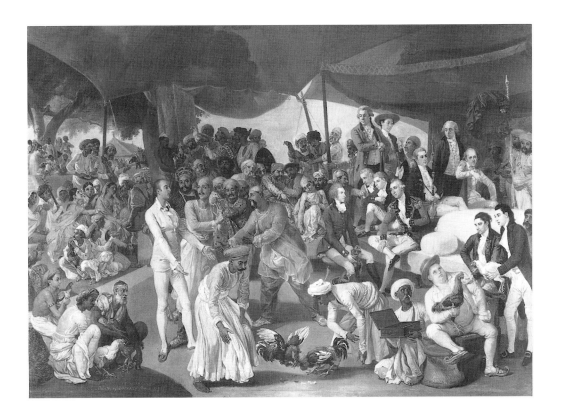

terms with the grand duke of Tuscany, and when visiting Vienna in 1776, the duke's mother, Empress Maria Theresa, granted him the title of baron of the Holy Roman Empire. Zoffany's father had occupied important positions for the prestigious House of Thurn and Taxis, but the son had far outstripped him, joining the upper classes his father had done so much to serve.

In Italy, Zoffany acquired a new wife. Before leaving London he had impregnated a fourteen-year-old girl, who, smuggling herself aboard his ship on his departure, revealed herself once they were at sea. Zoffany married her in Florence after ascertaining that his first wife had died. The son to whom his new wife gave birth died when he was only sixteen months old, but the Zoffanys went on to have four daughters, all of whom survived their father.

After his return to London in 1779, Zoffany did not enjoy his previous success. Without his family, he left for India in 1783 to make his fortune among the nouveaux riches. After stopping briefly in Madras, he arrived in Calcutta in September 1783, where no less a personage than Warren Hastings, the governor general of India, numbered among his patrons. One of the pictures he executed for Hastings shows a cockfight (Fig. 4), a favorite court entertainment at Lucknow, the capital of

Oudh.[9] In the composition's exact center stands Asaf-ud-daula, Nawab Wazir of Oudh, who banters with Colonel John Mordaunt, the commander of his bodyguard and his master of ceremonies. The choice of subject offered Zoffany an opportunity to paint a large assembly of prominent Europeans and Indians participating in a colorful spectacle in which the exotic nature of "Indian" India is very much in evidence. The artist takes liberties in improving on the lavishness of the setting and choosing a cast of characters who would not have all been present at the same time.[10] He introduces himself at the upper right, just behind the Nawab's vacated seat, but typically shows himself somewhat detached from the proceedings. Ozias Humphry, the painting's only other artist, stands at his side, familiarly resting a hand on his shoulder. Conspicuous by his absence is Warren Hastings, until one realizes he is indeed present as the painting's viewer. Presumably for Hastings's amusement, the painting abounds in double entendres, for many of the males hold cocks between their legs and the billowing protrusion of the Nawab's shirt suggests that more than one cockfight is in progress.

On Zoffany's journey back to London in 1789, he experienced a bout of paralysis, and, his health already in decline, he was not as active in the 1790s as he had been earlier. He exhibited his last works in 1800, although he did not die until ten years later. John Williams, who was critical of the artist's political conservatism, somewhat derisively summed up this late period: "He returned from the oriental world with a heavier purse but a weaker frame, and retired to a house near Kew bridge [at Strand-on-the-Green], where he watched the ebbing and flowing of the Thames, and applied his rumination to the vicissitudes of our being."[11]

Over his career, Zoffany also executed a series of extraordinary self-portraits, and through these works he reveals his perception of himself as a man set apart, as someone distinguished by intellectual superiority.[12] For example, in the self-portrait that he executed for the collection of the grand duke of Tuscany (Fig. 5), he shows himself in the character of Melancholy Genius. He greets the viewer with a smile, but it is the mirthless smile of Democritus, the melancholy philosopher who laughs out of pain. Democritus, who retired to the privacy of his garden to contemplate the human condition, was often associated with the hermit saints of Christianity, and Zoffany shows himself holding a skull and hourglass, traditional *vanitas* imagery associated with saints, and the painting on the wall behind him depicts the Temptation of Saint Anthony. Democritus was also closely associated with Christ, and Zoffany relies on this connection as well. The *écorché* (flayed figure) on the table copies Houdon's study for his statue of Saint John the Baptist. Here the baptizing hand is poised directly over the head of the artist as John the Baptist anoints him in his aggrandizing roles of Democritus, the Christian saints, and Christ himself.

Although Zoffany died in 1810, his much younger wife did not die until 1832, when she and a daughter succumbed to the massive cholera epidemic of that year. Ignorant of the causes of this disease, authorities burned the contents of the house in a misguided effort to stop contamination. Consequently, if Zoffany did leave cor-

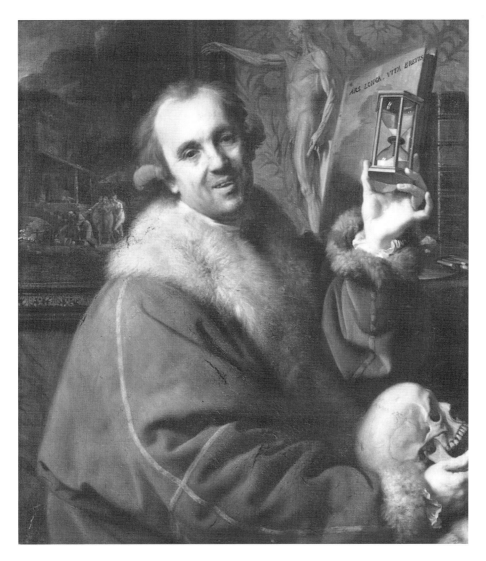

FIGURE 5
Zoffany, *Self-Portrait,* ca. 1775–78.
Oil on panel, 87.5 × 77 cm. (34⅛ × 30 in.).
Uffizi Gallery, Florence.

respondence and notes, almost nothing has survived, making it impossible to turn
to the artist's own writings as a guide to interpreting his work. Surviving anecdotes,
however, tend to reinforce the view that Zoffany presents of himself in the self-por-
trait he executed for the grand duke of Tuscany. He is said to have moved in 1765
from one London residence to another "in order to save shoe-leather in attending
the [Roman Catholic] Sardinian Chapel, his usual place of worship."[13] Although he

was later to join the Church of England in conformity with his wife's religion and that of his adopted country, the content of the French Revolution pictures suggests he remained at heart a Roman Catholic. The writer Henry Angelo, however, records another anecdote involving a dispute between Zoffany and his colleague John Hamilton Mortimer, apparently dating to not long after Zoffany's arrival in London, that suggests the artist's piety from the beginning had been less than orthodox:

> Mortimer and he were very intimate, until one day, whilst sitting for this portrait [i.e., his portrait in the picture *The Portraits of the Academicians of the Royal Academy,* which was exhibited in 1772], Zoffany began to play off his wit against the authority of scripture, and turn the Old Testament into burlesque. Mortimer, though a *bon vivant,* and a choice wit, having too much sense of propriety to endure this, called him an ass, which, abstracted of his professional talent, was not far from the truth. Zoffany, highly offended at this, for he was as vain as he was weak, bade Mortimer quit his room, which he did, but not without first giving him such a lecture that he might have well remembered, had he not been too much addicted to his weakness, which lasted him, even to old age.[14]

The evidence of the pictures themselves indicates Zoffany was attracted to Christian subject matter but in works that, as suggested by Angelo's statement, exhibit more than just a bland piety.

In an early work, dated 1756, Zoffany depicts himself as David with the head of Goliath, a bold analogy made more so by his placement of the phallic sling tauntingly close to Goliath's parted lips.[15] Sexual allusions and religious imagery also form an integral part of the private meanings underlying his painting *The Tribuna of the Uffizi,* as they do in the Uffizi self-portrait where the Three Graces taunt Saint Anthony in the picture hanging on the wall. In his self-portrait, dated to his birthday in 1779 (Fig. 6), he again provides a stimulating, even mocking, mixture of sex and piety. The artist pauses in the act of donning a Franciscan habit, while the rosary, with its vulva-shaped opening, hangs on the wall between prophylactic sheaths and a print of Titian's *Venus of Urbino* that is torn so that the pendent flap duplicates the shape of the foremost prophylactic.[16]

In 1787, when in Calcutta, Zoffany donated a large altarpiece of the Last Supper to Saint John's Church, a generous gesture, but one that was somewhat marred by his choice of models. He introduced an enemy as Judas and selected an effeminate gentleman well known for his hostility to Christianity for his Saint John.[17] On his return to London, the Parish Church of Saint Anne in Kew, where the artist and his wife were later buried, commissioned an altarpiece of the same subject, but this work was rejected after Zoffany again modeled Judas on an enemy, in this instance a prominent local attorney.[18] For Chiswick Parish Church, another local institution, Zoffany painted a scene of King David playing his harp in which an angel standing

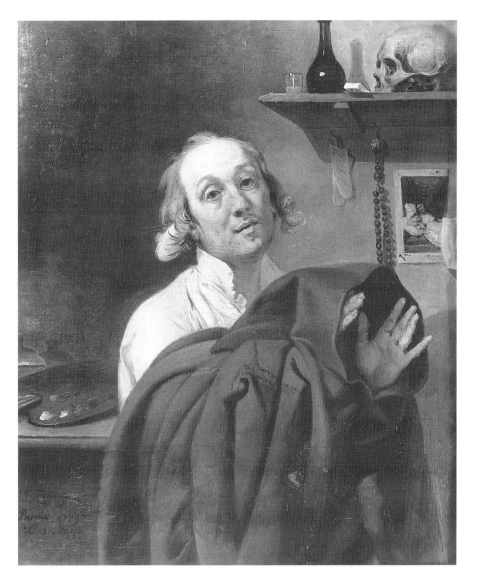

FIGURE 6
Zoffany, *Self-Portrait,* 1779. Oil on panel,
43 × 39 cm. (16¾ × 15³⁄₁₆ in.). Galleria
Nazionale, Parma.

next to the tablets of the Ten Commandments points with a disarming innocence
to the seventh: "Thou shalt not commit adultery," a commandment that David had
violated with Bathsheba and one that the artist had also ignored more than once.[19]

While one does not doubt the sincerity of his beliefs, Zoffany obviously did not
think of religious painting as merely the expression of pious platitudes. In his use of
Christian imagery he displays more than just a standard orthodoxy, and, as will be
seen, his paintings of the French Revolution must be viewed in the context of a
highly personal and creative response to religious doctrines.

2

THE *JOURNÉE* OF AUGUST 10, 1792

The French Revolution

The French Revolution, unfolding over a number of years, was not a linear progression from absolute monarchy to republicanism, but rather a dynamic, constantly shifting process whose goals at any one moment varied from group to group. Certainly, few at the beginning could have predicted, or even desired, that the monarchy itself would eventually be abolished, the king and queen losing their heads in the process.

With the government deadlocked over issues of taxation, Louis XVI, at the insistence of the nobles, called for a meeting of the Estates General, which officially opened at Versailles on May 5, 1789, the first time this body had been convened in over a century and a half. Traditionally the Estates General consisted of three orders or estates: the clergy, the nobility, and everybody else. Because the Third Estate represented approximately 98 percent of the populace, many associated it with the nation itself. On June 17 its representatives, struggling for power with the first two estates, declared themselves the National Assembly, whose goal was to write a constitution. The revolt begun by the aristocracy against the king's policies was now superseded by the revolt of the middle class. On June 20 the deputies of the National Assembly, having been locked out of their chamber, met in a tennis court at Versailles to swear an oath to continue to work, despite the opposition of the king—a moment that France's premier artist, Jacques-Louis David, was commissioned to immortalize. Almost immediately, sympathetic members of the clergy and nobility joined them in this effort, including the king's own cousin, the duc d'Orléans.

Some Parisians, confronted with the king's calling up of troops and exiling of Jacques Necker, the popular minister of finance, became convinced of a conservative conspiracy. They took to the streets on July 12, with the climax coming two days later when crowds, in search of gunpowder, stormed the Bastille. This gloomy fortress, a legendary prison, was a powerful symbol of tyranny, and its capitulation and subsequent demolition came to represent the nation's liberation from despo-

tism. The victory of July 14 required sacrifices, including the decapitation of the governor of the Bastille, his head, like those of others who had displeased the insurgents, being paraded on a pike. From the beginning, punitive violence went hand in hand with revolutionary ardor.

The shift of the center of power from Versailles to Paris was completed soon thereafter. Angered by reports that royalist troops had insulted the patriotic cockade and starved by the high price of bread, several thousand women, whose core was composed of the Parisian *poissardes* (fishwives and market women), marched to Versailles on October 5 to confront the king. They were followed by units of the National Guard, a bourgeois militia commanded by General Lafayette that had only recently been created to maintain order. The guardsmen were marching in support of the women against the wishes of their commander, who accompanied his troops only after realizing he was powerless to stop them. Louis's concessions helped to defuse the anger of many, but others, who were less easily appeased, decided that the royal family should accompany them on their return to Paris. The uneasy stalemate was broken early in the morning of October 6, when an armed crowd forced its way into the queen's apartments, killing two of her bodyguards before she narrowly escaped. Loyal troops rescued the frightened royal family, and the king went out onto the balcony to accede to the crowd's demand that the family leave for Paris. Lafayette helped to reconcile the king with his subjects and within hours began the march back to Paris, with the women and the National Guard escorting the royal carriage, members of the court, and deputies of the National Assembly. An English print of October 31, 1789 (Fig. 7), depicts this march as a ragtag procession, with the royal family on foot prodded by a *poissarde* riding on a cannon. The head of one of the slain bodyguards is mounted on a pike, its bearer admonishing General Lafayette. At the right, women pull a wagon filled with sacks of flour, the shortage of bread having been instrumental in causing the uprising. On arriving in Paris, the royal family was confined to the Tuileries Palace, where the king's and queen's actions could be monitored by their increasingly unruly subjects.

A constitutional monarchy replaced the absolutist one of the ancien régime, but the king never fully accepted his new role. His recalcitrance became clear to all when, accompanied by his family, he fled Paris on the night of June 20, 1791. They were recognized before they could reach their refuge at Montmédy, captured at Varennes, and escorted back to the Tuileries, a cloud of suspicion and mistrust the legacy of their unsuccessful flight.

On June 20, 1792, the first anniversary of the flight to Varennes and the third of the Tennis Court Oath, another popular revolt was organized, participants this time invading the Tuileries itself in hopes of forcing the monarch to accede to more of the revolutionary demands. Although the king held firm, he did don the militant symbol of liberty, the *bonnet rouge* (red cap of liberty), and drank to the nation's health. This intrusion into the palace proved a prelude to the attack of August 10, 1792, the insurrection depicted by Zoffany in his two paintings.

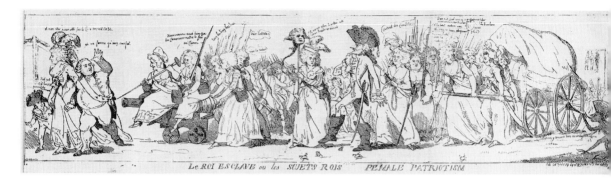

FIGURE 7

[Isaac Cruikshank?], *Le Roi Esclave ou les Sujets Rois* [*The king enslaved; or, the royal subjects*] / *Female Patriotism.* Etching, 17.8 × 71.1 cm. (7 × 28 in.), October 31, 1789. British Museum, London.

On April 20, 1792, France had declared war on Austria, whose forces were soon joined by those of Prussia. On July 25 this coalition issued the Brunswick Manifesto, threatening severe retribution if any harm befell the French royal family. Louis and his queen, Marie-Antoinette, were now more than ever closely associated with the enemies of France, and the more radical leaders were determined to see them deposed.

The working-class districts of Paris were organized to march against the king. The workers were often referred to as the sansculottes, literally meaning "without breeches."[1] Clothes had long marked the distinction between classes, and fitted breeches (*culottes*) extending to just below the knee, combined with silk hose, were the attire of the aristocracy and the middle classes. Artisans wore baggy trousers (*pantalons*) made of rough fabric. When the term *sanculotte* was first coined in early 1791, it was meant derisively,[2] but as so often is the case, it was soon co-opted by those it was intended to ridicule. The sansculottes were joined by volunteers, the *fédérés,* from the provinces who were streaming into Paris on their way to fight the invaders. One such contingent from Marseille brought with it a new song, christened "La Marseillaise," a stirring call against tyranny. On the morning of August 10, these forces converged on the palace, where the king was protected by troops from the National Guard and the loyal Swiss guards.

Most members of the National Guard had gone over to the side of the insurgents, and an uneasy peace between the opposing factions soon erupted into a battle.[3] Royalists claimed that the attacking forces fired the first shot, while the republicans maintained it was the Swiss guards. Louis, safely ensconced in the National Assembly, sent a message ordering the guards to cease firing, but not before 376 attackers had been killed or wounded.[4] After the guards obeyed the king's order, the invad-

ing force showed no mercy. The surviving troops were massacred; the palace was ransacked; those noblemen who had not escaped were killed along with the soldiers. August 10, 1792, marks the toppling of the French throne.

The Tuileries

When Louis XVI and his family were escorted from Versailles to Paris, in October 1789, they were installed in the Tuileries Palace,[5] which had been unoccupied for several decades.[6] The palace, situated west of the Louvre, had been begun in 1564 for Catherine de Médicis, the widow of Henry II and influential mother of their three sons, who reigned successively as kings from 1559 to 1589. Her architect, Philibert Delorme, followed by Jean Bullant, constructed a central pavilion and two flanking galleries, the first parts of a projected, much larger structure. Henry IV continued to extend the palace, and by the time of his assassination in 1610, the Pavillon de Flore anchored the southern end, now connected to the Louvre by the Grande Galerie, which stretched along the Seine, and the Petite Galerie.

The palace that Louis inhabited was largely the work of the architect Louis Le Vau, who in the 1660s renovated for Louis XIV some of the earlier parts of the structure and to the north constructed the Pavillon du Théâtre and the Pavillon de Marsan to balance the southern portion. Simultaneously, André Le Nôtre reconfigured the Tuileries Gardens, which extended from the west front of the palace to what became the Place de Louis XV (now the Place de la Concorde). The appropriate sections of the map of Paris commissioned by Michel-Etienne Turgot, marquis de Sousmont, begun in 1734 and completed five years later, show the Tuileries and its environs much as they appeared in 1792 (Figs. 8A–B). The formal gardens unfold on one side of the palace, while on the other were three courts, the central Court Royal being where the main attack was launched on August 10. A more schematized map (Fig. 9), published as a frontispiece to an account designed to introduce an English audience to the events of August 10, indicates that very little had changed. Even today the gardens are much as Le Nôtre had left them, but the terrain east of the palace has been completely transformed, and the palace itself no longer exists. It was pulled down in the early 1880s after being gutted by fire during the uprising of the Commune in 1871. The flanking Pavillon de Flore and Pavillon de Marsan remain, but they are not the original buildings, having been reconstructed, the first around 1861 and the second in 1874.

The king and his ministers formed the executive branch of the government, with the legislative branch meeting nearby in the Manège, the former royal riding academy that stood near the center of the north parterre of the gardens. Although some of its leaders supported the call for the dethronement of the king, the attack of August 10 was orchestrated, not from this site, but from the Hôtel de Ville, Paris's city hall, which was then controlled by the Jacobins.

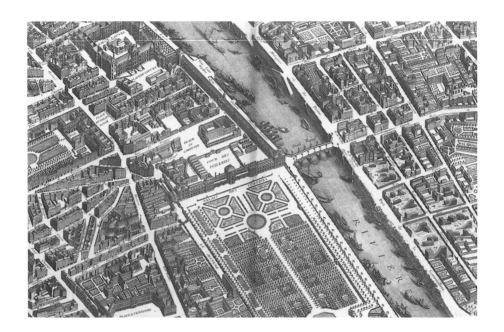

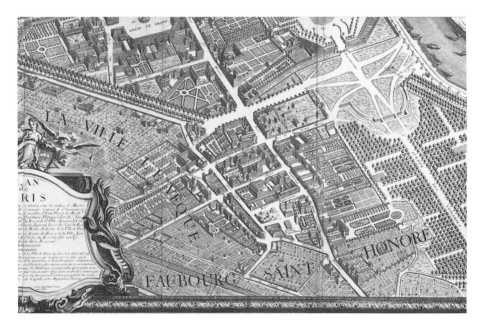

FIGURE 8A (*top of page*)
Turgot Map of Paris. Designed by Louis Bretez,
engraved by Claude Lucas, and lettered by
Aubin. Plate 15, 52.7 × 80.6 cm. (20⅛ × 31¾
in.), 1739. Map Division, Library of Congress,
Washington, D.C.

FIGURE 8B (*above*)
Turgot Map of Paris. Right-hand half of
a single oversized plate identified as Plates 18
and 19, 52.7 × 81.2 cm. (20¼ × 32 in.), cropped,
1739. Map Division, Library of Congress,
Washington, D.C.

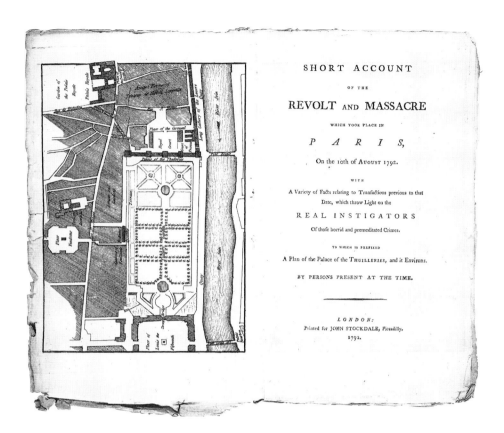

FIGURE 9
Frontispiece and title page of *Short Account of the Revolt and Massacre,*
London, 1792. The Huntington Library, San Marino, California.

The Assault

The revolt of August 10 was not a spontaneous outburst. Carefully planned, it rep-
resented national aspirations as well as those of the capital. In this instance, however,
the Legislative Assembly did not provide leadership. On May 21, 1790, Paris had
been reorganized into forty-eight sections; their leaders and those of the radical clubs
throughout the city became increasingly democratic in spirit. Events moved quickly
in late July and early August 1792. Some of the sections abolished the distinction be-
tween active and passive citizens, which had been used to impose restrictions, based
on property, on who could vote and who could serve in the National Guard. A Cen-
tral Committee was formed, providing a unifying political organization, and forty-
seven of the forty-eight sections voted to dethrone the monarch. The *fédérés,* who
had marched in from the provinces, also favored such a resolution, and a petition

calling for the replacement of the existing government by a democratic one was presented to the Legislative Assembly. When the Assembly failed to respond adequately to revolutionary demands, the tocsins (alarm bells) began to ring late in the night of August 9–10, signaling the beginning of the revolt. That same night an insurrectional commune took over governance of the municipality, replacing the legally elected one.

Aware of the impending attack, the royal family and their supporters anxiously listened to the tocsins and drums. The Tuileries was well fortified, protected by nearly a thousand Swiss guards, more than two thousand National Guards, and close to a thousand mounted police. In addition, around two to three hundred noblemen, the *chevaliers du poignard* (knights of the poniard), commanded by the octogenarian maréchal de Mailly, had rallied to defend the king.[7] The capable marquis de Mandat, the commandant of the National Guard, was in overall command. It was a formidable force that seemed to offer adequate protection. The defenders were soon stripped of their commander, however, when Mandat, summoned to the Hôtel de Ville, was arrested by the Insurrectionist Commune. As he was leaving the building on his way to detention, he was shot and killed, his body torn to pieces and thrown into the Seine. Not only had the forces at the Tuileries lost their commander, but the king could no longer rely on the loyalty of many of those Mandat had left behind.

The insurrectionists marched in two columns, one from the Place de Grève (now the Place de l' Hôtel de Ville) and the other from the Left Bank, to converge outside the palace, primarily in the Place du Carrousel between the Tuileries and the Louvre. National Guardsmen allowed them to march unhindered, more and more of the guard itself going over to the opposing forces. Eventually the only defenders of any consequence to remain loyal to the king were the feared Swiss guards, a mercenary troop with an unflinching record of service to the crown. Around 8:30 A.M., as the crowd outside the palace began to grow, Pierre-Louis Roederer, the *procureur-général syndic* of the department of Paris, persuaded the king to exit the palace from the garden side. Escorted by a contingent of the National Guard, Louis, his family, and several ministers made their way through the park to seek asylum in the Assembly. Pushing their way through an angry crowd, the royal family finally entered the Manège, where they sat out the remainder of the day's events.

The more than five hundred *fédérés* from Marseille were among the first to arrive in the Place du Carrousel. Forcing the gates to the Court Royal, they poured into the courtyard up to the doors of the palace. An uneasy stalemate was broken when shots were fired, and the Swiss, shooting from the windows of the palace, soon cleared the courtyard. A contingent then marched out to the Place du Carrousel, where, forming a hollow square, they continued the rout of the insurrectionists. But the rebellion was far from over. Reinforcements, particularly in the form of sansculottes, continued to arrive, and the assault was renewed. Louis, hearing the battle from the confines of the Manège, wrote an order commanding the Swiss guard to

cease firing. Obeying the command, the guard marched out in two files, both proceeding through the Tuileries Gardens, one to their barracks, the other to the Manège itself, where they tearfully surrendered their arms in front of the king. The incensed attackers, who felt the guard had behaved treacherously, butchered them. Only about a third survived, and many of these, taken as prisoners, were killed a few weeks later in the September massacres. The palace itself was looted; fires were set; and most of those found within, whether noblemen or servants, women or children, suffered the same fate as the Swiss.

Because of the work of modern scholars, today we know a great deal more about the people who participated in the assault and its bloody aftermath than did Zoffany and his contemporaries. One of the pioneering writers is George Rudé, who in several books has analyzed the makeup of the "crowd" that participated in the military operation of August 10. The military units were composed primarily of householders; the sansculottes, drawn from the "petty trades and crafts and shops," comprised, as in other preindustrial riots, mostly "small workshop masters, shopkeepers, apprentices, independent craftsmen, journeymen, laborers, and city poor."[8] Ultimately, though, *sansculottes* is a political term rather than one that defines a social class, for among the insurgents were also civil servants, rentiers, and professional men, and in Zoffany's paintings one also encounters a few well-dressed sympathizers alongside the *menu peuple* (lower classes).

August 10 in Art

In depicting the events of this day, French artists normally focused on one of two incidents: the assault on the palace, or Louis XVI and his family taking sanctuary in the Assembly. Paintings of the fighting appeared in the next Salon, that of 1793 (see, for example, Fig. 10), and numerous prints were also issued recording the attack. Some of these prints formed parts of larger series commemorating important episodes beginning with the momentous events of 1789. From the start, there was a self-conscious awareness on the part of artists and their audiences that they were living through historic times worth recording for posterity. One such series, later entitled *Principales Journées de la Revolution*, was inaugurated on May 4, 1790, when the engraver Isidore-Stanislas Helman presented to the Constituent Assembly his print after Charles Monnet's drawing of the opening of the Estates General on May 5, 1789. *Journée du 10 Aout 1792* (Fig. 11), which belonged to this series, was on sale by September 1793. It offers an expansive view of the Tuileries looking toward the Pavillon de Flore in the southwest end of the palace. At the right is the center tower of the main facade, and the wall separating the Court Royal from the Court of the Princes can be seen at the left in front of the Grande Galerie. Monnet's depiction, like most of those by his contemporaries, takes a point of view behind the insurrectionists, allowing the viewer to identify with the attacking forces, many of whom wear the *bonnet rouge.* The assault is that of an organized force rather than a wild

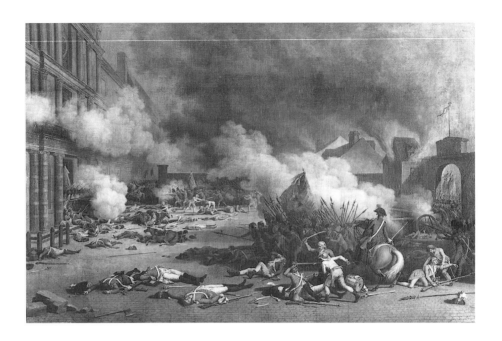

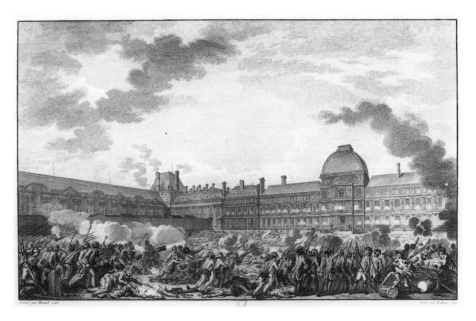

FIGURE 10 (*top of page*)
Jacques Bertaux, *Prise du Palais des Tuileries, le
10 Août 1792* (Capture of the Tuileries Palace,
August 10, 1792), Salon of 1793 [artist's name
listed in catalogue as "Berthaud"]. Oil on
canvas, 1.24 × 1.92 m. (48⅝ × 74¹⁵⁄₁₆ in.).
Musée National du Château, Versailles.

FIGURE 11 (*above*)
After Charles Monnet, *Journée du 10
Aout 1792* (August 10, 1792). Engraved
by Isidore-Stanislas Helman and etched
by Antoine-Jean Duclos, 35 × 46 cm.
(13⅝ × 17¹⁵⁄₁₆ in.), 1793. Bibliothèque
Nationale, Paris.

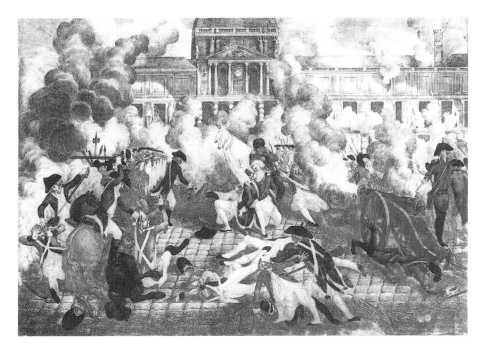

Artist unknown, *Fondation de la République le 10 Août 1792* (Founding the Republic, August 10, 1792). Colored etching, 36.5 × 53.5 cm. (14³⁄₁₆ × 20⅞ in.), [1792]. Bibliothèque Nationale, Paris.

mob, as the sansculottes and *fédérés* courageously fight in the open against the Swiss troops and the royalists, who fire from the windows of the palace. In the left foreground, sansculottes strip the corpses of fallen Swiss soldiers, Monnet distinguishing between the military discipline of the insurrectionist soldiers and the more impassioned response of the citizenry. He is not alone in making such distinctions: other artists also show the sansculottes more frequently than the regular military units engaged in hand-to-hand combat with the Swiss.

A crude, unsigned, and undated print, *Fondation de la République le 10 Août 1792*, offers a more partisan view of the fighting (Fig. 12). Its propagandistic caption offers a republican account of how the battle unfolded:

> Around ten thirty in the morning, all Paris, so to speak, could be found assembled at the Place du Carrousel and the adjacent area, with the troops from Marseille at their head. The Marseillais demanded that the gates to the Princes' Court be opened, and when the gates were opened without difficulty, they entered, and advanced abreast; they were welcomed by the Swiss, who were lined up in several columns: they were even given cartridges by them as a sign of friendship; they advanced still further, followed by the Cordeliers' battalion. When they were ten paces from the palace, there was a running fire

from the right and the left simultaneously, even through the windows of the castle, followed by cannonades and musket fire from concealed batteries, and a large number of men fell from this unexpected and perfidious attack. Their comrades reformed in good order and withdrew without breaking ranks, supported by the Bretons; the firing was ceaseless; they were exposed and almost alone for nearly an hour, given that the Paris battalions were ill-provided with ammunition and had scarcely enough powder for three rounds. The Swiss kept up the fusillade from inside their barracks, where they had hidden after the first attack to reload at their ease, scarcely inconvenienced by the volunteers. At the same time, the people were being fired upon from every window, from the Pavillon de Flore and from the Grande Galerie that runs the length of the quay; a number of citizens, mainly women and children, were not able to avoid their fire except by jumping over the parapets along the river. Firing was coming from both the garden side and the city side, from the roofs and the cellars; it seemed that word had gone out at the palace to perpetrate another Saint Bartholomew's Day massacre. Finally the Marseillais and the Bretons were no longer alone in bearing the brunt of the concealed Swiss artillery; the infantry and cavalry, who played such a part in the glory of this day, which without them would have been even bloodier for the patriots, rushed up, and without a moment's hesitation swooped down on the barracks and set them on fire. A number of horsemen and horses stayed on the spot; a twelve-year-old trumpeter had his horse shot from under him, but kept his head, cut the saddle girth, picked up his pack, and went off to find a place in the ranks of the infantry. The pikemen showed no less courage than the other troops: they braved the artillery fire and, joined with the bayonets, were very effective.[9]

The massacre of the Swiss troops after they had ceased firing is not mentioned, but such actions are implicitly justified by references to Swiss perfidy. According to the caption, the Swiss not only treacherously lured the insurrectionists into a trap, but also fired on women and children, who, it is implied, were noncombatants in that they were on the river side of the Grande Galerie. The image, unlike the caption, restricts itself to showing uniformed soldiers engaged in combat within the courtyard.

The exterior setting for the French portrayals of the attack invariably is the courtyard side of the palace, and the artists render it as a military operation involving soldiers and armed citizens. In addition, with only one exception, it is an all-male affair.[10] Furthermore, whenever hand-to-hand combat is depicted, it is always the Swiss soldiers who are on the losing end.

Surely the first illustrations of this important *journée* are the small, crude designs, published within a few days of the events they depict, that appeared in Louis-Marie Prudhomme's popular radical journal *Révolutions de Paris*. Two of these works, *Fusillade du Château des Thuilleries* (Fig. 13) and *Incendie de la Caserne des Suisses, au Carrousel, le 10 Août* (Fig. 14), function as pendants, the first depicting the as-

Sur l'invitation perfide des suisses à-travers les Croisées du Château les Citoyens entrent dans la Cour avec confiance, à l'instant un feu roulant fait sur eux en couche par terre un grand nombre.

Le Carrousel étoit comme une vaste fournaise ardente ; pour entrer au Château, il fallait traverser deux Corps de logis incendiés dans toute leur longueur ; on ne pouvoit y pénétrer sans passer sur une poutre enflammée, ou marcher sur un cadavre encore chaud.

FIGURE 13 (*top of page*)
Artist unknown, *Fusillade du Château des Thuilleries* (Firing on the Tuileries Palace), August 1792. Etching, 9 × 15 cm. (3½ × 5⅞ in.) (border), from *Révolutions de Paris,* no. 161, facing p. 230. Princeton University Library.

FIGURE 14 (*above*)
Artist unknown, *Incendie de la Caserne des Suisses, au Carrousel, le 10 Août* (Burning of the Swiss barracks in the Place Carrousel, August 10), August 1792. Etching, 9 × 15 cm. (3½ × 5⅞ in.) (border), from *Révolutions de Paris,* no. 161, facing p. 238. Bibliothèque Nationale, Paris.

FIGURE 15
[Etienne Béricourt], *Sansculottes Disposing of the Bodies of the Swiss Guards.*
Pen and ink with watercolor, 17.5 × 31.5 cm. (6¾ × 12¼ in.) (border),
[1792]. Bibliothèque Nationale, Paris.

sault and the second focusing on its aftermath, one of the few French images to do
so. At the right in the first design, the protected Swiss fire from the windows of the
palace. At the left, pikemen rush through the gateway, while in the back of the cob-
blestone courtyard disciplined troops led by a vigorous leader stand with dead bod-
ies at their feet. The caption tells the story of Swiss treachery—"Sur l'invitation
perfide des suisses à travers les Croisées du Château les Citoyens entrent dans la
Cour avec confiance, à l'instant un feu roulant fait sur eux en couche par terre un
grand nombre [On the perfidious invitation of the Swiss from the palace's casement
windows, the citizens confidently entered the courtyard; at that instant a rolling fire
felled a great number]"—but as the image testifies, such treacherous conduct
could not shake the attackers' resolve. The companion image, *Incendie de la Caserne
des Suisses,* depicts the violent denouement with a visceral immediacy. Its caption,
concentrating on the intensity of the fire, with its smoldering bodies, comes directly
from the journal 's text.[11] The victorious troops, lined up along the left foreground
and across the right-hand side, watch as two men are beheaded next to a pile of
their decapitated comrades. Rather than the bodies of those men slain by treach-
ery seen in the first image, this one shows those executed for perpetrating that in-
famy. The journal's account described the barracks as a place of concealment for
the Swiss, where they could reload at their leisure. The fire in the background of
the print, which at first glance conjures up the fires of hell, is instead a purifying
one, eradicating a vipers' nest.

While French artists, for the most part, refrained from depicting scenes of the carnage, the minor watercolorist Etienne Béricourt presents an interesting exception. Béricourt's recorded oeuvre is made up of such popular subjects as village festivals, dances, performances of saltimbanques and charlatans, and the depiction of fashionable promenades like the Tuileries Gardens.[12] The Bibliothèque Nationale owns twenty watercolors and five prints by him depicting revolutionary themes, and one of these, which I am titling *Sansculottes Disposing of the Bodies of the Swiss Guards* (Fig. 15),[13] shows the defeated soldiers, some perhaps still alive, being tossed from the windows of the palace to a waiting crowd below. As if traveling along a hellish assembly line, the bodies are then stripped and hauled to a bonfire at the left. The scene is situated in the palace courtyard, and the main building, though cursorily rendered, provides a dramatic diagonal as it sharply recedes into the background. A group at the right takes time off from the gruesome tasks to indulge in drink or watch its compatriots. Some carry pieces of the Swiss guards' clothing as trophies of war on their pikes.[14]

Outside France, interpretations of the fighting could be far more biting. For example, an Augsburg publisher issued two prints (Figs. 16 and 17) that, like Zoffany's paintings, take a highly jaundiced view.[15] In the first print the anonymous artist telescopes both the narrative and the setting, placing his version of the Legislative Assembly opposite a fanciful re-creation of the Tuileries Palace as seen from outside the gate to the Court Royal. Even the author of this counterrevolutionary work, however, could not fully condone the conduct of the king, who, in the caption, is described as seeking to save his life by entering the National Assembly at the same moment his queen courageously defies their assailants. The bloodlust of the insurrectionists is alluded to in the figure who is about to be hanged from the lamppost at the right, its lantern carefully removed and placed on the ground. In the caption he is identified as a member of the Assembly who is eventually rescued. The caption also states that the valiant Swiss were not so fortunate, and, at right of center, a soldier's head has already been severed from his body.

The second print of this pair shows even greater atrocities. At the right, the king and queen are being driven to the Temple prison, a journey they actually did not make until August 13, while young men hurl stones at their carriage. In the lower right, a sansculotte relieves himself on a broken statue of a classically attired French king. Such actions were insulting, but in the scenes at left and center the violence dramatically escalates. A naked man is hurled from the window of the flaming palace; beneath him, aristocrats hang from a bracket; in the lower left corner, defenseless Swiss soldiers in their shirts are murdered in cold blood; in the background heads and a heart of some of the victims are paraded on pikes; and in the center lie the piled bodies of murdered priests, one tonsured head clearly visible. The figure holding a flag in one hand and a saber in the other is identified in the caption as Santerre, the republican brewer who had replaced the royalist Mandat as head of the National Guard. Below him, a soldier drags the body of Colonel d'Affry, the leader of

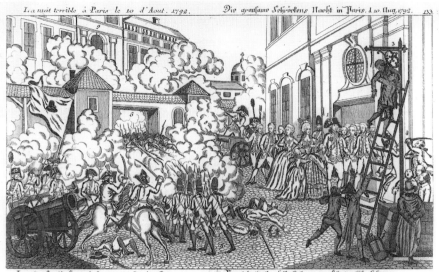

La nuit terrible à Paris le 10 d'Aout. 1792. Die grausame Schröckens Nacht in Paris, d 10 Aug. 1792. 133.

La nuit effroyable s'approche. La race maudite des Clups
Crie à haute voix: Qu'on dépose le Roi, qu'on le dethronse!
1 Le Roi se refugie dans la salle de l'Assemblée Nationale, et cherche.
A sauver sa vie. Mais 2. la Reine, tout courageuse, s'ecrie sans peur.
Voila ma poitrine, si je suis coupable, Percés la.
Epargnez seulement la vie de mon epoux, de mes enfans.
3 Un Membre de l'Assemblée fut deja lanterne.
Mais pourtant il fut encore à tems sauve et delivré de leur rage.
4 Le Capitaine de la Garde fut blessé en sonnan le tocsin, et tout fut alarmé.
5 Et les Marseillois courent pleins de rage vers le château
Apportant celui, qu'ils massacreo venican, et toute la rée si france.
6 Des Suisses vaillants etoit ca com. Ils etoient perdus.
7. La Cavallerie, 8 on braque les Canons.
On pille les Thuilleries, 9. on les brule, on n'egorgue rien.

Nun reicht die Graul Nacht Heran, der Klugsten böse Schaaren.
Schreit feroch man seh den Konig ab, sie lebren zur Barbyret.
1. Der König flieht zur Nation, sucht Rettung für sein Leben.
2. Die Konigin aber ganz beherst, voll ohne furcht und beben.
Her ist die Brust, wan schuldich bin; Rugt doch sie durch zu bohren.
Nur das Armuth und Kinder leib, im Leben zu bohren.
Ein Mitglied von der Nation, ward schon 3 Laternmord.
Doch noch zu rechter Zeit gerett, und ihre Wuth gestillet.
4. Der Guarde Hauptman selbst verwundt; Ersban erschlagen
Und die 3. Marseilleis stürzen an, mit Schössel voll wuth zu zinden.
Am anzug der Gewehel an, und alles niederschlen.—
Die Schweizer Schwermer hält hier anveste; Sie musten untergehen.
Es fiel der 7. Reuterey, hierdey gran richtet die 8 Kanonen.
Man plandert, Thuilleries steht in Brandt Furth, nirgende war kein schonen.

Horribles attentats des François comis à Paris le 10 d'Aout.1792. Schaudervolle Unterhandlung der Franzosen untereinander geschehen zu Paris, d 10 Aug. 1792. 134.

Quels horreurs, quels crimes atroces ne commet on point en France.
1. On conduit le Roi et la Reine au Temple en prison.
2. Les populace les outrage, et veut leur jetter des pierres.
3. D'Assy et massacre est traine dans la boue.
On pend 4. tous les Aristocrates, et 5. la statue de Louis XV est deshonoreé.
On y 6 plante le chapeau de la liberté, on font les debris decet ouvrage d'art.
On tue une quantité d'homes, et 7. les aristocrates ecartelés.
Desquille 8 les Suisses jusqu'à la chemise, et les egorge.
9. On jette les homes tous vivs par les fenestres.
On porte sur les piques 10. les tetes, coeurs et intestines des malheureux égorgés.
11. Lantenier, et fameus bruleur comande le peuple furieux.
On court 12. vers les Thuilleries, D. on brule les redut en centres.
Lestonne de enfine entre pius le tentes, s'endurecissent au point.
De sorte Mamese des tetes d'homes coupeés Malheur à toi, à France!

1. Der König und die Königin wird Temple angeführt sich setzen
2. Der Pöbel spottet ihrer, noch, und zielt mit Strimen auf den Wagen.
3. Der gemordete Schweizlich fortgeschleppt nachdem man ihn zur Todtgeschlagen.
Man hängt auf alle 4 Hochgern, nach 5 Ludowig Fünfzig wird entehret.
6. Ein Freyheits Hudt ihm aufgestekt, wo man die Kunstheit ließt zerschret.
Man tödt viel Menschen ohne Zahl, noch arbeitet 7 Peischlers Grube.
8. Sich aus 8 die Schweizer bis aufs Grab, u mordet sie mit grosser Kunde.
9. Eins wurfnt noch die Menschen mit Gewalt zum Fenster hin verdammen.
10 Tragt auf den Pieten 10. Kopf, Herz Herz, von denen massacrirten Herzen.
11. Plunderte der schöne beruchtete Peman fürt man zur Volck voll Wuth u. Hosser.
Man renit 12 auss Schloss Thuilleries zeunst 10. u fend u brent da voller Eifer.
So füllt in weisse Kinder Herz, auch Blut, u. spiett zu arg Menschenfressen.
D. Frankreich Frankreich geh in Dich, der Todt steht schon in deiner Türen.

the Swiss guards, who, being ill, was not actually present during the fighting. This rendition juxtaposes the fallen commander's desecrated corpse with the newly elected military leader of the insurrectionists, who still wears a brewer's apron. Women participate in the violence as well. A fashionably dressed couple watch with amusement the defecating man at the right, while lower-class women, glimpsed below the bracket at left, form an integral part of the bloodthirsty mob being led by Santerre. Even more shocking are the two young boys who play with the heads of decapitated men in the center foreground. Women and children, cited as defenseless victims in the anonymous republican print (see Fig. 12), are here turned into depraved and callous monsters. Although similar to Zoffany's paintings in their expression of outrage, these two works ultimately underscore the uncommonness of his portrayal. One expects this type of crude propaganda to appear in the medium of prints, but there is in fact no parallel to Zoffany's treatment of similar themes on a large scale in oils.

An English Perspective

Initially, the English response to events in France was generally sympathetic. Many welcomed the changes, believing the French were becoming more like them as they moved away from absolute monarchy. On November 4, 1789, Richard Price, a dissenting Protestant minister, delivered his soon-to-be-published sermon *A Discourse on the Love of Our Country* to the London Revolution Society, formed the year before to celebrate the centenary of the Glorious Revolution. In closing, he linked Simeon's thanks to God for having been permitted to live long enough to see the coming of Christ (the "Nunc Dimittis," Luke 2:29–32) with his having lived to see the new world now at hand:

> What an eventful period is this! I am thankful that I have lived to it; and I could almost say, *Lord now lettest thou thy servant depart in peace, for mine eyes have seen thy salvation.* I have lived to see a diffusion of knowledge, which has undermined superstition and error—I have lived to see the rights of men better understood than ever; and nations panting for liberty, which seemed to have lost the idea of it.—I have lived to see THIRTY MILLIONS of people, indignant and resolute, spurning at slavery, and demanding liberty with an irresistible voice; their king led in triumph, and an arbitrary monarch surrendering himself to his subjects.—After sharing in the benefits of one Revolution

FIGURE 16 (*opposite, above*) Artist unknown, *La nuit terrible à Paris le 10 d'Août 1792* (The terrible night at Paris of August 10, 1792). Etching, 29 × 40.5 cm. (11 5/16 × 15 3/4 in.), [1792]. Bibliothèque Nationale, Paris.

FIGURE 17 (*opposite*) Artist unknown, *Horribles Attentats des François comis à Paris le 10 d'Août 1792* (The horrible crimes committed by the French at Paris, August 10, 1792). Etching, 29 × 40.5 cm. (11 5/16 × 15 3/4 in.), [1792]. Bibliothèque Nationale, Paris.

[the Glorious Revolution of 1688], I have been spared to be a witness to two other Revolutions, both glorious [the American and the French].—And now, methinks, I see the ardour for liberty catching and spreading; a general amendment beginning in human affairs; the dominion of kings changed for the dominion of laws, and the dominion of priests giving way to the dominion of reason and conscience.[16]

Price ends with an even stronger denunciation of tyranny. Pitting light against darkness, he predicts the complete triumph of the "friends of freedom."

Tremble all ye oppressors of the world! Take warning all ye supporters of slavish governments, and slavish hierarchies! Call no more (absurdly and wickedly) REFORMATION, innovation. You cannot now hold the world in darkness. Struggle no longer against increasing light and liberality. Restore to mankind their rights; and consent to the correction of abuses, before they and you are destroyed together.[17]

William Wordsworth visited France twice during the Revolution, the first time on July 13, 1790, landing at Calais shortly after he had turned twenty, and the second time in November 1791. He later wrote of his reactions to these formative experiences in his epic *Prelude; or, Growth of a Poet's Mind,* which, first published in 1850, bears the descriptive subtitle *An Autobiographical Poem.* In book 6 he says of the timing of his first trip, a summer vacation undertaken with a friend to visit the Alps:

But Europe at that time was thrilled with joy,
France standing on the top of golden hours,
And human nature seeming born again.
 (6.339–41)[18]

The heady excitement of his response to the Revolution's potential is perhaps best expressed in his oft-quoted lines,

Bliss was it in that dawn to be alive,
But to be young was very Heaven!
 (11.108–9)

At this same time, where Price saw "increasing light and liberality" and Wordsworth, a dawn and a heaven, the not-so-young politician Edmund Burke, who, born in 1729, was just four years older than Zoffany, took a far more pessimistic and disgruntled view. His *Reflections on the Revolution in France,* published November 1, 1790, was the first major dissent, and in it he prophesied a bloody denouement. Written in an epistolary form, it ostensibly replied to a young French acquaintance, Charles-Jean-François Depont, who had inquired about his views on develop-

ments in France in a letter coincidentally written on the day Price had delivered his sermon. But Burke's true audience was the English public. As indicated by its full title, *Reflections on the Revolution in France, and on the Proceedings in Certain Societies in London relative to that Event,* the book, in large part, responds to Price's discourse, where Burke refutes the minister's interpretations of the underlying meaning of the Glorious Revolution of 1688 and its implications for the reforms under way in France.

After reviewing Zoffany's paintings in detail, it will become clear how central Burke's argument was to the artist's conception. Suffice it to say here that Burke provided the first comprehensive philosophical framework within which developments in France could be understood from a counterrevolutionary perspective. The statesman argued for the importance of tradition, even prejudice, as embodying a nation's collective wisdom, painstakingly accumulated and tested over centuries in an organic, evolutionary unfolding of a social order. Anything other than gradual, moderate change in civic affairs courted disaster. The French, in rejecting their heritage, were attempting to construct a new society built on arbitrary, abstract principles that could only lead to a fruitless, reductive system, unresponsive to society's true, complex nature. The paternalistic and chivalric system of the ancien régime, rooted in what was natural and divinely sanctioned, provided for the nation's happiness, despite its faults, far better than the Revolution's tyranny of reason.

For Burke, the October Days offered the best proof of the monstrous possibilities latent in revolutionary reform. The assault on Versailles, a prime example of the misrule of women, was a violation of the unwritten contract between the king-father and his people-family, a violation both of the queen as representative of a vulnerable and quasi-divine femininity and of the royal children, the nation's hope for a resplendent future. Burke applied Price's hymn of thanksgiving to these events, rather than to the fall of the Bastille, which Price maintained was his source of inspiration, and Isaac Cruikshank effectively conveyed in a caricature (Fig. 18) the highly charged emotions of Burke's account. On the left Price, accompanied by a devil and kneeling on a crown, witnesses the savage assault on Marie-Antoinette's bedchamber while piously uttering Simeon's sentiments, "Lord now lettest thou thy Servant depart in peace for mine Eyes have Seen." Counterbalancing Price at the right is the escaping queen, dressed only in her nightgown, her virtue contrasted to his vice. Cruikshank's print is an exception to the majority view. The English caricaturists were more inclined to see Burke as overreacting to reform and offering a reactionary's support for despotism, aristocratic conservatism, and Roman Catholicism.[19]

Burke's book began a pamphlet war between the supporters and opponents of the French Revolution. The most influential of the pro-French writers was Thomas Paine, whose *Rights of Man,* part 1, appeared in February 1791, followed a year later by part 2. For decades in England there had been agitation for reforms, and the French Revolution increased the strength and direction of these concerns. One of

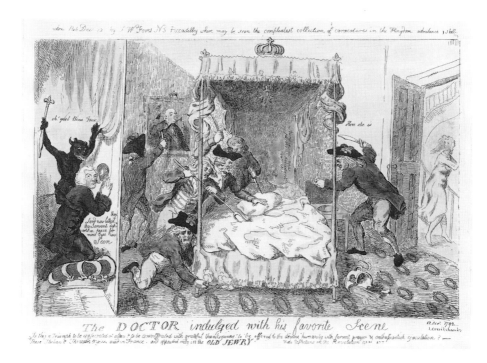

FIGURE 18
[Isaac Cruikshank], *The Doctor indulged with his favorite Scene.* Etching, 22.9 ×
35.2 cm. (9 × 13⅞ in.), December 12, 1790. British Museum, London.

the more important radical organizations was the London Corresponding Society,
which, founded on January 25, 1792, was composed of tradesmen and artisans, the
English counterpart to the French sansculottes, as well as middle-class profession-
als, who espoused such revolutionary goals as universal suffrage for males, annual
general elections, and more equal representation in Parliament.

In 1792 a backlash against reform began to make itself felt. Burke's initially iso-
lated interpretation, that the French Revolution espoused principles attacking the
foundations of the English constitution, became the majority view when events in
France accelerated away from constitutional monarchy. The English loyalists began
in earnest to oppose the views of English Jacobins once reform was viewed as a trea-
sonous challenge to traditional English liberties. After the fall of the French monar-
chy on August 10, 1792, English attitudes hardened. The agriculturist Arthur Young
spoke for many in calling this day a turning point: "The Revolution before the 10th
of August, was as different from the Revolution after that day as light from darkness;
as clearly distinct in principle and practice as liberty and slavery."[20]

The *Times,* one of the London daily papers that promoted the views of the Pitt
ministry, had no doubt about the significance of August 10, the newspaper's earliest
reports placing the drama in a larger context:

What we have long suspected is at length come to pass. The tyranny of the FRENCH MOB has prevailed. . . .

. . . the voice of the mob has obliged the National Assembly to dethrone the King, and have [*sic*] denied the authority they solemnly bound themselves to obey; wading through the blood of their fellow citizens to establish the despotic truncheon of Democracy. . . .

Whatever little respect the French Revolution had in this country, is now converted into the most inveterate detestation. To dethrone their King and assassinate their Representatives, must gain them the hatred of every other nation in Europe.[21]

The next day the *Times* maintained that the bloody excesses of the assault were part of the radicals' agenda from the beginning:

the outrages were not provoked by any perfidy or stratagem on the part of the Royal Family, but were the result of cool, deliberate, and premeditated revenge.

. . . They [the numerous incendiaries] had repeatedly declared that it was resolved to massacre the Swiss Guards,—to drive out of the Tuilleries those National Guards who had remained faithful to the King,—and to destroy the Palace, that it might be no longer the abode of Kings.[22]

Later, the publisher John Stockdale issued a forty-two-page booklet offering eye-witness accounts of what had transpired. Its description of the *fédérés,* particularly those from Marseille, is in marked contrast to the portrayal of these military units in French images:

Those who have not seen these Federates will, doubtless, be curious to know what sort of persons the different departments of France had sent in order to represent them in this irregular manner [i.e., sending them to attend the commemoration of July 14 although the date had already passed]. Unlike those respectable citizens who came at their own expence to the Federation of [July 14,] 1790, and who, actuated by a strong and real love of freedom, shewed their attachment to their King and Country by submission to the laws, and a proper conduct towards their fellow citizens, the Federates of 1792 were distinguished by that livid, hardened, and impudent front which generally characterises men who live by subverting the law, and invading property.—They were in general from about sixteen to thirty years of age, cloathed in rags, and covered with dirt; men whose employment ever since the reign of anarchy had been to create confusion and augment disorder in their own respective provinces. To all these were added, by way of pre-eminence, a band of those ruffians who had so long desolated Avignon, Arles, and the Southern Provinces. Collected on purpose, these banditti, who called themselves Marseillois,

began their exploits at Paris, on the day of their arrival, by an open murder, and several assassinations; and carried their insolence to such a pitch, as to oblige the Parisians to wear a cockade in the form they chose to prescribe. The pusillanimous Parisians submitted, and that city, which has the insolence and vanity to compare itself to ancient Rome, and which is actually peopled with 700,000 inhabitants, received the law from 500 ragamuffins, without arms, and almost without shoes.[23]

Jean-Gabriel Peltier, the founder of the pro-royalist newspaper *Actes des Apôtres* (Acts of the Apostles) who fled France for England on September 21, 1792, quickly published his account of what had transpired, describing the troops in similarly disparaging terms as "banditti, under the name of a *Marseillais* army, consisting of about two hundred and fifty desperadoes, the scum of Barbary, Malta, Italy, Genoa, and Piedmont."[24] Military units motivated by patriotic zeal are in both accounts turned into banditti, a word often used in the English press to characterize the insurrectionists.

Neither the king and his ministers nor the people's elected representatives but rather the action of armed revolutionaries determined the course of government on August 10, a force that the *Times* referred to on August 16 as "the sovereign mob."[25] The next day, the newspaper published a letter from Jean-Louis Carra, one of the revolutionary leaders, whom it introduced as "the eternally infamous and execrable M. CARRA, a man who confesses himself to have been a principal instrument in this wicked plot, and who is a Member of the French Legislature."[26] Carra agreed about who controlled the nation's destiny, but he characterized this group somewhat differently. In his first sentence he refers to the power and majesty of the wrath of "the Sovereign People" that was exhibited on August 10. Thus the insurrection could be portrayed as an expression of either the sovereign people or the tyrannical, sovereign mob. These two polar viewpoints are still with us today, and one should heed George Rudé's caution that "both are stereotypes and both present the crowd as a disembodied abstraction."[27] The truth is more complex, but for Zoffany and many of his contemporaries the negative stereotype was more than adequate.

August 10 set into motion even greater horrors. With the renewed success of the approaching coalition armies, mobs broke into jails to murder those suspected of counterrevolution during several violent days of bloodletting known as the September massacres. At least fourteen hundred people were butchered, including nonjuring priests, common criminals, and women and children. James Gillray captures some of the revulsion the English felt at these atrocities in his print *Un petit Soupèr, a la Parisiènne;—or—A Family of Sans-Culotts refreshing after the fatigues of the day*, dated September 20, 1792 (Fig. 19). Men, women, and children engage in an orgy of cannibalism, ravenously consuming portions of their victims. The headless body of "Louis le Grand" on the wall is prophetic, as Louis XVI was guillotined on January 21, 1793.

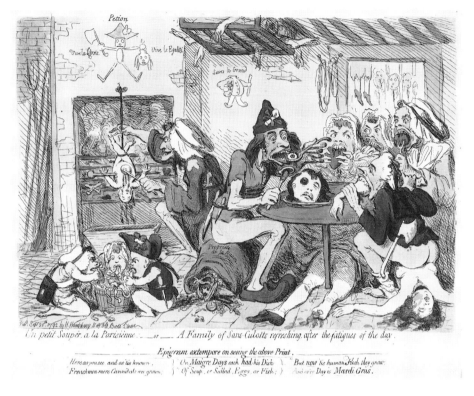

FIGURE 19
James Gillray, *Un petit Soupèr, a la Parisiènne [A small supper in the Parisian manner];—or—A Family of Sans-Culotts refreshing after the fatigues of the day.* Colored etching, 24.2 × 34.8 cm. (9⅜ × 13⅝ in.), September 20, 1792. British Museum, London.

As I argue in Chapter 6, Zoffany probably did not begin his two canvases in earnest until the spring of 1794, almost a full two years after the events to which they give mournful witness. If this dating is correct, his interpretation of the fall of the monarchy was filtered through the lens of the Revolution's subsequent history. He knew not only the fate of the king and queen when he sat down to compose his works, but also the full litany of the horrors spawned by the Reign of Terror. Pressed from within and without, the Revolution became increasingly more radical in its philosophy and more extreme in the measures it took to consolidate its power. Revolts and unrest in some of the large provincial cities and the counterrevolution that erupted in the Vendée led to reprisals whose scale and cruelty could never have been imagined by the Enlightenment philosophy of the prerevolutionary period. In Paris itself the execution of Marie-Antoinette on October 16, 1793, inaugurated the large-scale guillotining of political prisoners that did not abate until the violent convul-

sions of the Terror were slowed with the death of Maximilien Robespierre, the uncompromising leader of revolutionary justice, in July 1794. Thus when Zoffany executed his works, the events of August 10, 1792, were not an isolated spasm of violent upheaval—one that regrettably, but perhaps inevitably, accompanied the fall of the monarchy and the birth of the republic—but the event that had introduced violence, much of it state sponsored, as a fundamental principle of revolutionary theory and practice. The historian Colin Lucas points out that "almost every radical commentary on 10 August emphasized its orderly quality" as part of a conscious effort "to evacuate rhetorically as far as possible the violent quality of popular action."[28] In his paintings, Zoffany reintroduces violence as the *journée's* central focus.

The news from France was, of course, not only about bloody resolutions of ideological conflict, but also about legislative changes that audaciously sought to restructure the country's core values. To give one example, a new calendar was adopted in November 1793, dating the Year 1 from September 22, 1792. This reconfiguration replaced Christ's birth as a chronological marker with the birth of the French Republic, and in the process of constructing a new system based on ten-day weeks and months of equal length with a new nomenclature, it swept away the annual Christian cycle of Sundays, saints' days, and major religious holidays. The de-Christianization movement even invaded Notre-Dame Cathedral itself, which, in the Festival of Liberty and Reason held on November 10, 1793, was renamed the Temple of Reason. For Zoffany, August 10, 1792, would have denoted not only the end of the monarchy but also the event that opened the floodgates for an ever-increasing assault on fundamental principles.

The Portrayal of the French Revolution in British Painting

As with the literary reactions, in England the initial pictorial response to the French Revolution was sympathetic to reform. Yet the fall of the Bastille and its subsequent destruction, the subject of numerous French images, was treated only once in the Royal Academy exhibitions. In 1792 G. Stephany, an ivory carver who was perhaps originally from Augsburg, exhibited the following: "Taking of the Bastille, and the sacrifice of Cupid, in ivory" (no. 237). It would be hard to imagine how one could better trivialize so important an event.[29]

There was more interest in the subject of the fall of the Bastille outside the Royal Academy than within, but no paintings have survived, all of these images now being known only from the prints after them. Henry Singleton attempted what may have been a large, ambitious picture entitled *The Destruction of the Bastille,* which shows the assault from the vantage point of the insurgents,[30] the most typical point of view. But the most imaginative of the British responses to this event is a work by the Royal Academician James Northcote now known from James Gillray's engraving after it, published July 12, 1790, just in time for the first anniversary (Fig. 20).[31]

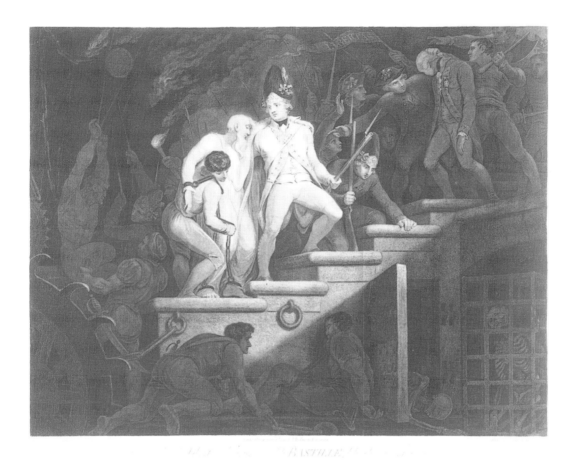

Le Triomphe de la Liberté en l'élargissement de la Bastille, dédié à la Nation Françoise, as its title indicates, reaches out to a French audience as well as to an English one. Northcote ignores the primary reason for the assault—that the Bastille was an arsenal containing valuable supplies— to focus instead on its function, then extremely limited, as a prison. His imagined atrocities are more closely related to Giulio Romano's famous prison scene in the Sala dei Venti in the Palazzo del Tè, which he would have known from Antonio da Trento's etching after it, than to any reality. Surrounded by instruments of torture, their victims, and the still imprisoned skeletons of former inmates, the spotlighted central group pauses on a stairwell landing. One of the French Guards leads the way in helping the aged victim negotiate the passage

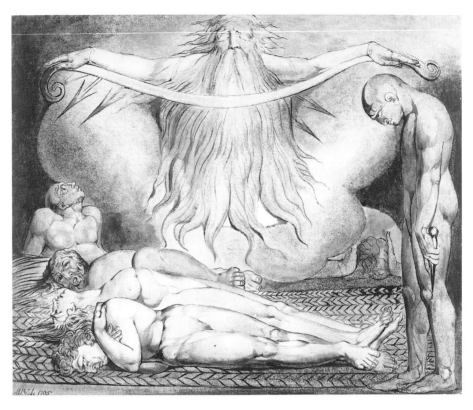

FIGURE 21
William Blake, *The House of Death*. Color print finished in pen and watercolor, 47.3 × 59 cm. (18⅝ × 23¼ in.), trimmed, 1795. British Museum, London.

to freedom. They will soon pass the Bastille's governor, the marquis de Launay, who is descending the stairs, the executioner behind him foreshadowing his fate. Northcote's expressive use of body language contrasts the feeble, elderly victim slumping in exhaustion with the bowed misery of the governor, who carries his sins upon his back. William Blake was to make use of this last figure when composing his compact angst-ridden murderer at the right in *The House of Death* (Fig. 21).

Once Great Britain was at war with France, the initial small wave of images celebrating French liberty disappeared. Artists sympathetic to the French cause, however, found other ways to support revolutionary principles. As the figure in Blake's *House of Death* is based on that of the marquis de Launay, so too Blake's illustration of the vision of suffering humanity shown to Adam in Milton's *Paradise Lost* refers to the contemporary situation in which an unseeing tyranny hovers above, inflicting agonies on mankind. Another example of veiled allusion is James Barry's print *Satan and His Legions Hurling Defiance toward the Vault of Heaven* (Fig. 22), in which the artist exults in the defiant spirit of revolt against implacable authority. Because

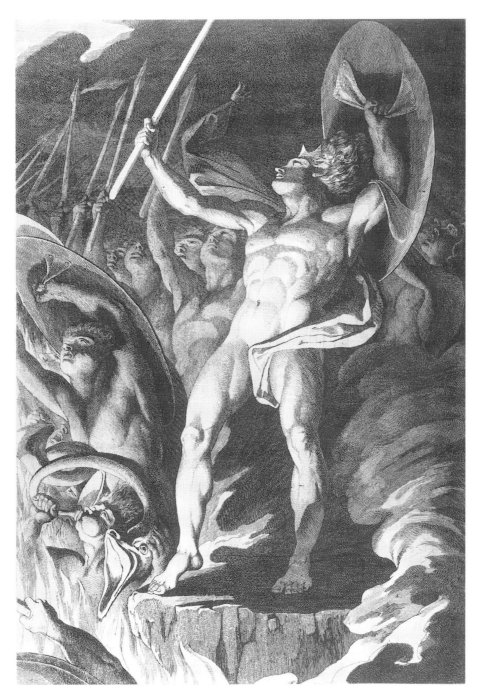

FIGURE 22
James Barry, *Satan and His Legions Hurling Defiance toward the Vault of Heaven.*
Etching and engraving, 74.6 × 48.7 cm. (29⅜ × 19³⁄₁₆ in.), ca. 1792–95. British
Museum, London.

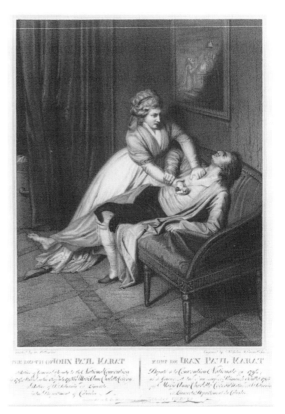

FIGURE 23
After Domenico Pellegrini,
The Death of Jean-Paul Marat.
Stipple engraving by Schiavonetti,
38.3 × 30 cm. (14¹⁵⁄₁₆ × 11¾ in.),
February 10, 1794. British
Museum, London.

Milton depicts the archangel's descent into evil as a graduated one, Satan's presence just after the Fall retains much of its original glory.

> his form had yet not lost
> All her Original brightness, nor appear'd
> Less than Arch-Angel ruin'd, and th' excess
> Of Glory obscur'd . . .
>
> (*Paradise Lost*, 1.591–94)

Seizing on such imagery, Barry creates a highly sympathetic portrayal of Satan and his legions, and he positions the viewer so that he (his audience is male) must stand in the fiery flood, shouting alongside the other fallen angels, offering a British counterpart to the French celebration of fraternity against an unjust "father."[32]

After war was declared, those public images that addressed contemporary France directly were overwhelmingly negative. Martial scenes began to appear, but because these paintings are primarily conventional wartime responses, they do not add ap-

preciably to the high art discourse on the meaning underlying the events in France.[33] One should look for a counterrevolutionary iconography, not in scenes of military engagement, but in images that focus on events in the French capital, like the earlier images of the Bastille executed when the British were still sympathetic to French reformist aspirations. The first painting exhibited at the Royal Academy that took a jaundiced view of developments in Paris was Domenico Pellegrini's *Death of Marat,* exhibited in 1794 and now known from the print after it published on February 10, 1794, before the exhibition's spring opening (Fig. 23). The print, with its English and French titles, again addresses a dual audience. Charlotte Corday stabbed the inflammatory politician Jean-Paul Marat in his bath on July 13, 1793, but Pellegrini, with the tub glimpsed behind the curtain at the left, shows the assault taking place on a sofa, with Marat in casual attire. The revolutionary "monster" clutches the upholstery with his left hand, a conventional representation of the death grip, while sprawling beneath a picture extolling the idolatrous worship of liberty. Corday thrusts her dagger into the villain's heart, and Pellegrini, in not flinching from the nature of her act, underscores the violence unleashed in all factions.

In 1795 two more counterrevolutionary paintings were exhibited, the last of this small group to appear at the Royal Academy, and coincidentally they both have as their subject matter the events of August 10, 1792. The first is Zoffany's *Plundering the King's Cellar at Paris,*[34] and the second is another work by Pellegrini, *The Royal Family of France entering the National Assembly on the 10th of August, 1792* (no. 421). Unfortunately, the whereabouts of this last picture is unknown, but like the most popular type of British counterrevolutionary painting it takes as its subject the trials and tribulations of Louis XVI and his family. Pellegrini executed a number of other images of their fate, and the engravings after them make clear that the exhibited picture showing Louis XVI and his family taking refuge in the National Assembly would have been entirely sympathetic to the king, a point of view that was not universally shared, with some interpreting his flight as an act of cowardice or callous indifference.[35]

In high art, paintings of the distress of the royal family proved the most popular counterrevolutionary images, for they personalized the conflict while showing the reversal of traditional hierarchies, with the "father of his country" overturned by the people, his "children."[36] Images of the king, and later the queen, being guillotined were left for the minor genres to record, contemporary history painting preferring the more intimate moments of family pathos.

Of the numerous British images devoted to the royal family, two stand out. The first is Mather Brown's *Louis XVI of France Saying Farewell to His Family* (Fig. 24), whose size alone (7 ft. 2 in. × 9 ft. 3 in.) makes it difficult to overlook.[37] Beginning in late 1793, Brown sent this large canvas on a tour of provincial cities, an expansion of the London private exhibition that was to prove popular in the nineteenth century. Underlying the composition of the central group is the celebrated classical

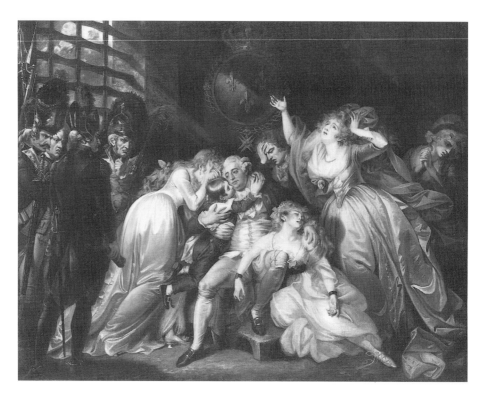

FIGURE 24
Mather Brown, *King Louis XVI of France Saying Farewell to His Family.* Oil
on canvas, 2.2 × 2.8 m. (86 × 111 in.), 1793. Wadsworth Atheneum, Hartford,
Connecticut. The Ella Gallup Sumner and Mary Catlin Sumner Collection Fund.

sculpture of the Laocoön (see Fig. 75): the positioning of Louis XVI's legs is a reversal
of the Trojan priest's pose; their own anguished progeny accompany both the king
and Laocoön; and Marie-Antoinette's heavenward plea echoes the sculpture's up-
raised arm. In principle, the sublime agony of Laocoön, who, with his sons, suffered
a painful death for attempting to warn his people of impending danger, is an ap-
propriate association for the tribulations of the French king and his family, but in
practice the potbellied monarch fails to live up to his classical prototype. Brown's
painting illustrates the pitfalls awaiting those who attempt history paintings of con-
temporary subjects, for the heroic posturing of the grand manner may be more
ridiculous than sublime when employed with modern subjects.[38]

A more successful painting of royal martyrdom is William Hamilton's *Marie-
Antoinette Leaving the Conciergerie* (Fig. 25), which, signed and dated 1794, shows the
queen departing for the guillotine on October 16, 1793. Although the artist did not
exhibit his painting, a print after it was published May 27, 1796, followed by a sec-
ond edition four years later.[39] Like Edmund Burke before him, Hamilton contrasts

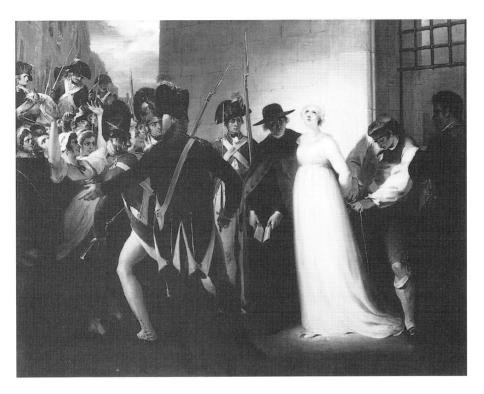

FIGURE 25
William Hamilton, *Marie-Antoinette Leaving the Conciergerie.* Oil on canvas, 1.52 × 1.97 m.
(59¾ × 77½ in.), 1794. Musée de la Révolution Française, Vizille.

the queen, beatifically pure and innocent, with lower-class women who embody, albeit in a subdued form more appropriate to history painting, Burke's 1790 description of "the vilest of women."[40]

Even more revealing is a drawing by Hamilton preparatory to the painting (Fig. 26). In this preliminary conception, the overall format is that of an Ecce Homo with Marie-Antoinette as Christ reviled by the rabble. The soldiers impose order on this unruly mob while the officer descends the stairs with a balletic grace derived from Reynolds's meditations on the Apollo Belvedere.[41] With the jeering women kept at bay at the upper left, the primary tension is between the queen and the sansculottes at the right. This exulting male chorus evokes contemporary Miltonic imagery of Satan and his legions hurling defiance at God himself (*Paradise Lost,* 1.669), as can be seen in James Barry's print (see Fig. 22).[42] In Hamilton's rendition, the satanic males howl their defiance while hoisting pikes similar to the legions' spears, and the hat held high by the foremost figure suggests Satan's shield.

Associating the republican French with hell's denizens was commonplace. In a letter responding to the events of August 10, 1792, Horace Walpole would not even

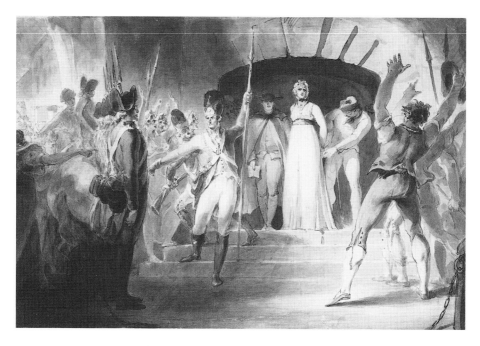

FIGURE 26
William Hamilton, *Marie-Antoinette Leaving the Conciergerie.* Black and gray wash over pencil, 28.9 × 41.9 cm. (11¼ × 16⅜ in.), ca. 1794. Pierpont Morgan Library, New York.

permit the French insurrectionists to join the fallen ranks described by the Bible and Milton:

> Agree with you I most certainly do, Sir, about the *Fiends* on the Continent—*French* I will not call them, for that would confound the innocent with the guilty; and though *Devils* are sometimes styled *Fallen Angels,* that term I will as little use, as it might imply that I have thought that the French have been *Angels,* which I assure you I never did.[43]

Burke, too, in a speech delivered in the House of Commons on April 11, 1794, associated France with Milton's hell, arguing that even the poet's characterization falls short of conjuring up the Jacobin nightmare:

> The condition of France at this moment was so frightful and horrible, that if a painter wished to portray a description of hell, he could not find so terrible a model, or a subject so pregnant with horror, and fit for his purpose. Milton, with all that genius which enabled him to excel in descriptions of this nature, would have been ashamed to have presented to his readers such a hell as

France now has, or such a devil as a modern Jacobin; he would have thought his design revolting to the most unlimited imagination, and his colouring overcharged beyond all allowance for the license even of poetical painting.[44]

In his allusion to Satan's legions, Hamilton makes clear that the French *menu peuple* do indeed inhabit a hell on earth.

When Zoffany's two works are seen in the context of other counterrevolutionary paintings, their originality becomes clearer. His colleagues, whether pro-Revolution, like Northcote in his painting of the Bastille, or anti-Revolution, like Brown and Hamilton in their pictures of the royal family, adopt the conventions of contemporary history painting to convey their message, aggrandizing and transforming memorable events of modern life by painting them in an elevated mode. Zoffany, in contrast, represents memorable modern events, but those he depicts are noteworthy for their criminal excess. They defile rather than uplift.

3

A MODERN BACCHANAL

Plundering the King's Cellar at Paris

Zoffany, who was German-born and a longtime resident of Italy and India, as well as England, was a true cosmopolitan, yet he apparently had been in Paris only once, from July 9 to 13, 1772, when traveling from London to Florence.[1] Although he would have had access to numerous views of the French capital, in *Plundering the King's Cellar* (Plate 1), the magnificent arching entrance is entirely fictitious, and even the receding outline of the Tuileries Palace at the far right only approximates the building's actual appearance. Presumably the setting is the courtyard side of the palace rather than the garden side, but such speculation is largely irrelevant. More important, the architecture, invented and real, provides the painting's structure. This is the order (literally the old order, or ancien régime) that provides a framework for the chaos of the raucous crowd. The massive gateway to the cellar organizes the space, the mob receding along its diagonal line both above and beneath, with a triangular grouping anchoring the right foreground. The *menu peuple* peck away at the Bourbon coat of arms above the center of the arch, chiseling off the carvings of the fleur-de-lis, itself a symbol of Christian purity, and smoke partially obscures the palace, but the members of the mob seem puny in comparison with the grandeur they are attempting, with limited success, to efface.

Because the artist had no firsthand experience of the Parisian uprisings during the French Revolution, his knowledge could have come only from secondhand sources such as rumor and hearsay, journalistic accounts, speeches, pamphlets, and books. Since there is no evidence that he read or spoke French, one presumes that such materials were confined to those published in English or German. Prints, however, spoke a "universal" language, no matter the nationality of their maker. Again, though, Zoffany was most heavily influenced by those caricaturists such as Gillray and Rowlandson who were close at hand, borrowing from their works the motifs and visual puns that invigorate his fictional cast of characters. His composition, as complex as any of Hogarth's narratives, similarly invites viewers to "read" his account-

ing of this horrific *journée* with careful attention to detail. In his conception, the mob indulges in violent and destructive looting, with the debauched pillaging of the king's wine cellar as their primary target.

"One Drunken Paroxysm"

Within days of the assault on August 10, the *London Chronicle* inaccurately reported that "the wine cellars were alone plundered,"[2] while the *World* stressed the inebriated state of the victors: "The whole people, with little intermission, appear to be in one drunken paroxysm."[3] An extract from a letter from Paris dated August 12 provided a more detailed report:

> The day was excessively hot; and they regaled themselves on the KING's wine. They brought it out in immense quantities; and it was not uncommon to see men and women, after their own draught, put the bottle to the mouth of the dead lying in mangled heaps, with that spirit of furious sport which they have all along exhibited, crying,—"Here, take your last drink! F———! Drink to the Nation!"[4]

Zoffany depicts just such a cruel toast as a man in a blue coat pours wine down the throat of a dead Swiss guard (Fig. 27). This Frenchman, who gleefully exacts his revenge, is shabbily attired, his shirt visible through a hole in his jacket and his big toe projecting beyond his disintegrating shoe.

Many of the figures, including the one offering his diabolical toast, are shown without pants. In such details Zoffany picks up on the outrageous imagery of the English political caricaturists. As already mentioned, the term *sansculottes* gained acceptance in 1792 to describe the working classes, who wore trousers instead of the knee breeches of the more well-to-do. English caricaturists enjoyed interpreting the phrase literally to show the French without pants. An early example is Gillray's print *Un petit Soupèr* (see Fig. 19), where both men are naked from the waist down. One of them even plops his bottom onto a woman's bare torso, which he uses as a seat. Another of Gillray's more biting satires is his print *The Zenith of French Glory* (Fig. 28), commemorating the death of Louis XVI, where a bare-bottomed and shoeless sansculotte sits astride the glass globe of a lantern—a shelter for light soon to be reduced to a receptacle for foulness—from whose support hang a bishop and two monks. Such scatological attacks find their echo in *Plundering* in the figure exposing his rump while stringing up a cleric on the support for a lantern at the right (Fig. 29). Zoffany embraces these elements of the world of the political caricature in which literal truth gives way to metaphoric truth. These figures without trousers, the visualization of a pun, signify the bestial and lascivious nature of these creatures who have abandoned their humanity.

FIGURE 27
Detail of Plate 1.

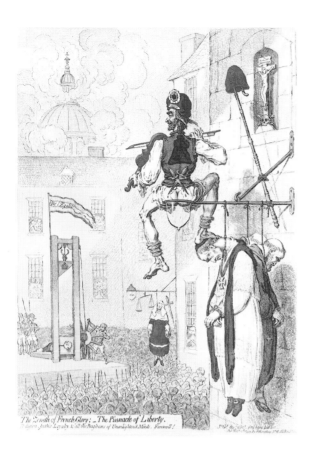

FIGURE 28
James Gillray, *The Zenith of French
Glory;—The Pinnacle of Liberty.* Colored
etching, 35.1 × 24.8 cm. (13⅝ × 9¾ in.),
February 12, 1793. British Museum,
London.

FIGURE 29
Detail of Plate 1.

FIGURE 30
Detail of Plate 1.

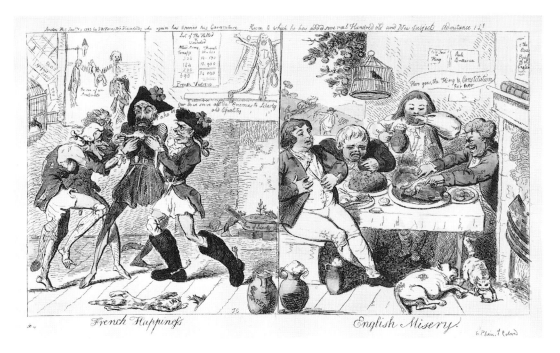

FIGURE 31
Isaac Cruikshank, *French Happiness / English Misery.* Etching, 21.8 x 38.2 cm. (8⅝ x 15 in.),
January 13, 1793. British Museum, London.

A soldier without pants at the extreme left (Fig. 30) offers another image of depraved debauchery as he drinks from a bottle while carrying a pike to which is affixed a severed head. His sleeve also peeks through at the elbow of his jacket, but his footwear, large jackboots with spurs, is no more realistic than his seminaked condition. French accounts of the fighting, such as the prints illustrated in Figures 11 and 12, show none of the soldiers wearing such cumbersome attire, but oversized jackboots had long been a staple in the arsenal of artists denigrating French customs. For example, Isaac Cruikshank's print *French Happiness / English Misery* (Fig. 31) of January 13, 1793, shows four Frenchmen fighting over a frog, the one on the right wearing jackboots much too large for his slender frame. Zoffany's soldier has a whip tucked in his right boot, while the spacious jackboots of one of Richard Newton's sansculotte soldiers (Fig. 32) are stuffed with a variety of instruments. Zoffany did not hesitate to appeal to such false stereotypes to convey effectively the repulsion he felt over the mob's behavior.

In their art and culture the French at this time often drew parallels between their own virtuous conduct and the stoic virtues of the classical past, particularly the Roman Republic. The academic artist Jacques-Louis David, for instance, made a career out of forging such links, which often presume a sophisticated knowledge of classical history. One antique symbol, however, was associated almost exclusively with the

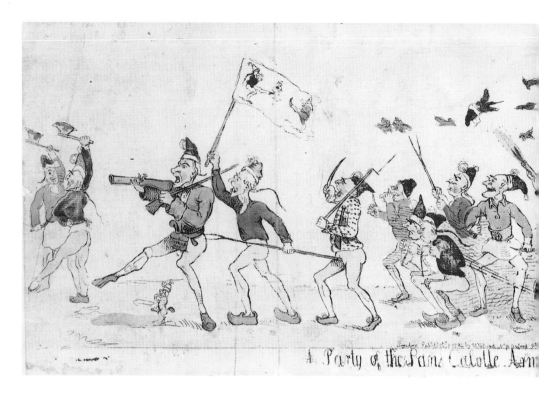

FIGURE 32 (*above*)
Richard Newton, *A Party of the Sans Culotte Army marching to the Frontiers.* Colored etching, 21.7 × 67.8 cm. (8½ × 26⅜ in.), October 1, 1792. British Museum, London.

FIGURE 33 (*opposite*)
James Gillray, *Hopes of the Party, prior to July 14th.* Etching, 33.3 × 49.5 cm. (13⅛ × 19½ in.), July 19, 1791. British Museum, London.

lower classes. The sansculottes adopted the red cap of liberty, which was derived from the headgear worn by freed Roman slaves.[5] The prominent figure on the ladder in Zoffany's painting holds up a *bonnet rouge* on a staff, where it becomes the scepter of the sovereign mob. The cap is flanked by two severed heads on staffs, Zoffany inviting the viewer to equate the red cap with these grisly trophies. In a similar detail in Gillray's *Hopes of the Party, prior to July 14th* (Fig. 33), issued on July 19, 1791, one sees Liberty in the background holding her cap on a staff that is juxtaposed with two more staffs above Temple Bar on which are perched heads or skulls.

In showing heads on pikes, Zoffany did not exaggerate the mob's bloody actions. Severed heads were indeed paraded on August 10, a continuation of the custom begun three years earlier in the aftermath of the storming of the Bastille. The pike, a weapon accessible to the common man, was a fitting instrument to signal the lower orders' usurpation of the power of the monarchy. On August 10 the first heads to be mounted on pikes were those of seven *chevaliers du poignard* butchered before the

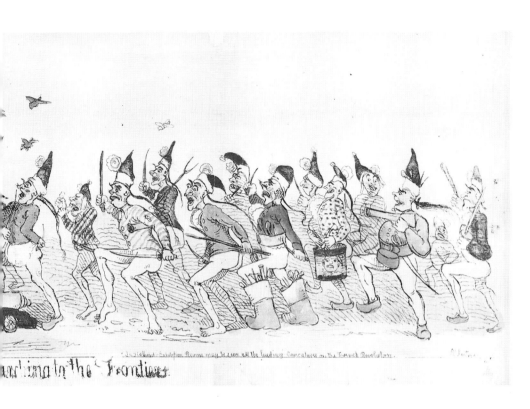

In Holland, London and Rome may be seen all the leading Caricatures on the French Revolution.

...arching to the Frontiers

The HOPES of the PARTY, prior to July 14th _____ *From such wicked CROWN & ANCHOR Dreams, good Lord deliver us!*

FIGURE 34
Detail of Plate 1.

general assault; they were soon followed by the heads of Swiss soldiers.[6] Zoffany represents both classes of victims, the natural hair on the head of a presumed Swiss soldier on the pike at the left contrasting with the powdered wig on the elevated head near the composition's center. The guillotine, with its mechanical impersonality, was to become a gory symbol of revolutionary efficiency as it separated thousands of heads from their bodies, but the headless corpses of such *journées* as July 14 and October 6, 1789, and of August 10, 1792, were not its victims. Their end was more personal, their assassins having to chop or cut off the heads, which were then displayed as trophies. At the right a half-naked woman with pendulous breasts holds aloft a head in her hands while an impromptu executioner with an axe prepares to behead

a prone Swiss soldier (Fig. 34). This last figure lies next to a kneeling Swiss guard in his shirtsleeves, who, held by his hair, is about to be dispatched with a knife.

The insurrectionists who broke into the palace were intent on seizing its contents as well as its inhabitants. Furniture was thrown out of windows and set on fire, while jewelry and other valuables were taken from the palace. A number of accounts describe how this treasure was brought to the National Assembly, where it was laid before the legislature as rightfully belonging to the entire nation. J. B. d'Aumont, a staunch antimonarchist writing from Paris on August 15, 1792, unrestrainedly praised the righteousness of the crowd's conduct:

> The people though now masters every where, disdained to plunder. Every thing valuable that was found in the palace, was carried to the Assembly and to the municipality. A few wretches who were caught in the act of stealing, were killed upon the spot, and others were carried to the Place de Greve, (the common place of execution of criminals) where they were tried, condemned and shot. Such was the justice of the people.[7]

He went on to compare this "disinterested honour of the people" to the earlier appellation of "swinish multitude" given them by Burke.

Some English accounts, however, were more than a little skeptical about the crowd's virtuous patriotism:

> Some persons carried to the National Assembly a part of the plate and other booty seized in the palace, and the good people were thereby exculpated from the charge of stealing: their honour and patriotism were praised by the Members of the Assembly, who knew, nevertheless, that while as much as might be worth about three hundred thousand livres was saved, the value of above three millions was never heard of. It was an expiatory tythe which the people offered up to the Assembly; and the Assembly, of which it is said the Members, in the morning, disputed with each other the honour of running away, dared not withhold its approbation from the conduct of the sovereign people who demanded it.[8]

Gillray had depicted a sansculotte family at home with the royal treasures they had stolen (see Fig. 19), the overflowing bag of booty sarcastically labeled "Propriete de la Nation." In the lower right corner, Zoffany shows some of this loot being converted into cash (Fig. 35). His own touch, not in any contemporary account, is to depict a Jewish clothesman, a stock character in both France and England, with a sack of silver plate on his back bargaining for the jacket of one of the stripped Swiss guards. A newspaper had written, "All the Swiss, above 500, were put to death, and the people carried the remnants of their clothes on the ends of their pikes in triumph [see Fig. 15],"[9] and an eyewitness source confirms that "not a man, woman, nor child, but gloried in having a piece of the bloody garments of a Swiss."[10] These trophies

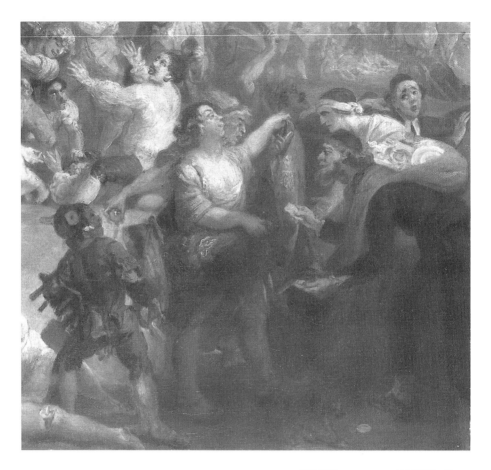

FIGURE 35 FIGURE 36
Detail of Plate 1. Detail of Plate 1.

in Zoffany's depiction are exchanged for money, the mob's motive, in his opinion, being greed more than triumphant display.[11] Behind the woman holding up the red jacket can be glimpsed a frenzied old crone, who, holding in her right hand what appears to be the spherical form of a pocket watch with its ribbon or chain still attached, bargains with a woman (possibly a Gypsy) who is behind the Jew. The hag in the center foreground poised to stab the collapsed aristocratic female palms a similar watch in her left hand, in this instance committing murder to obtain her prize. Again the artist interjects invented, prejudicial details into a scene for which the documented facts are horrifying enough.

Zoffany binds together his large cast of characters by grouping the figures into units, both compositionally and in relation to narrative exposition. He also relies on color to help unify the whole. Against the flesh tones and darker clothing he em-

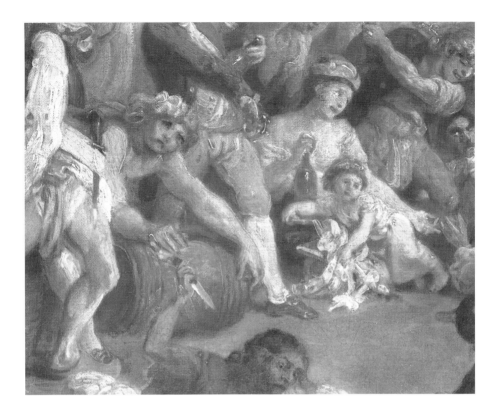

phasizes vivid red, white, and blue, the colors of the revolutionary tricolor. The most prominent figures are those grouped around the wine basket in the left center of the composition. The two sides of the large basket are bridged as the stocky man at the left vulgarly gestures with one hand at the *fédéré* reaching for a bottle while pointing with the other to the puking black boy as if to say this fate will soon be the soldier's.[12] The sansculotte tugging at the wine basket is the picture's most prominent figure (see Frontispiece and Fig. 78). He is another celebrant who has discarded his pants, yet he has not removed his bright *bonnet rouge,* which is positioned close to the painting's exact center. A cross of Saint Louis, still attached to its blue ribbon, lies across one of his sabots. Such crude wooden shoes had long been associated with the French lower classes, but it is doubtful that any of the August 10 participants actually wore such footwear. The English traveler Richard Twiss, who was in France from July 25 to August 24, 1792, took the trouble to report, "I did not see a single pair of *sabôts* (wooden-shoes) in France this time."[13] If the peasants outside Paris were no longer wearing sabots, the sansculottes surely were not, and Zoffany again introduces a detail that is prejudicial rather than accurate.

To this celebrant's right, an almost nude corpulent figure rolls out a barrel (Fig. 36), a modern-day Bacchus whose unhappy expression suggests how this bacchana-

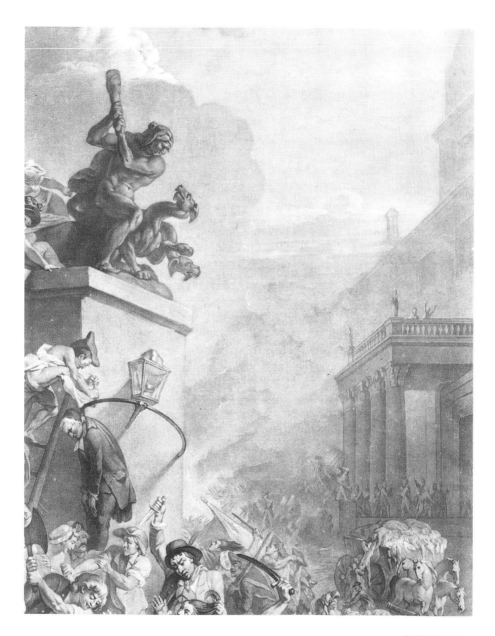

FIGURE 37
Detail of Fig. 1.

lia differs from those joyous celebrations of antiquity. The drinking mother next to him encourages her young child to watch the grisly executions, and the child's overturned doll, one of the spoils of the palace, is yet another image of violated aristocracy. Behind the basket, a beautiful lower-class woman (see Frontispiece) holds up a bottle with one hand while cradling another. She points to her exposed nipple, an example of perverted femininity in that her breasts are licentious rather than nurturing. The "gentleman" beside her holds up his hat behind the extended bottle, pointing to it as he looks at the bashful woman on his other side. Zoffany suggests a love triangle that may not remain cordial, the woman holding the bottle already looking askance at her rival. Beneath the hesitating woman, two black women busily pick the pockets of the citizen who is pouring wine down the throat of the dead Swiss soldier, there being little honor among thieves. Zoffany intends that the pickpocketing, an activity frequently associated with prostitutes, remind viewers that greed, rather than revolutionary principles, motivated the revolt. This same theme plays out at the right, where a black shoeshine boy cautiously attempts to steal a garment from the woman haggling with the clothesman.[14]

At the lower left Zoffany depicts a tragic pile of naked gray bodies, apparently a family consisting of mother, daughter, and infant. The spaniel waiting beside demonstrates more honor and "humanity" than the people. The dog, whose faithfulness Zoffany associates with the victims, contrasts with the snarling, menacing cat, a traditional symbol of liberty that appears beside the puking boy slumped against the basket. Besides individualizing these victims, Zoffany alludes to the larger dimensions of the slaughter at the far right (Fig. 37), where a cart is piled high with naked corpses. Richard Twiss's account of his visit to Paris during July and August 1792 may have inspired this last detail, for he specifically mentioned that on August 10 "the streets were filled with carts, carrying away the dead."[15] So much industry was necessary because of the thousands he estimated had been slain on both sides: "Soon after noon the Swiss had exhausted all their powder, which the populace perceiving, they stormed the *chateau,* broke open the doors, and put every person they found to the sword, tumbling the bodies out of the windows into the garden, to the amount, it is supposed, of about two thousand, having lost four thousand on their own side. Among the slain in the *chateau,* were, it is asserted, about two hundred noblemen and three bishops."[16] In the group of bodies beside the cart, Zoffany shows a hooded woman bending over and raising up a male corpse. She is perhaps a widow grieving over her slain husband, her tender concern contrasting with the businesslike efficiency of the men beside her who methodically stockpile the dead.

At the top of the entrance to the wine cellar, figures work at destroying the royal coat of arms, symbolically overturning monarchy itself. In this instance, Zoffany may have influenced Gillray. On May 12, 1800, Gillray issued a print in eight parts showing episodes in the life of Napoleon. The third scene, entitled *Democratic Gratitude* (Fig. 38), erroneously depicts Napoleon on August 10 directing vagabond troops

FIGURE 38
James Gillray, *Democratic Gratitude,* detail of *Democracy;—or—a Sketch of the Life of Buonaparte.* Etching, 26.7 × 45.1 cm. (10½ × 17¾ in.), May 12, 1800. British Museum, London.

against the palace.[17] While other soldiers exit from the building carrying loot, two chip away at the fabric of the entrance. One on a ladder swings an axe at the coat of arms, which, as in Zoffany's painting, incorrectly shows one fleur-de-lis on top with two on the bottom rather than the reverse. These artists may have simply made a mistake in reversing the positions of the fleur-de-lis, but they may also have intended to symbolize the world of the ancien régime turned upside down.[18]

The statue of Hercules clubbing the Lernaean Hydra (Fig. 39), like the building it adorns, is another of Zoffany's creations. The French kings had traditionally been associated with Hercules, but the republicans also claimed him for their own as an apt representative of the power of the sovereign people, with the Hydra as a favored metaphor for counterrevolution. Within months after the dissolution of the monarchy, a depiction of Hercules clubbing the Hydra appeared on the *timbre sec* (embossed stamp) used on the assignats for fifty livres issued on December 14, 1792.[19] His club and the slain Hydra also figure prominently in Jean-François Janinet's print of the figure of Liberty issued on November 10, 1793, after a design by Jean-Guillaume Moitte.[20] Zoffany may well have been familiar with such imagery, but he, and

FIGURE 39
Detail of Plate 1.

everyone else for that matter, could not have missed the relationship between the
French Republic and Hercules as slayer of the Hydra after the appearance of Denis-
Antoine Chaudet's colossal sculpture of the god overwhelming the Hydra of Fed-
eralism. Chaudet's work marked the fourth station in the Festival of Unity and In-
divisibility, held on August 10, 1793, whose pageantry had been planned by David.[21]

In his painting, Zoffany deliberately takes back this popular revolutionary sym-
bol, returning it to its earlier royalist connotations.[22] In revolutionary symbolism the
Hydra had stood for various impediments, such as the aristocracy or federalism,[23]
but in Zoffany's interpretation it represents the mob, an even more appropriate anal-
ogy in light of this creature's ability to regenerate, for whenever Hercules cut off one
of its heads, two more grew in its place. The concept of the masses as a many-headed
monster is an old one,[24] and accounts of the *journée* of August 10 convey this sense
of the mob as an unstoppable monster: "The people, in number like the sand on the
sea shore, and animated with the fury of daemons, attacked the palace from every
quarter, and cut the Swiss in pieces wherever they appeared."[25] Beneath the statue
is the *fédéré* about to behead the Swiss soldier (see Fig. 34). By making his pose

mimic that of Hercules, Zoffany relishes the contrast between the self-appointed executioner of the people, disheveled and grinning sadistically, and the idealized classical hero, imposing and dignified, who here represents the ancien régime.

Because the arched entrance to the wine cellar is symmetrical, there must be a statue on the left-hand side balancing the one of Hercules on the right, but Zoffany, by positioning it just outside the picture frame, has chosen not to identify it. Hercules frequently is paired with the figure of Minerva, a juxtaposition of strength with wisdom. In London, for example, one could point to Rubens's painting of Hercules clubbing a serpent-entwined figure on one side with Minerva triumphant on the other in the ceiling decoration of Whitehall Palace, or to James Barry's *Crowning the Victors at Olympia* at the (Royal) Society of Arts, where a painted statue of Hercules trampling the Serpent of Envy at the left is paired with Minerva on the right. Tiepolo had also paired painted statues of the god and goddess in his fresco *Homage to the Emperor* in the Kaisersaal of the prince-bishop's palace, the Residenz, at Würzburg, the hometown of Zoffany's first wife. In *Plundering* it may be that Zoffany wishes to imply the absence of Minerva. Although the revolutionaries never tired of extolling the triumph of reason, Zoffany suggests that where they are concerned, Wisdom is literally left out of the picture.

The artist introduces one other sculpture. Although it can no longer be seen in the painting, the print after it shows a statue of a kneeling Atlas shouldering the globe, encircled by the ring of the zodiac. This statue, on a pedestal in front of the central portico of the king's palace (see Fig. 37), suggests, because of its placement, that Louis XVI, like Atlas, had to bear the weight of the world upon his shoulders. Yet as a symbol of the responsibility of leadership, it can refer as well to the revolutionaries who have usurped this power, a fitting analogy in that Atlas himself had been made to undertake this task as punishment for joining the Titans in their revolt against the gods. The revolutionary mob, now sovereign, must carry the burdens of state. Zoffany is intent on showing its unfitness to govern: in his view the sovereignty of the people leads only to the horrors of anarchy.

Hell's Mouth

Zoffany's inclusion of priests among the victims is historically accurate. On July 12, 1790, the Constituent Assembly passed the Civil Constitution of the Clergy, embodying the government's decision on the role the church was to play in its new relationship to the state. Traditionally, the French church, under the concept of "Gallican liberties," had enjoyed an unusual degree of independence from the papacy, but the Assembly's radical new law went so far as to create a French national church firmly under the jurisdiction of the civil authority. When the Vatican opposed the Civil Constitution, the Assembly required the French clergy to swear an oath of loyalty, creating a schism in the church between those who took the oath, the "constitutional" clergy, and those who refused, the "refractory" clergy. The re-

fractory clergy continued to serve, independent of the official church sanctioned by the state; they soon identified with the counterrevolution, as did the papacy. Louis himself employed only the services of refractory priests, and in the assault of August 10 these figures of the royal establishment were included in the roll call of victims: "When the armed multitude entered the palace, every one who belonged to it was put to death, and every corner was ransacked for victims. Swiss, pages, gentlemen of the chamber, valets, chaplains, cooks, women, &c. &c. all underwent the same fate."[26]

Zoffany shows a fleeing priest in the lower right corner about to receive a fatal blow from a cutlass, and his depiction of a priest, his hands tied in front, hanging from the bar supporting the lantern was already a familiar figure in counterrevolutionary propaganda, as, for example, in Gillray's print (see Fig. 28). Edmund Burke had earlier written how the mob, on October 6, 1789, had barely stopped short of murdering bishops, even recording its "animating cry which called 'for all the BISHOPS to be hanged on the lamp-posts.'"[27] The lines "Tous les Evêques à la lanterne" (Hang all the bishops from the lamppost) and "Les aristocrates à la lanterne" even formed parts of some versions of the famous revolutionary song "Ça ira" (Things will work out),[28] and the victim in Zoffany's painting about to be hauled up the ladder by the noose around his neck to join the priest may be an aristocrat in that he wears a wig instead of a skullcap.[29]

By the time Zoffany embarked on his two paintings in 1794, a great deal more had happened in the struggle between the refractory priests and the revolutionaries. In the September massacres, following on the heels of the *journée* of August 10, hundreds of priests were summarily executed, and in the following year the de-Christianization movement was to reach its height. One suspects that Zoffany and his English audience made little distinction between the hostility shown toward the refractory clergy and that toward Christianity itself, with the insurrectionists portrayed here as atheistic murderers rather than just opponents of the king and his entourage. This was indeed the point of view of one anonymous English writer who, in a work of 1792, saw the French actions of August 10 as godless, without remorse or conscience:

> You will observe, my Friends, that those French Philosophers whom our Reformers so much admire, had nothing to restrain them but the risk they might run in this world. All belief of a God and another world they had thrown entirely aside. . . . For the purposes of the French 10th of August Men this conversion was, no doubt, well contrived; they had overthrown the Law and the Government; they had only to efface the remaining check, the DEITY, from the minds of their Followers, and they could then be set to any thing.[30]

The groundwork for the godless attitudes of the "10th of August Men" had been laid well in advance. In an attempt to place their actions in perspective, the *Public Ad-*

vertiser lay the blame particularly on Voltaire and Joseph Priestley for having derided revealed religion with their claims that "the gospel is a fable of the first magnitude, the Saviour a fantastick idol, a phantom of imagination." The author of this diatribe, who signed himself Causidicus, went on to characterize these modern philosophers, English as well as French, as zealots who had aligned themselves with the devil:

> These sanguine and laborious emissaries of darkness preach the black creed of infidelity with as much zeal and assiduity as the Apostles preached the creed of salvation. . . . They stretched every nerve of their souls to degrade and extirpate the great fundamental truths of Religion; they laboured morning, noon and night most anxiously to persuade the *world* to *cease to be Christian,* and once more to *become Pagan,* to relinquish Revelation, and once more adopt the religion of nature.[31]

While the French had succumbed to this perfidious barrage, Causidicus enjoined his countrymen to resist and fight back against the blandishments of a Tom Paine.

A force more demonic than atheism is involved in this assault on Christianity. In this context, Zoffany's introduction of the clothesman at the lower right deserves closer scrutiny. Although Jews are not mentioned in the literature or shown in other imagery as having participated in the events of August 10, the Jewish clothesman was a stock figure in satirical art. He had already appeared in revolutionary iconography as a purchaser of religious garments (Fig. 40), and the caption to this print introduces sexual humor in suggesting the cowl could be converted to a codpiece.[32] Zoffany's interpretation also suggests that more than clothes are on the merchant's mind. The woman lifts up her skirt in order to hold other garments, and while the clothesman offers money with his right hand for the jacket, the money held in his left may be intended for sexual favors. In gazing at the woman's breasts, he leaves little doubt about the nature of his interests, and in this context the overloaded sack hanging down in front suggests a grotesque scrotum.

Zoffany himself was rumored to be Jewish,[33] and his stereotypical anti-Semitism may have been in part an attempt to distance himself from such assertions, all the more so if they were true. Yet the introduction of the Jew serves a profounder purpose. While he is the lustful outsider, ready to profit from social anarchy, he functions primarily as an anti-Christian presence. The revolutionary print had shown the clothesman profiting at the expense of the Capuchin order, and in Zoffany's painting the objects sticking out of the part of the sack on the clothesman's back appear to be ecclesiastical, presumably items looted from the chapel of the Tuileries Palace. The ornate piece protruding between two plates (perhaps patens) appears to be surmounted by a cross and has a circular, ringed pocket in its center. Surely this is a monstrance, intended to display the Host.[34] The juxtaposition of these objects with the priest who is about to be sabered reinforces a religious association. At the foot

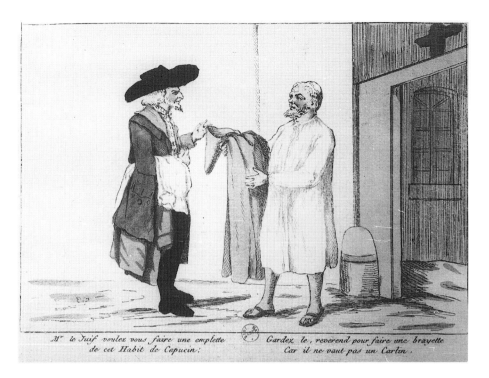

FIGURE 40
Artist unknown, *Mr. le Juif voulez vous faire une emplette de cet Habit de Capucin* (Mr. Jew, would you like to purchase this Capuchin habit?). Etching, 17 × 23 cm. (6¹¹⁄₁₆ × 9¹⁄₁₆ in.), [1790]. Bibliothèque Nationale, Paris.

of the Jew, Zoffany prominently inserts a white disk, a curious detail except in relation to the monstrance. It is the Host itself, dethroned and debased by the mob's irreligion.[35] Significantly, it appears in an area of the canvas that is as dark as the cavernous interior of the cellar, if not darker.

The subplot of the Jewish clothesman updates an earlier tradition of supposed Host desecration on the part of Jews. Such stories, along with the related charges of ritual murder, in which Jews were accused of killing for their blood young Christian children, were commonplace in the German-speaking lands of central Europe, the very areas in which Zoffany had grown up. Indeed the authorities at Frankfurt, Zoffany's native city, allowed a painting of the tortured Simon of Trent, the victim of an alleged ritual murder of 1474, to be prominently displayed on the Brückenturn Gate. This work was not removed until the 1770s, over two decades after the Zoffanys had left the city.[36] The earliest and most famous account of Host desecration was the Miracle of Paris of 1290, in which a Jewish clothesman bartered with a woman to secure the Host.[37] Zoffany depicts a modern version of this medieval legend, and his full intentions may have been available only to a perceptive few. For the latter, the introduction of the Host desecration narrative ultimately makes clear that

the revolutionaries have not just overthrown a king, have not just overthrown a so-cial order sanctioned by Christianity, have not just made victims and martyrs out of innocent people, but have also aided and abetted the putting at risk of Christ's ac-tual living body in the form of the consecrated Host. From a Catholic perspective, no more serious charge of heinous conduct was possible.

For Zoffany, the *menu peuple* go beyond denying the truths of Christianity to per-vert those truths, proving themselves more fiendish than human. In this interpre-tation, the overarching entrance to the wine cellar behind them appears like a Hell's Mouth through which these tormenting devils have entered this world.[38] Al-though the edifice itself, as we have seen, represents the stabilizing grandeur of the ancien régime, it overarches a dark subterranean world, a world of mankind's base and vicious instincts. Forty-three years later, George Cruikshank offered a similar representation of the French Revolution in his design for the wrapper to M. A. Thiers's history (Fig. 41). At the bottom of the composition, the Gates of Hell open wide to release wild, satanic creatures who have burst their chains. Egalité at the left offers a dagger, Liberté at the right a firebrand. Zoffany and Cruikshank invert the pro-republican imagery of the oppressed breaking their chains to emerge from dark confinement, as, for example, in such celebrated episodes as the storming of the Bastille, where the persecuted are released from tyrannical imprisonment. In the con-servative recounting, the passions that are unleashed spring from the demonic im-pulses of chaotic violence and satanic irreligion.

Contemporary Reactions

Because *Plundering* was the only one of Zoffany's two pictures of the French Revo-lution to be exhibited, it is the only one discussed in contemporary published ac-counts. The reviewer for the *Morning Chronicle* supplied a perceptive response:

> Mr. Zoffani's representation of *the French Mob plundering the King's Cellar at Paris, August 10, 1793,* has a most singular effect; what is called the cellar bears a stronger resemblance to the arch of a bridge, and the heterogeneous crew who are delineated as performing their horrid orgies, *above, beneath, and all around,* when viewed at some distance, reminded us of a swarm of bees clustering on a hive; some of the characters bear a striking resemblance to characters we have seen in Hogarth—but the whole scene, though well painted, is too horrid to be contemplated.[39]

John Williams, under his pseudonym Anthony Pasquin, provided a longer, more critical reaction:

> How lamentable it is that such a floundering w[e]ight should sully his honor in the evening of his days; but even Socrates acknowledged a temporary imbecility! the virtuous artist slept in November, charged with repletion and

FIGURE 41

George Cruikshank, wrapper for Part 15 of M. A. Thiers's *The History of the French Revolution.* Wood engraving by Thompson, 21.9 × 14 cm. (8½ × 5½ in.), 1838. Princeton University Library.

indigestion, and imagined in his dormitory, that he saw a *sansculotte* befouling the threshold of the millenium, and scratching his buttocks with the regalia. The amiable painter's anatomy shook with horror at the ideal spectacle;—he raved about liberty and licentiousness; her immunities, and her madness, until his fancy overthrew his discretion; and in the moments of his weakness, or his antipathy, he embodied a group of *Parisians plundering the King's cellar!*—and this vulgar untruth, was exhibited with all the pride of a gothic sacrifice to Prejudice!

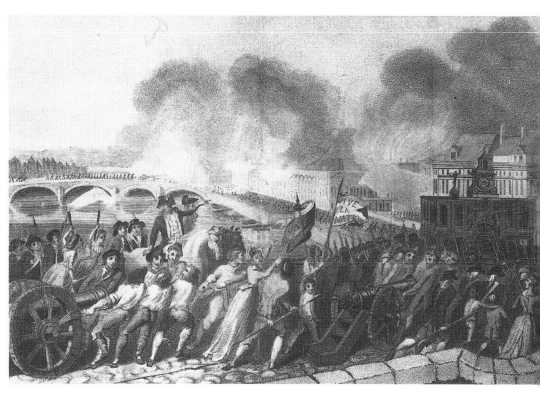

FIGURE 42

Artist unknown, *Louis, XVIth: Deposed: and the Massacre, at Paris, on the 10th of August 1792*. Stipple engraving, 13 × 19 cm. (5⅛ × 7½ in.) (border), January 19, 1795. Bibliothèque Nationale, Paris.

Every candid observer must consider this foul production as one of those irregular tributes to the malice and folly of the moment, which every mean man is eager to pay to those who have purposes to answer, which are not very consonant with truth, humanity, or justice. Of all the pieces I have seen from the pencil of Mr. Zofanii, this is the most unlike himself; he evidently labours to tread in the steps of Mr. Hogarth, but is truly unsuccessful. This savage assemblage of monsters are denied the possession of human lineaments by this indignant German. It is but too certain that the mobs of Paris committed atrocities at which a generous nature will shudder; yet I do not think that the cause of morality will be much strengthened by making the perpetrators of a crime singularly deformed and repulsively hideous; this offending spectacle can only be reviewed with pleasure by a blackguard or an assassin.[40]

Williams, a staunch liberal who supported the French Revolution, clearly did not approve of the picture's sentiments, and he scores direct hits with such pungent

phrases as "a gothic sacrifice to Prejudice." His last observation—"this offending spectacle can only be reviewed with pleasure by a blackguard or an assassin"—is unintentionally ironic in light of the obvious relish with which he undertakes his criticism of Zoffany's work.

Williams was not the only one critical of the uncompromising conservativism of Zoffany's conception. A few months before the painting itself was exhibited, Earlom's print of January 1, 1795, reproducing it had appeared (see Fig. 1). Although published two and a half years after the moment it depicts, it was the first image produced in England focusing exclusively on the *journée* of August 10. It thus seems more than coincidental that the only other English work treating this subject should have appeared a little less than three weeks later. On January 19, 1795, B. Crosby at 4 Stationers Court, Ludgate Street, published the anonymous print *Louis, XVIth: Deposed: and the Massacre, at Paris, on the 10th of August 1792* (Fig. 42). While the title, with its characterization of the events as a massacre, reflects Zoffany's interpretation, the image itself does not. Rather it seems implicitly critical of Zoffany's presentation, for it ironically undercuts its own title's reactionary ideology. Instead of the horrors committed by Zoffany's mob in the name of liberty, the artist depicts "the people" moving with measured dignity and resolute purpose as they file over the Pont-Neuf toward the smoke of the battle raging in the background. Women and children join with uniformed soldiers under the fluttering tricolor with its patriotic message "VIVE LA NATION."

4

THE FURIES OF HELL

Celebrating over the Bodies of the Swiss Soldiers

Zoffany's other large painting of the French Revolution (Plate 2) was first mentioned in the 1811 posthumous sale catalogue under the entry "A scene in the Champ de Mars on the 12th of August, with a Portrait of the Duke of Orleans."[1] When the picture appeared at auction at Sotheby's on March 18, 1981, a lengthy analysis of its subject matter was offered:

> It is likely that the date was confused in the 1811 catalogue, and that the subject depicted relates to the so-called Massacre of the Champ de Mars of 17th July 1791, which took place just after the Royal Family's abortive flight to Varennes which precipitated the Cordeliers' petition to request the Assembly to replace Louis XVI. Although there is no historical evidence that the Duke had any direct personal link with any of these events, Georges Lefebvre seems to suggest a connection (*The French Revolution,* London, 1962, pp. 208, 209).[2]

In the major bicentenary exhibition on the French Revolution held in Paris in 1989, the painting was exhibited with the title *The Massacre of July 17, 1791, in the Champ de Mars.*[3] The events of July 17, 1791, were important, but they are not the ones depicted by Zoffany. Agitation had mounted over what should be done with the king and queen after they had attempted to flee the country, and on July 17 an unarmed crowd rallied on the altar of the nation in the Champ-de-Mars in support of a republican petition proposed by the Cordeliers Club that would have deposed the royal couple. Though the demonstration was relatively peaceful, authorities called in the National Guard, who fired on the demonstrators, killing anywhere from thirteen to fifty, depending on whose accounting is accepted. This event (Fig. 43) made martyrs of the republican "rabble," and as even the most cursory look at either of Zoffany's paintings demonstrates, his sympathies were not with the revolutionaries.[4]

Writing in 1989, the same year the Regensburg picture was exhibited as a repre-

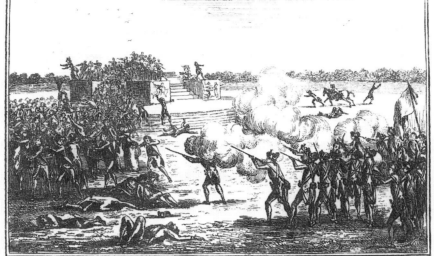

Des Hommes, des Femmes, des Enfans ont été massacrés sur l'útutel de la Patrie au Champ de la féderation.
Bureau des Révolutions de Paris Rue des Marais F. B. St. G. N° 20

FIGURE 43
Artist unknown, *Malheureuse Journée du 17 Juillet 1791* (Unhappy day of July
17, 1791). Etching, 9 × 14.5 cm. (3⁹⁄16 × 5¹¹⁄16 in.) (border), [1791]. Bibliothèque
Nationale, Paris.

sentation of July 17, 1791, David Bindman maintained that the painting "appears
to depict the women of Paris dancing on the bodies of the Swiss guards killed in
the assault [on the Tuileries of August 10, 1792]."[5] Bindman is correct: the scene is the
Tuileries Gardens, not the Champ-de-Mars. Even those who have argued that the
subject is that of the Champ-de-Mars massacre have, like Bindman, related this
work to a diary entry made by Joseph Farington on August 1, 1794:

> Left Strawberry Hill [the home of Horace Walpole] at 7 oClock & break-
> fasted at Kew. Called on Zoffany & I made a drawing of Kew Bridge from his
> window.—He was painting on one of his Parisian subjects.—the woemen &
> Sans Culottes, dancing &c over the dead bodies of the Swiss Soldiers.—
> Zoffany's legs are much swelled by a scorbutic humour.[6]

This is obviously Zoffany's subject. He shows the mob celebrating over the bodies
of the murdered Swiss guards, whose mangled corpses have been stripped.

The question arises whether August 12, the date given in the posthumous sale cat-
alogue instead of August 10, is correct. The entry, of course, was not written by the

FIGURE 44
Detail of Plate 2.

FIGURE 45
Detail of Plate 2.

artist, and even he, as we have seen, could be careless with his dates, but one hesitates to dismiss this citation as an unfortunate error when in the same catalogue the August 10 date is correctly given for *Plundering the King's Cellar.* The explanation lies in the fact that the tenth, the day of the assault, was a Friday, and by dating his second picture to the twelfth, Zoffany placed the event on Sunday. The frantic looting, the ongoing executions, and the excessive drinking depicted in the first painting have now given way to a macabre celebration, made worse by its taking place on the Sabbath, the most unholy of acts enacted on the holiest day of the week. Zoffany's interpretation is best understood against the tradition of showing Sunday recreation in an idyllic park setting, a tradition later monumentalized in such images as Manet's *Concert in the Tuileries* (1860–62) or Seurat's *Sunday on the Grande-Jatte—1884* (1884–86) that depict Parisians engaging in leisurely pursuits, but of a different kind.

The background for *Celebrating over the Bodies of the Swiss Soldiers, August 12, 1792* is a generalized view of the Tuileries Gardens, with ramps rising from each side toward the esplanades at the western end (Figs. 44 and 45). As in his depiction of the Tuileries Palace in *Plundering the King's Cellar at Paris,* the setting is an approximation rather than an accurate portrayal. The garden's exact appearance is better conveyed in a revolutionary print of 1789 (Fig. 46). Zoffany shows only one statue, that

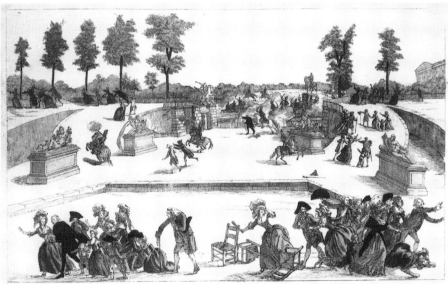

Evenement du 12 Juillet 1789 a six heures du Soir .

Le Prince Lambesc entrant dans les Thuilleries le Sabre a la main, avec un Detachement de son Regiment, Royal Almand, abbat a ses Pieds un Vieillard
ce qui fait fuir tous les Citoyens qui s'y promenent .

FIGURE 46

Artist unknown, *Evenement du 12 Juillet 1789 à six heures du Soir* (Events of July 12, 1789, at six o'clock in the evening). Colored etching, 25.5 × 37.5 cm. (10 × 14⅝ in.), [ca. 1789]. Bibliothèque Nationale, Paris.

of a goddess, anchoring the ramp at the right, and in the center of the composition the ramps dissolve into an ill-defined mist, which may be a reflection more of the painting's poor condition than of the artist's original conception, the central portion of the gardens appearing to have been inexpertly overpainted. One suspects as well that little of Zoffany's hand remains in the pedestrian rendering of the sky.

In the days immediately prior to August 10 the gardens had been a cause of friction between the king and the public. J. B. d'Aumont, a confirmed antiroyalist, wrote that the monarch "still kept his garden of the Thuileries shut up in sullen sulkiness. For the opening of this garden to the public, like the gates of the Temple of Janus, announced his hostile or peaceable intentions, his good or bad humour."[7] John Moore, the physician and writer, also reported in his published journal of his trip to France, from August through December 1792, how the garden's closure fed the people's hostility:

> I returned by the key [quay] of the Louvre, intending, before I went to the
> Hotel de Moscovie, just to step into the gardens of the Tuileries, by the gate
> next the Pont Royal, and was a good deal surprised to find that two Swiss
> sentinels refused entrance to all but those who presented a ticket: while I
> stood on the bridge I saw several persons admitted by that means, and the
> gate carefully shut immediately after them. This seemed to be viewed with an
> evil eye by the people—some of whom murmured, and talked of the garden's
> belonging to the public, and not to the family lodged in the Palace, of all of
> whom the populace spoke with irreverence, and of some of them in terms too
> indecent to be repeated.[8]

By Sunday, August 12, the day depicted by Zoffany, the gardens belonged exclusively to the people. Moore, writing on Monday, the thirteenth, described what one might have encountered there:

> A stranger just come to Paris, without having heard of the late transactions,
> and walking through the gardens of the Thuilleries, Place de Louis XVI.
> [i.e., Louis XV] and Champs Elisées, would naturally imagine from the
> frisky behaviour and cheerful faces of the company he meets, that this day
> was a continuation of a series of days appointed for dissipation, mirth, and
> enjoyment; he could not possibly imagine that the ground he is walking over
> was so lately covered with the bodies of slaughtered men; or that the gay
> lively people he saw were so lately overwhelmed with sorrow and dismay.[9]

Moore's view is contradicted by Peltier's gloomier assessment: "More than three days were spent in conveying away the bodies of those who were killed on the 10th August: the air began to be tainted with their putrefaction."[10] Richard Twiss reported

with surprising specificity the number of bodies that remained on Saturday: "On the Saturday morning, at seven, I was in the *Tuileries* gardens; only thirty-eight dead naked bodies were still lying there; they were however covered where decency required; the people who stript them on the preceding evening, having cut a gash in the belly, and left a bit of the shirt sticking to the carcase by means of the dried blood."[11] Another of the visitors, an Englishman who worked for a Parisian publisher, recorded a larger number:

> I went early on Saturday morning with some of our men, all over the palace;
> and then they had not removed all the bodies that were killed the day before;
> for they lay stripped naked all about the palace; and in the garden (where
> they had retired for supposed safety) they lay exposed. At least in one heap I
> saw 100; in all the adjoining palaces, four, five, or six, one on another, some
> by the bayonets run through them, others their heads shot or cut off; others
> cut through their bodies: I have been sick ever since.[12]

Some of the victims' bodies were disposed of by burial in the gardens; some were burned in fires made from the contents of the palace; some were thrown into the Seine. If any corpses were still present in the Tuileries Gardens on Sunday, one doubts, given the heat of August, that anyone would have felt like dancing over these remains. Again, though, Zoffany was not interested in documenting reality.

When describing the view offered from the grand garden walk looking westward, Peltier contrasted its past appearance with its present condition: "The collected beauties of art and nature which adorn the prospect, made this spot the Elysium of France! The scene, alas! is going to change: it will soon become the theatre of furies and of dæmons."[13] This contrast is also Zoffany's point of view. In the background of his painting, the tree-lined spaces offer a quiet refuge. Small figures can be glimpsed near the base of the statue engaged in tranquil reflection, while others are seen serenely promenading in the park. The overarching symmetry of the gardens, another creation and symbol of the ancien régime, provides a quiet haven, in contrast to the violent excesses of the foreground groups. The *menu peuple* have invaded this privileged Elysium, turning it into a hellish scene of butchery.

The Women of Paris

Men and women mix freely in both of Zoffany's paintings, but the dominating central figure in *Plundering* is that of the sansculotte wearing a *bonnet rouge* and tugging on the wine basket. Although there are exceptions, the women in this exhibited picture tend to be more interested in the spoils of victory, whether valuables or wine, than in violent retaliation. In *Celebrating over the Bodies* all this has changed: the dominant central figure is the woman standing on the pile of corpses (Fig. 47), and women in general lead the way in committing atrocities.

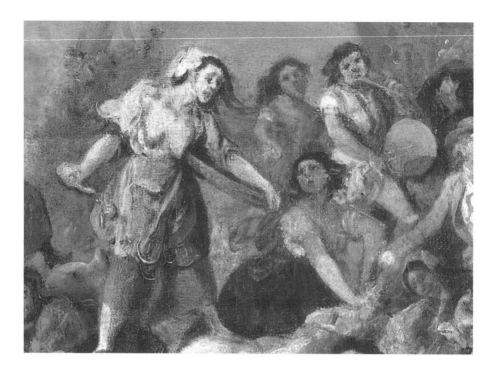

FIGURE 47
Detail of Plate 2.

In the lower left corner a woman, wearing the sabots of the lower classes, bends over to pick up the head she has just cut loose from the body of a dead soldier (Fig. 48). Women usurp the phallic power of men, not only in the knives that they wield to such chilling effect, but also in the power to be seen between their legs. At the extreme left corner next to this woman with the bloodied knife is a seductive maiden with a sharp pike protruding up between her thighs. With ecstatic fervor, she and the powerful figure beside her grip this rod. On the far side of the composition appears a woman riding a cannon, the back end of the barrel protruding between her legs (Fig. 49), a conception that may owe a debt to prints showing women along with soldiers of the National Guard straddling cannons on their return from Versailles on October 6, 1789 (see, for example, Fig. 7).[14] Yet in *Celebrating over the Bodies* none of the males are so empowered, and in giving to the women these masculine attributes Zoffany suggests the males have been figuratively castrated. The more potent the women, the less the men.

In commenting on the events of August 10, the English press criticized the participating women for their "unnatural" behavior:

> Amidst these scenes of horror, the women shewed no signs of that sensibility natural to their sex, and many of them mixed boldly among the mob.

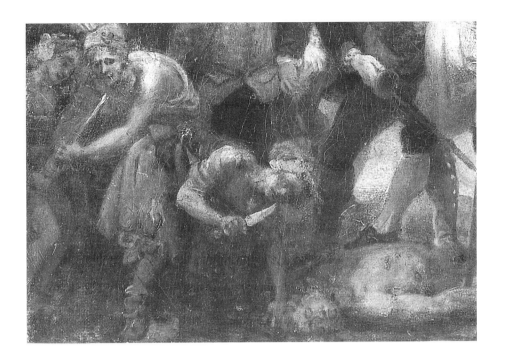

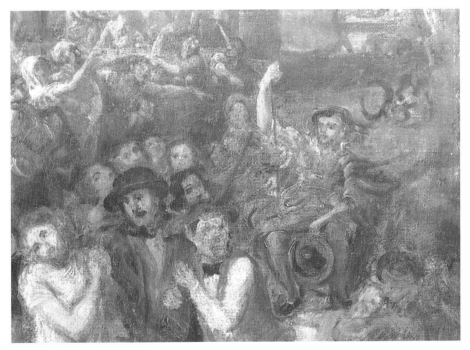

FIGURE 48 FIGURE 49
Detail of Plate 2. Detail of Plate 2.

Towards eight o'clock, the light of flames, the approach of night, and the sight of many dead bodies, particularly those of the Swiss, exposed quite naked, exhibited a spectacle awful and horrid beyond description.[15]

In another newspaper, the conduct of French women was purposefully contrasted with that of the English:

The few English women who were at Paris on the 10th of August, were overwhelmed with affliction, and confined themselves to their chambers to weep for the fate of the unhappy victims! while the French ladies were enjoying the horrours exhibited in every street of the metropolis of France, and taking their promenades among the dead and mangled carcasses of the Swiss Guards.[16]

If these women were willing spectators, those of the lower classes were described as indulging in conduct as brutal as that of the men. One of the reported scenes, though it did not take place at the Tuileries, involved women and the Swiss guards:

About 60 [Swiss soldiers] who were not killed on the spot, were taken prisoners and conducted to the Town Hall of the Commons of Paris. It was intended that they should have here a summary trial, but the women, particularly the *Poissardes,* rushed in torrents into the Hall, crying for vengeance, and the Swiss Guards were given up to their fury, and every man of them murdered on the spot.[17]

Peltier's description of the carnage at the palace is still more damning:

Streams of blood flowed every where, from the roofs to the cellars: it was impossible to set a foot on a single spot without treading upon a dead body. Stripped as soon as they were murdered, their lifeless bodies presented, in addition to the ghastliness of death, the shocking spectacle of a mutilation which the mind may conceive, but which modesty forbids me to describe; and these atrocious deeds were perpetrated by women! by daemons! by furies![18]

James Fennell, the impecunious actor and writer who was visiting Paris in 1792 as a young man of twenty-five, similarly refers to "the female furies (for they cannot be called women)."[19]

In its accounts the English newspaper the *World* focused on the conduct of the women of Paris, writing on August 21:

Who can hear, without manifest indignation and horror, that the French women (heretofore distinguished for humanity and feminine softness) should

lately, with a degree of ferocity unparalleled, at the late massacre of the Swiss soldiery in Paris, literally tear the dead bodies to pieces, and practise with them the most shocking indecencies—breaking open the apartments in the *Thuilleries,* and dancing there while the floors were flowing with blood.[20]

Three days later the newspaper reported that "the most abandoned profligacy was united with the most outrageous barbarity; and the fair sex were transformed into the most hideous and inhuman monsters."[21] On the twenty-seventh it continued to dehumanize the female participants, ascribing to them the forcing of toasts down the throats of the dead Swiss soldiers in a manner more gruesome than Zoffany depicted in *Plundering:*

> FATE itself seems to urge on the extirpation of the FRENCH! The WOMEN of PARIS have left behind them all the parallels that are delivered to us from history or memory. Such FIENDS, in *human shape,* the most savage nations have not exhibited. A SEX, whose nature should shrink from the narration of barbarous act—*that Sex,* stripping the dead soldier, pulling about his lifeless carcass, tearing open his wounds, and thrusting their hands into his mouth to open it, to make him drink—*the downfall of his King!*[22]

In other newspaper accounts, one woman was described as having displayed a body part of a soldier she had killed: "The Mistress of the Caffé National, *Rue St. Denis,* though only about 16, killed a Swiss soldier on the 10th; and his hand is fixed up over her sign."[23] In Zoffany's painting, the severed hand lying at the bottom of the pile of corpses (Fig. 50) represents such dismemberments undertaken even by teenage girls.

Outside England one can find similar responses, also surely exaggerated, to the atrocities carried out by women. On August 14 the Hamburg newspaper *Minerva* published a "Letter from Paris" by Konrad Engelbert Oelsner, a German Girondist, detailing the women's participation and blaming their savage actions on their weaker and more excitable nature:

> And though it disgrace all womanhood, I must say that it is the women who, in all the stormy scenes of the Revolution, have always been the first to invent and execute atrocities, or to incite men to commit new tortures and bloody deeds. During the night following that horrible day, they reportedly denuded themselves on the dead bodies, roasted the limbs of the killed men, and offered them as food. Even the morning after, I have seen women clawing among the dead, mutilating their limbs. This tendency toward excess was noticeable even among the educated class of women. I have always found that the weaker half of society has the greatest inclination to commit desperate and horrendous acts, and I could abhor women, were not that very same

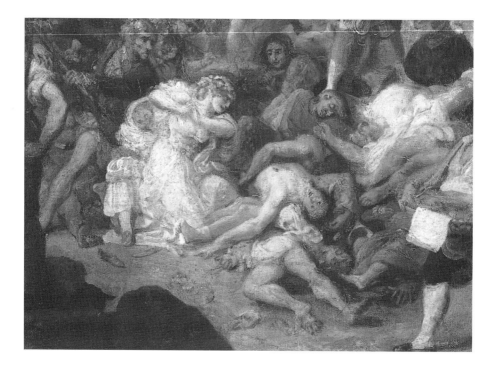

FIGURE 50
Detail of Plate 2.

excitability, which in an eruption of hatred and revenge transforms them into repulsive monsters, almost the sole mainspring of their virtues.[24]

Zoffany castigates all the participants, male and female, but in both pictures the women are particularly demonized. In *Plundering,* as we have seen, the men carry heads hoisted on pikes, but a woman is shown carrying a head in her bare hands, her dark skin and hair, pendulous breasts, and large nose suggesting the savagery of one of the American Indians Burke mentioned in his account.[25] In addition, while men execute other men, the two crones violating and stabbing the aristocratic woman are placed front and center. In *Celebrating,* the women have unsexed the men and are almost the sole perpetrators of barbarity. Even an image of sparkling grace— the dancing woman with tambourine or basket to the left of the central fury (Fig. 51)—is undercut by the dark silhouette of the stolid peasant woman behind her, a jarring reminder of the true spirit of this macabre dance.

Zoffany's women are also the ones who convey the most extreme emotions. In conceiving the disoriented figure crawling on all fours in the lower right of *Celebrating* (Fig. 52), Zoffany abandoned all sense of eighteenth-century decorum. It is

FIGURE 51
Detail of Plate 2.

FIGURE 52
Detail of Plate 2.

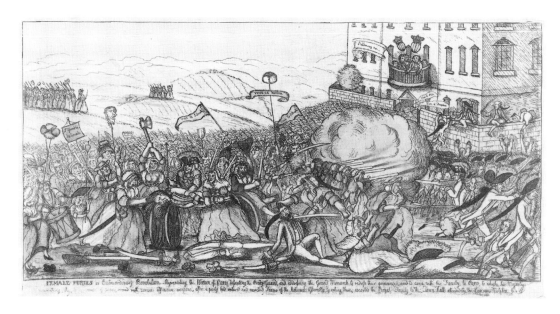

FIGURE 53
William Dent, *Female Furies; or, Extraordinary Revolution.* Colored etching,
25.5 × 42.2 cm. (10 × 16⅜ in.), October 18, 1789. British Museum, London.

not clear if this figure and the kneeling woman behind her are crazed with grief or
with bloodlust, but one suspects they have given themselves over to the violent mae-
nadic excesses Burke referred to when he noted "the Theban and Thracian Orgies,
acted in France" during the earlier October Days.[26] One does not experience again
in art this frenzied delirium and painful alienation until Goya executes his macabre
Black Paintings in the early 1820s. While Zoffany left his canvas unfinished, he may
also have felt a broad, sketchy style was best suited to convey this wild abandonment.

Burke set the horrified tone for reacting to female frenzy in his *Reflections on the
Revolution in France,* where he describes the forced journey of the royal family from
Versailles to Paris: "The royal captives who followed in the train were slowly moved
along, amidst the horrid yells, and shrilling screams, and frantic dances, and infa-
mous contumelies, and all the unutterable abominations of the furies of hell, in the
abused shape of the vilest of women."[27] Burke's vivid phrasemaking had been an-
ticipated by William Dent in the title of his work *Female Furies; or, Extraordinary
Revolution* (Fig. 53), showing the women of Paris storming Versailles. They attack as
a disciplined military force, and two unfortunate soldiers who have been captured
are being beheaded, one with an axe, the other with a sword. Dent's interpretation
at heart is a comic one, however, as he plays on the women's reversal of traditional
gender roles. There is nothing comic about Burke's, Peltier's, Fennell's, the *World*'s,
or Zoffany's reactions to these modern-day furies.

Gillray had also been sensitive to the role played by women during August and

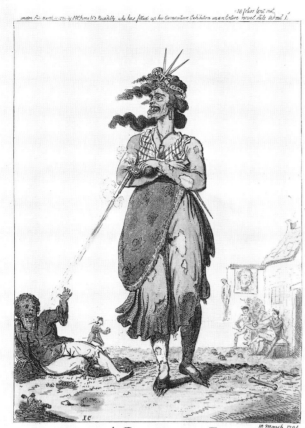

A REPUBLICAN BELLE.
A Picture of Paris for 1794.

FIGURE 54
Isaac Cruikshank,
A Republican Belle.
Colored etching,
25 × 17.3 cm. (9⅞ ×
6¾ in.), March 10,
1794. British Museum,
London.

September 1792. In his print *Un petit Soupèr* (see Fig. 19), the two sansculottes are prominently positioned, but the women outnumber the men two to one, a ratio that is maintained even among the junior recruits gathered around the tub of guts at the lower left.[28] Gillray makes clear the women's embracing of male attributes, for one of the females prepares to engorge a victim's testicles. The leg of the table screens the crotch of a male victim, discreetly suggesting castration. Isaac Cruikshank's satiric fashion plate *A Republican Belle* (Fig. 54) is another grimly hilarious look at these new specimens of womanhood. The belle bristles with a tiara made of daggers, guillotine jewelry, razor-sharp teeth, and clawlike toenails, and her apron is patterned with skulls and crossbones. She absentmindedly discharges her phallic pistol, killing the young boy at her side who is presumably her son.[29]

Although *Plundering* depicts a number of bare-breasted women—a group that includes both the victims, whose garments have been stripped from them, and the tor-

mentors, who have exposed themselves in frenzied excess—in *Celebrating* only the central figure standing over the bodies is portrayed with a breast exposed. In England in the late eighteenth century, the breast-baring woman was often associated with the madwoman. Her state of undress, according to Jane Kromm, typifies a view in which "the analogue for frenzied unreason is a sexualizing physical abandon and a disregard for the apparel of civilized behavior."[30] As Kromm goes on to point out, "In France, the breast-baring madwoman seems to be unknown until the last quarter of the nineteenth century." One reason for this was that the French closely associated this female type with the allegorical figure of Liberty, which became the official representative of the state in the aftermath of the changes wrought by August 10 and the September massacres, replacing the image of the monarch. In Maurice Agulhon's summation, "The Revolution celebrated the Republic as an allegory of Liberty; the allegory took the twofold form of plastic representation and live theatre; and the live representations [in which women played the role of Liberty in various festivals and celebrations] are among the most enduring memories that the allegory left behind."[31] Zoffany has it both ways. His central figure in *Celebrating* is the living embodiment of the Republic,[32] but it is Liberty gone mad. In this regard, his figure is the evil twin of Delacroix's bare-breasted champion in *Liberty Leading the People* of 1830.

Zoffany may have intended another association as well. By assigning the diabolical celebration to the Sabbath, he could also have meant this scene to suggest the sabbat, the name given to witches' meetings that were seen as parodying the Christian day of worship. In this context the central figure with her sagging breasts is a hag or witch, more appropriate to a Christian demonology. Just as the sabbat is a demonic inversion of social, political, and religious hierarchies, Zoffany's witch presides over a revolutionary world of misrule.[33] Perhaps he intended as well an echo of the biblical injunction "For rebellion is as the sin of witchcraft" (1 Samuel 15:23).

Witches performing incantations had appeared at least twice in prints on French Revolution subjects, but in both cases as benign sorceresses. One, *La Fée Patriote* (Fig. 55),[34] is a creative adaptation of 1789 or 1790 of a 1626 print by Jan van de Velde the Younger.[35] It faithfully replicates the original image, only reversing the design and updating it by inserting a distant view of the Bastille at the upper left, its author calling attention to his source by signing the print "Vanvelde Sculp." Yet the meaning of this adaptation completely reverses that of its model. Van de Velde's image contains lines in Latin that warn against unlimited desire, which, deceiving mankind with its sweet song, makes one forget the brevity of a life of pleasure whose close brings an eternity of grief.[36] The sorceress, a figure of wild abandon with her exposed breasts and windblown hair, is extremely attractive—if temptation were ugly, it could easily be resisted. This seductive witch is joined by numerous macabre creatures as she conjures up evil diversions for an easily distracted mankind. *La Fée Patriote* inverts the print's meaning by turning the witch into a good fairy who, as the verse in the margin makes clear, is busily banishing the nightmarish world of the ancien

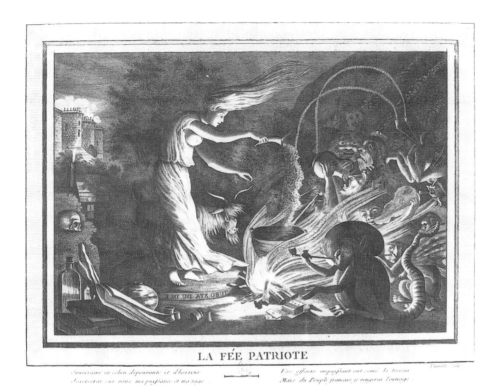

LA FÉE PATRIOTE

FIGURE 55
Artist unknown, *La Fée Patriote* (The patriotic fairy). Etching, 22 × 30 cm. (8¹¹⁄₁₆ × 11¹³⁄₁₆ in.)
(border), 1789 or 1790. Bibliothèque Nationale, Paris.

régime. Witchcraft and revolution are no longer threats to the social order. The old
demonology has been replaced by an optimistic outlook that gives birth to a brave
new world. Van de Velde's outmoded beliefs and the value system they represent
have been made to serve a new world order. Zoffany, of course, will have none of
this revisionism, the ugliness of his withered crone making clear his revulsion at this
world of demonic misrule.

Edmund Burke had earlier set up a pronounced duality in characterizing the *pois-
sardes* as the "vilest of women" while offering his famous, some would argue infa-
mous, tribute to Queen Marie-Antoinette:

> It is now sixteen or seventeen years since I saw the queen of France, then
> the dauphiness, at Versailles; and surely never lighted on this orb, which she
> hardly seemed to touch, a more delightful vision. I saw her just above the
> horizon, decorating and cheering the elevated sphere she just began to move
> in,—glittering like the morning-star, full of life, and splendor, and joy.[37]

This same contrast of ideal womanhood, as embodied in aristocracy, and debased

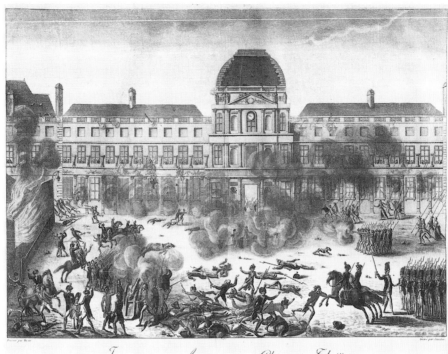

Journée du 10 Août 1792 au Château des Thuillerie.

FIGURE 56 (*above*)
After G. Texier, *Journée du 10 Août 1792 au Château des Thuillerie* (August 10, 1792, at the Tuileries Palace). Engraving by Madame Jourdan, 36 × 52 cm. (14 × 20¼ in.) (border), [ca. 1792]. Bibliothèque Nationale, Paris.

FIGURE 57 (*opposite*)
Thomas Rowlandson, after a design by Lord George Murray, *The Contrast.* Colored etching, 30.5 × 47 cm. (12 × 18⅜ in.), 1792. British Museum, London.

womanhood, as embodied in the lower classes, is part of Zoffany's conception, and the artist's central fury, so dramatically positioned in *Celebrating,* is like an anti-queen. The beatific vision is now replaced by a demonic one: Mary, the Mother of God, who is remote and pure, is replaced by Marianne, the republican symbol of Liberty, who is aggressive and fearsome.

From the beginning, women of various social backgrounds had played an important role in the advancement of revolutionary causes, but Zoffany focuses on the Parisian laboring poor, the female counterparts of the sansculottes, a group now variously referred to as the *femmes sans-culottes,* the *sans-culotterie,* or the *sans-jupons* (without fancy petticoats).[38] These women, driven by economic insecurity, had instigated the march on Versailles on October 5, 1789. Women had participated as well in the assault on the Tuileries of August 10. The artists who chronicled the attack, however, did not include women in their depictions, the sole exception being G.

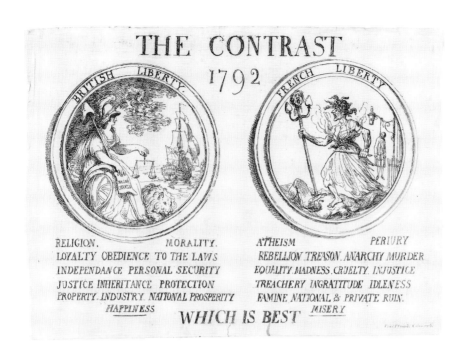

THE CONTRAST
1792

BRITISH LIBERTY. FRENCH LIBERTY

RELIGION. MORALITY.
LOYALTY OBEDIENCE TO THE LAWS
INDEPENDANCE PERSONAL SECURITY
JUSTICE INHERITANCE PROTECTION
PROPERTY INDUSTRY NATIONAL PROSPERITY
 HAPPINESS

ATHEISM PERJURY
REBELLION TREASON ANARCHY MURDER
EQUALITY MADNESS CRUELTY INJUSTICE
TREACHERY INGRATITUDE IDLENESS
FAMINE NATIONAL & PRIVATE RUIN.
 MISERY

WHICH IS BEST

Texier's engraving showing two marginalized women at the right, one who leads three pikemen and one who brings up the rear of another cluster of four (Fig. 56).[39] Each of three female combatants, Reine Audu, Claire Lacombe, and Théroigne de Méricourt, received a "civic crown" for her efforts,[40] and the "amazon" Théroigne de Méricourt in particular captured the attention of the English, who frequently singled her out for praise or damnation.[41] Moore credited her with rallying the attacking forces after their initial repulse by the Swiss guard and then leading the second assault of the Marseille *fédérés*.[42] But she is most frequently cited as a cruel tormentor, credited with gleefully instigating some of the worst atrocities on August 10 and during the September massacres.[43] While Zoffany presumably did not intend his central fury as a portrait, the numerous accounts of Théroigne's ferocious barbarity may have inspired him to see in her a prototype of his commanding figure.

Looking more closely at the figures in Zoffany's painting makes it clear that their activities are more diabolical than one might at first suspect. The central "fury" holds a knife and basket (see Fig. 47), while exchanging glances with a kneeling companion who is beside her atop the pile of corpses. The hands of this companion are on one of the bodies, from which blood squirts upward. The activity of the kneeling woman—she is cutting into a body or removing something from it—explains the task the standing woman has set herself: she is a harvester, come to fill her basket with body parts.

An allegorical forerunner of Zoffany's figure can be found in Thomas Rowlandson's print *The Contrast* (Fig. 57), after a design by Lord George Murray, where

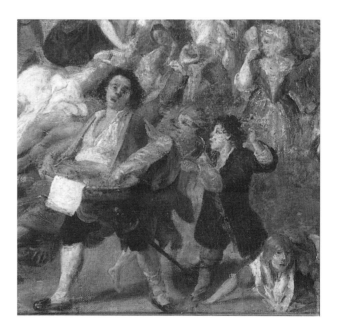

FIGURE 58
Thomas Rowlandson, after a design by
G. L. S., *Philosophy Run Mad; or, a Stu-
pendous Monument of Human Wisdom.*
Etching, 23.7 × 35.3 cm. (9¼ × 13¾ in.), ca.
1792–93. British Museum, London.

FIGURE 59
Detail of Plate 2.

SUPPLICE DE FOULON A LA PLACE DE GRÈVE .

FIGURE 60
After Jean-Louis Prieur, *Supplice de Foulon à la Place de Grève, le 23 Juillet 1789*
(Execution of Foulon at Place de Grève, July 23, 1789). Engraving by Pierre Gabriel
Berthault, 24 × 29 cm. (9⁷⁄₁₆ × 11⁷⁄₁₆ in.), [1802]. Bibliothèque Nationale, Paris.

French Liberty is depicted as a castrating fury with gaunt features and medusan
snakes in her hair.[44] Impaled on her trident is the head of the man she has just de-
capitated, flanked by two hearts. Rowlandson's print *Philosophy Run Mad; or, a Stu-
pendous Monument of Human Wisdom* (Fig. 58), executed after the design of an am-
ateur with the initials G. L. S., contains another significant detail: the banner at
lower right depicts a woman, kneeling over a nude male corpse, holding up the heart
she has just cut out. Zoffany presents his furies more discreetly, but the sentiment
is the same. In addition, given that his is not an emblematic rendering, it is all the
more terrifying in its impact.

While some of the women in Zoffany's *Celebrating* gather body parts, a street ven-
dor in the center foreground (Fig. 59) hawks the contents of a full basket. The young
boy attempting to filch some of his wares could again be a detail out of Hogarth, the
gentleman's sword he wears at his side an anomaly, a souvenir of the recent "riots."
At first glance, one suspects he is selling bread. At lower right in the print *Supplice
de Foulon à la Place de Grève,* after Jean-Louis Prieur (Fig. 60), a bread seller blithely

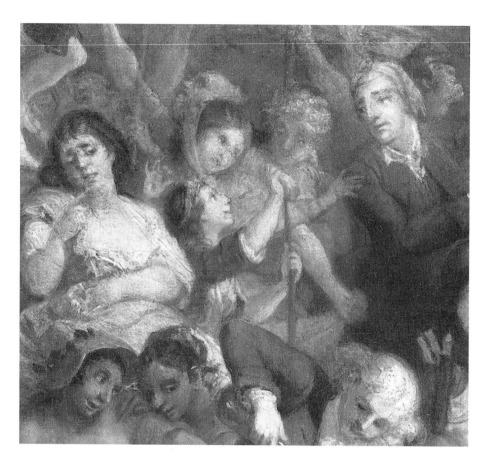

FIGURE 61
Detail of Plate 1.

hawks her wares during the execution of the unpopular court minister Joseph-François Foullon; in comparison, Zoffany's vendor is even less out of place during this Sunday excursion in the Tuileries Gardens. Given, however, the activity around him, one cannot be entirely sure it is bread that he is selling. One eyewitness account, already quoted in part, specifically mentioned that "not a man, woman, nor child, but gloried in having a piece of the bloody garments of a Swiss, or still more inhumanly, a morsel of his flesh."[45] Returning to Zoffany's painting *Plundering,* one wonders just what the young girl is impaling on the end of her pike (Fig. 61). It could be bread, which makes little sense in this context, or a piece of flesh, a reading reinforced by the strong reaction of the woman beside her, who, with raised hand, intently watches the impaling. The man directly behind this woman already holds a pike on which is skewered another oblong object, perhaps another piece of flesh.

Women were closely linked to bread throughout the Revolution, for "the bread riot was their single most effective mode of political expression."[46] Bread riots had

traditionally been an almost exclusively feminine affair, the authorities tolerating women's participation but not that of men, tacitly accepting a mother's right to feed her starving children.[47] The march to Versailles in 1789 had of course begun as a protest over the high price of bread, and in the print by William Dent (see Fig. 53) loaves of bread and decapitated heads are both stuck on pikes, an equation even at this early date being made between the two. In both his pictures, Zoffany invites a deliberate ambiguity between pieces of bread and body parts, particularly in the hands—or on the pikes—of revolutionary women and children.

Madelyn Gutwirth has written on how and why women came "to embody in legend the most sensational aspects of French Revolutionary murderousness."[48] For males, politically left and right, women's barbaric behavior demonstrated their inability to wield power, and for the revolutionaries women as a group provided an easy scapegoat, males transferring their feelings of guilt for atrocities onto their female counterparts.[49] The visual imagery, however, in contrast to the textual, incriminates men more often than women. Figures 14–17 show males as the prime instigators of brutality on August 10, and the frontispiece to *Les Crimes Constitutionnels de France*, published in 1792 (Fig. 62), presumably a conflation of atrocities that is almost a primer for Zoffany's *Plundering*, focuses on masculine violence. In the foreground, a sansculotte who wears a liberty cap marked "égalité" and has broken symbols of royalty at his feet levels his rifle at a fallen bishop. While it is true that he is encouraged by a woman behind him, the more prominent female in the composition's center establishes the dominant motif, that of woman as victim. About to be stabbed by the sansculotte wearing a cockade cap inscribed "Liberté," she will presently join the bodies of the two boys, presumably her sons, and of the man trodden beneath her attacker's feet, presumably her husband. The family, the foundation of the nation's future, as well as the church and the nobility, is a prime casualty of the mob's civil disobedience. The print *Un Sans culotte instrument de crimes dansant au milieu des horreurs* (Fig. 63) even more pronouncedly contrasts male and female behavior.[50] Weeping Humanity, a female allegorical figure, is juxtaposed with the dancing revolutionary, who, in his triumphant moment, is seized and overthrown by the spirit of an avenging victim. This spirit is, in fact, no less a personage than Louis XVI himself, for the sansculotte's neck and upper torso outline the king's profile. While the print alludes to a number of sansculotte outrages, including the execution of the king, the background represents August 10, for the massacre enacted there takes place in front of the Tuileries Palace. In contrast to the sansculotte in the foreground, these figures are idealized, appearing nude or wearing tunics, the abstracting outline style also removing them from everyday reality. None of the women, though, are shown as aggressors; they are only victims of male fury. While in *Un petit Soupèr* (see Fig. 19) Gillray depicts the women behaving as savagely as the men, when he memorializes the execution of Louis XVI (see Fig. 28) the women are made marginal, appearing only in windows, and the woman next to the hanging judge has her hands clasped to her breast, seemingly sympathetic to the victims in

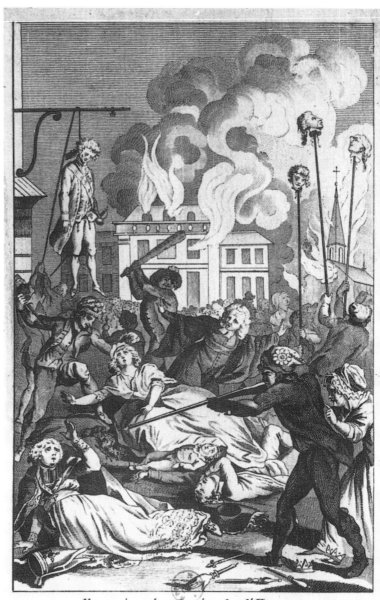

Exercice des Droits de l'Homme et du Citoyen Français.

FIGURE 62

Artist unknown, *Exercice des Droits de l'Homme et du Citoyen Français* (The exercise of the rights of man and of the French citizen). Etching, 18.5 × 12 cm. (7¼ × 4¾ in.), frontispiece to *Les Crimes Constitutionnels de France,* Paris, 1792. Bibliothèque Nationale, Paris.

Un Sans'culotte instrument de crimes dansant au milieu des
horreurs, Vient outrager l'humanité pleurante auprès d'un
cenotaphe . Il croit voir l'ombre de l'une des victimes de la revo
lution qui le saisit a la gorge . Cette effrayante apparition
le suffoque et le renverse

FIGURE 63
Artist unknown, *Un Sans culotte instrument de crimes dansant au milieu des horreurs*
(A sansculotte, instrument of crimes, dancing in the midst of horrors). Etching,
21.3 × 14.8 cm. (8⅜ × 5¹³⁄₁₆ in.), ca. 1794–96. Prints and Photographs Division, Library
of Congress, Washington, D.C.

FIGURE 64
Detail of Plate 2.

contrast with the throng of cheering males.[51] The immediacy and power of an image's impact may have made artists more reluctant than writers to condemn the "fair" sex. Whereas writers tended to censure women more severely than men for their participation in revolutionary horrors, artists more frequently depicted a different fiction, showing women as those more likely sinned against than sinning. In this context, Zoffany's paintings are all the more remarkable for so insistently calling attention to the criminal excesses of the *sans-culotterie*.

Not all the women of Paris in Zoffany's paintings are transgressors. Those who are victims or mournful witnesses conform to the more traditional concept of womanhood. One of the most prominent figures in *Celebrating* is the grief-stricken mother with her child, the child's face little more than a messy, anxious blur, at the left of the pile of corpses, where a gruff *fédéré* is about to strike them with the butt of his rifle (Fig. 64). The other sympathizers are far less prominent. Immediately above the kneeling mother are an old man and a well-dressed woman and to the left a priest with his hand on a boy's shoulder (Fig. 65). A black woman holding a knife

FIGURE 65
Detail of Plate 2.

just to the left of the old man ominously looks back toward the clergyman, reaffirming how unsafe it is to be seen commiserating with the victims.

In *Plundering,* the tormented aristocratic woman in the center foreground represents the feminine ideal: she is elegant, desirable, vulnerable, and pliant, the damsel in distress who has the same right to male gallantry proclaimed by Burke for Marie-Antoinette.[52] Her exposed breasts are full and nurturing. The crones who assault her are unnatural women, cruel, denatured, armed with a phallic knife. The scissors and ball of thread of the foremost crone identify her as a seamstress, one of the urban poor who is here a malignant Fate, perhaps intended as an anachronistic allusion to the *tricoteuses,* the "heartless" women who knit beside the guillotine.

The Hidden Hand

Male authority is present in *Celebrating,* but it is either pushed into the background or operates clandestinely. At far right in the middle distance, Zoffany sketches a makeshift military headquarters, depicting a soldier, identifiable by his crossed bandoliers, writing at a table under a canopy stretched across the garden's trees (Fig. 66). It is not clear if he is signing on new recruits to fight the counterrevolutionaries, or

FIGURE 66 FIGURE 67
Detail of Plate 2. Detail of Plate 2.

if this is a kangaroo court set up to dispatch any Swiss soldiers who may have survived the massacre.

Of greater importance is the group of four men anchoring the composition's left side (Fig. 67). The center of attention is a realistically rendered portrait of an aristocratic gentleman, a figure identified in the sale catalogue description as the duc d'Orléans, an identification confirmed by a comparison of this head with that in Sir Joshua Reynolds's portrait of the duke (Fig. 68), a work Zoffany apparently used as his source.[53] The duke shakes hands with a sansculotte while surreptitiously slipping a white paper to the man behind him. To the right, a *fédéré* and a butcher wearing a gray vest with gold decoration, a butcher's cap, and a bloodstained apron look on.[54] By inserting the duke into this macabre Sunday celebration, Zoffany explains the insurrection's origins.

The duke, a descendant of Louis XIV's younger brother, a cousin of Louis XVI, and the father of the future King Louis-Philippe, was a man of enormous wealth and influence. From 1787 he had opposed Louis XVI's policies, and the public galleries of his Palais Royal became a meeting place for liberals and dissidents beyond the ju-

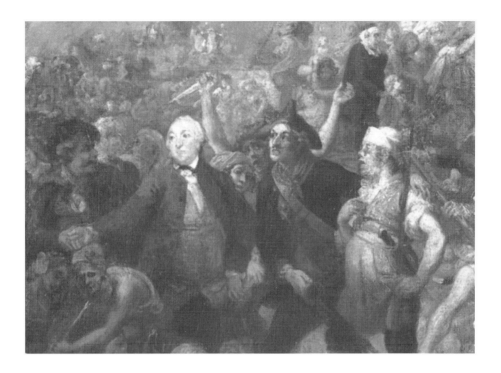

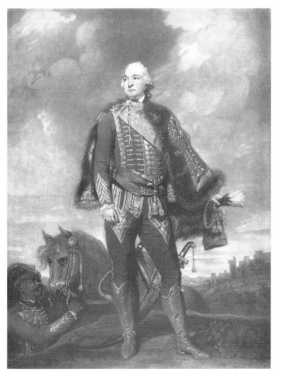

FIGURE 68 (*left*)
After Sir Joshua Reynolds, *His Most Serene Highness Louis Philippe Joseph, Duke of Orleans, First Prince of the Blood Royal of France.* Mezzotint by John Raphael Smith, 64.2 (trimmed) × 45.4 cm. (25 × 17^{11}/$_{16}$ in.), proof before final lettering, predates publication date of March 30, 1786. Yale Center for British Art, Paul Mellon Fund, New Haven.

Assassination

FIGURE 69
[Isaac Cruikshank], *Assassination. Versailles October 6, 1789.* Etching, 17.8 ×
71.1 cm.(7 × 28 in.), October 31, 1789. British Museum, London.

risdiction of the Parisian police. The duke led that faction of the nobility that joined
the Third Estate after it had reorganized itself as the National Assembly. When he
was elected to the National Convention in September 1792, the Commune of Paris
required him to adopt the name Citizen Philippe Egalité to dissociate himself from
his aristocratic roots.

Many supporters of Louis XVI suspected Orléans of attempting to secure the
throne for himself by fomenting the troubles that led to both the fall of the Bastille
in July 1789 and the march of the *poissardes* on Versailles a few months later.[55] In
Cruikshank's print *Assassination. Versailles October 6, 1789* (Fig. 69), Louis XVI
stands on the left with his queen and the dauphin, imploring the officer in the fore-
ground, "Save us from treatcherous Friends." The foremost "friend" on the right is
Orléans himself, clutching a dagger and disguised as one of the invading market
women. The duke unhappily moans, "Where shall we hide our selves—my Plot is
marr'd." In the print, also by Cruikshank, showing Price witnessing the bedlam he
so readily praised (see Fig. 18), one of the assailants stabbing the bed identifies Or-
léans as the beneficiary: "Alons le Duc nous payerons Noblement pour ceci" (Come
on, we will pay the duke nobly for this). And in the print of the procession from Ver-
sailles to Paris (see Fig. 7), the horn-blowing demon in the lower right corner, in-
scribed "chacun y trouve son avantage" (each finds his advantage), has been associ-
ated with Orléans's intrigue.[56]

Orléans was not displeased with the idea of becoming king in his cousin's place, and he certainly was a supporter of revolutionary thinkers, but there is no evidence that he actively plotted Louis's downfall. Peltier, however, was particularly vitriolic in his denunciations of Orléans's conduct, having no doubt that almost all the ills that befell royalty could be laid at his door. After cataloguing the duke's unsavory past, charging him with murder among other sins, he described uses to which he had put his ill-gotten gains: "But what is become of such heaps of treasure, such enormous accumulations of fraud and rapine? They have been spent in paying the wretched assassins of the 5th of October [1789], and in accomplishing the horrid deeds of the 10th of August, the 2d of September [the September massacres], and the 21st of January [the beheading of the king in 1793]."[57] In making Orléans the instigator of the August 10 insurrection, Zoffany was following a well-established tradition of casting him as the unseen villain.

Everyone recognized that the force that attacked the Tuileries Palace on August 10 did not appear spontaneously. It had been mustered by radical Jacobins with strong support inside and outside the capital to abolish the constitutional monarchy then in place. Everyone, including the king himself, knew what the sounding of the tocsins meant when they rang out late in the night of August 9. Yet, in characterizing the military units and the armed artisans who assaulted the palace as a mob, counterrevolutionaries were able to call into question the attackers' motivation. As George Rudé has pointed out, conservatives have often embraced the notion that a mob is composed of society's worst elements and consequently is both prone to violence and incapable of intelligent thought or action. Thus it can be easily manipulated, and Zoffany, like other counterrevolutionaries, wished to see in the actions of August 10 the "hidden hand" of bribery and conspiracy, the "true" mechanisms underlying mob rule. The artist and other conservatives accepted bribery and conspiracy as causes of revolution more readily than genuine grievances on the part of a nation.

For Zoffany, the duke's supposed treachery may have had a personal dimension as well. The duke had served for a time as the grand master of the Grand Orient of France, and the artist was himself a member of the Freemasons in England.[58] Freemasonry encouraged Enlightenment aspirations, and Zoffany must have been drawn to its utopian rhetoric, emphasizing harmony and rationality, and its offer of cosmopolitan fellowship. Its secretive nature, separating out the select few from society at large, must also have appealed to his sense of his own specialness. The duc d'Orléans could be seen to have betrayed Freemasonry itself, the organization he had headed ultimately expelling him.

Zoffany undoubtedly chose Reynolds's portrait of the duc d'Orléans as his model because it was a readily available likeness, but he may also have delighted in its having been commissioned by the Prince of Wales in 1785, when the prince was the duke's admirer. Just as Orléans was an important catalyst for French opposition to the king's policies, the Prince of Wales was the symbolic center of the English op-

FIGURE 70
[Isaac Cruikshank], *The near in Blood, The nearer Bloody.* Colored etching,
21.6 × 32.4 cm. (8½ × 12¾ in.), January 26, 1793. British Museum, London.

position to his father, George III. In addition, just as the duc d'Orléans had served
as grand master in France, from 1790 the Prince of Wales was to serve as grand mas-
ter in England. By choosing as model a painting that links the prince with the duke,
Zoffany may be suggesting that in encouraging dissent, the Prince of Wales was
inviting the disaster that had befallen Orléans and France. The English grand mas-
ter would be wise not to follow in the footsteps of his French counterpart, who
strayed, in Zoffany's opinion, from Freemasonry's interpretation of fraternity and
equality.

When he painted his picture, Zoffany already knew Philippe Egalité's fate. As a
member of the National Convention, Orléans had voted for the death of his cousin,
a decision, shocking enough in itself, that was made more so when the vote for un-
conditional and immediate death passed by a majority of one (361 ballots out of a
total of 721). Many felt revulsion at this act of familial betrayal. Isaac Cruikshank's
print *The near in Blood, The nearer Bloody* (Fig. 70), published on January 26, 1793,
shows a ragged Orléans preparing to chop off his cousin's head. The words Cruik-
shank puts in his mouth make clear the duke's motivation to possess the throne for

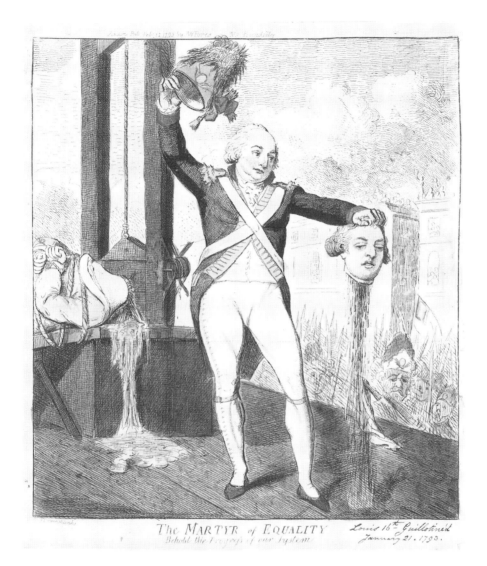

FIGURE 71

Isaac Cruikshank, *The Martyr of Equality.* Colored etching, 24.2 × 21.2 cm. (9⁹⁄16 × 8¼ in.),
February 12, 1793. British Museum, London.

himself, and the kneeling old woman on the left, identified as "Roberspierre en Pois-
sard" (Robespierre as a market woman), waits with a basket similar to that of
Zoffany's harvesting fury.

 Two weeks later, another print by Cruikshank appeared, *The Martyr of Equality*
(Fig. 71), showing Louis more accurately as a victim of the guillotine rather than the

axe that had associated him more closely with the fate of Charles I.[59] But this work with its punning title again blames Philippe Egalité for Louis's death, for in it he still plays the role of public executioner.[60] He himself was imprisoned just a few months later, after his eldest son had deserted to the enemy, and was guillotined in his turn on November 7, 1793. Behind and to the duke's side, Zoffany shows a celebrating sansculotte with his arms raised in the air, a dagger in one hand and his hat in the other. The knife is poised just over Philippe Egalité's head, a foreshadowing of his death at the hands of the revolutionaries.

5

THESIS AND ANTITHESIS

An Antiheroic Art

In his two paintings *Plundering the King's Cellar at Paris* and *Celebrating over the Bodies of the Swiss Soldiers,* Zoffany focused on the events of August 10, 1792, and its aftermath. If his scenes of the French Revolution have the topicality of a newspaper headline, one would nonetheless expect this Royal Academician to place the events in a larger framework. To what categories of art could Zoffany turn for models? How do his paintings borrow from these models, and how do they depart from accepted conventions?

Wheatley's English Precedent

There was a precedent for understanding and visualizing what was taking place in France, and it is instructive to see how Zoffany's paintings differ from an earlier ambitious attempt to depict an urban mob. The Gordon riots that paralyzed London for over a week in June 1780 were the worst the city experienced in the eighteenth century. Opposed to the recently passed Catholic Relief Act, Lord George Gordon, a member of Parliament and the president of the Protestant Association, presented a petition in the House of Commons on June 2, 1780, to repeal the act's minor reforms. Despite the association's having marshaled a large demonstration in support of Gordon, Parliament refused to consider the anti-Catholic petition, and eventually the crowd dispersed. In the early hours of June 3, however, a group of protesters marched to the Sardinian Chapel in Lincoln's Inn Fields. The chapel was looted; its contents were burned in the street; and then the building itself was burned to the ground. The crowds wreaked havoc before the military restored order. Prisons were emptied, with many of their inmates joining the rioters. Roman Catholic chapels were favorite targets, as were the homes of prominent Catholics and of men such as Sir George Savile, Lord Mansfield, and Sir John Fielding, who either were considered too favorably disposed toward Catholic relief or were identified with unwel-

FIGURE 72
After Francis Wheatley, *The Riot in Broad Street on the Seventh of June 1780.*
Engraving by James Heath, 47.9 × 62.9 cm. (18¹¹⁄₁₆ × 24½ in.), September 29, 1790.
British Museum, London.

come authority. What began as a political demonstration, with the rallying cry of
"No Popery," soon became an excuse for destruction on a large scale.

Alderman John Boydell commissioned Francis Wheatley, who had been in
Dublin during the disturbances, to undertake a large canvas of a climactic episode.
Although the painting was destroyed in a fire while it was at the engraver's, Zoffany
was surely familiar with the print after it (Fig. 72). Wheatley shows the London Mil-
itary Association restoring order on Broad Street on the night of June 7. The mob
had attacked the house of a rich Irishman, Mr. Donovan, and after the volunteer
troops arrived, their commander, Bernard Turner, gave several commands for the
crowd to disperse before instructing his men to fire. Order was restored, with four
men killed and fifteen wounded.[1] Turner later told the court, "There were one or two
odd pieces of firearms among the mob at Mr. Donovan's house, but they were
chiefly armed with bludgeons, spokes of wheels and iron bars."[2] Wheatley shows the
looting confined to the one house, smoke rising from a bonfire of its contents piled

in the street. The members of the "mob" are not particularly sinister. In addition to the looters, there is a gin-soaked mother at left neglecting her children, and in the center one man is restrained from hitting a soldier. The symbolism of the globe about to go up in flames on the edge of the bonfire seems somewhat overwrought in light of the overall portrayal. A soldier even offers assistance to a fallen foe, and the discharge of only a single rifle is seen. This last detail matches the assertion of one of the volunteers: "We were very merciful to them by firing only one gun at once, instead of a volley, thereby giving time to many to get off."[3] Restrained authority is very much in charge.

Similarities between the Gordon riots and the *journée* of August 10 extended from the trivial, such as the protestors' wearing of cockades, to the more serious, such as the drunken excesses of the rioters, the looting, the general destruction of property, and the xenophobic attacks on foreigners, Roman Catholics in London and anyone who was Swiss, soldier or not, in Paris.[4] There are also major differences, the most significant being that the mobs during the Gordon riots targeted only the property, not the persons, of the opposition. According to one estimate, some 458 of the Gordon rioters were killed (some authorities would argue more); another 21 were later executed for their participation.[5] On the other side of the ledger, the number of those killed by the mob totals zero.

Wheatley's subject, a mob in action, is similar to Zoffany's, yet the two artists present their material differently. Zoffany's paintings explore a violent dimension undreamed of in Wheatley's comparatively tame, even innocent, portrayal. Wheatley interprets events to dispel anxieties about the breakdown in governmental control; Zoffany does so to arouse them. Wheatley's approach fits comfortably within the conventions of narratives of contemporary subjects, albeit here on an inflated scale, while Zoffany's images break new ground.

Contemporary History Painting

Taking for their subject matter scenes from one of the French Revolution's most celebrated *journées*, Zoffany's paintings are related to, though hardly identical with, the newly created genre of contemporary history painting. According to traditional academic theory, history painting and painting of contemporary life were mutually exclusive. History painting, art's most exalted category, took scenes from the Bible, from classical mythology or history, or from epic poetry for its subject matter. Its high-minded subjects demanded a heroic treatment drawn from an idealized past. The modern world, on the other hand, was too familiar and ordinary to allow for the distancing required by the grand style. It was a prime example of familiarity breeding contempt, and contemporary history painting was, from the conventional point of view, a contradiction in terms.

In his picture *The Death of General Wolfe* (Fig. 73), executed in 1770 and exhibited at the Royal Academy the following year, the American-born painter Benjamin

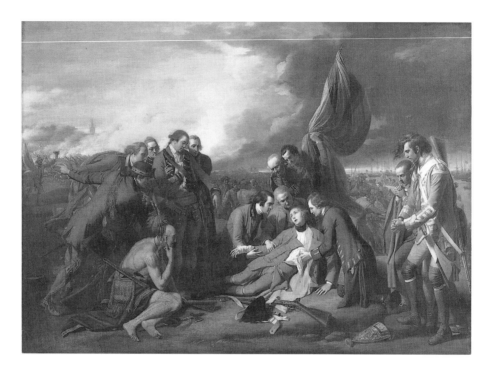

FIGURE 73
Benjamin West, *The Death of General Wolfe,* 1770. Oil on canvas, 1.5 × 2.1 m. (59½ × 84 in.). National Gallery of Canada, Ottawa.

West was the first to treat a modern subject in the grand style. He was not, however, the first to depict Wolfe's death, George Romney and Edward Penny having done so before him, but their more modest efforts should be termed narrative paintings.[6] Unlike them, West set out to monumentalize a contemporary subject in scale and composition, elevating it to high art by treating it in the exalted rhetoric formerly reserved for history painting. This work opened the door for a number of other painters, including his compatriots John Singleton Copley and Colonel John Trumbull, and was to have important repercussions in France, beginning with David's *Tennis Court Oath.*

Zoffany also attempted a contemporary history painting, his unfinished picture *The Death of Captain Cook* (Fig. 74), a canvas on which he was at work at almost the same moment he was fashioning his paintings of the French Revolution.[7] Following West's lead, he illustrates on a large scale and in heroic terms the death of a British military hero, relying on remoteness in place to compensate for proximity in time and exotic *mirabilia* to distance the image from mundane modern life.[8] Cook lies wounded in the center foreground. A nude warrior leans over him while a chief,

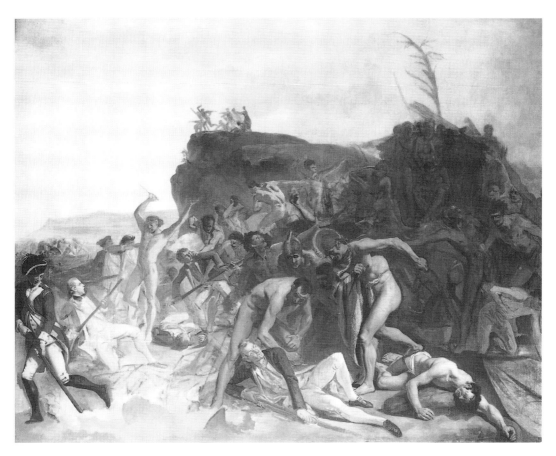

FIGURE 74
Zoffany, *The Death of Captain James Cook, February 14, 1779,* ca. 1795. Oil on canvas, 1.4 × 1.8 cm. (53½ × 71⁵⁄₁₆ in.). National Maritime Museum, Greenwich.

draped in a red ceremonial robe and wearing a red helmet, both trimmed in yellow, approaches from the right. The old king, whom Cook had attempted to bring aboard his ship as hostage for the return of a stolen boat, sits on the small hill to the far right, a stalk, perhaps the sugarcane his attendants were said to hold to shelter him from the sun,[9] waving over this close-knit group.

Just as West was not the first to depict Wolfe's death, Zoffany was hardly the first to depict Cook's,[10] but he again was the first to raise it to the level of history painting, elevating his subject by frequent quotations from classical sources, as sanctioned by high art. The two French Revolution pictures also depict contemporary subjects, but they take the viewer into a different world from that of *Wolfe* and *Cook,* or, as we have seen, from that of Wheatley's *Riot in Broad Street.* It is a world where the

macabre and petty overwhelm the heroic and grand, and for which there is little precedent in the conventions of high art.

The crowds that populate Zoffany's two depictions of the French Revolution exemplify coarse depravity. The English press often referred to the participants in the insurrection of August 10 as savages, much as Edmund Burke had earlier in describing the "mob" that escorted the royal family from Versailles to Paris.[11] A report from Paris of one of the encounters just prior to August 10 characterized some of the demonstrators as cannibals howling for blood,[12] and Twiss went even further in his remarks on the fate of some of the bodies burned on the tenth: "I was told that some of the women who were spectators took out an arm or a leg that was broiling, to taste: this I did *not see,* but I see no reason for *not believing it.*"[13] On August 17 the *Times*'s regular correspondent reported on "the cancer of civil discord":

> Who could have conceived that the present enlightened generation of France, so long the pride of their own country, so long the admiration of surrounding empires, should almost in a moment have fallen from the summit of polished manners to the savage wildness of untutored nature. But so the fact is. The gentleness of humanity has taken its flight, and barbarism usurped in its place.[14]

In an editorial published the next day, the *World* was even more incensed, contemplating the extermination of such a people: "The French are become worse than any savages which discovery has produced to the knowledge of this quarter of the Globe. The liberal and generous mind is almost, in its burst of indignation, led to wish, that the whole race of Frenchmen were exterminated, as a disgrace to the name of man."[15] For Zoffany, depictions of such wild savagery required a correspondingly savage style.

Zoffany's treatment of the South Sea "savages" in his painting *The Death of Captain Cook* makes a telling comparison with that of the Parisians, their "civilized" cousins. As Charles Mitchell has noted, Zoffany depicts the Hawaiians with noble dignity, basing some of their forms on classical prototypes.[16] For example, the pose and conception of the chieftain approaching the fallen Cook, who awaits the fatal blow in the center foreground, is based on a copy of Myron's statue Discobolus, well known to Zoffany because it was in his friend Charles Townley's collection, a collection, in fact, that he had painted. In addition, one of the warriors in the middle ground above the figures bending over Cook is modeled on the back view of the Belvedere Torso, while the figure beside him is modeled on a traditional pose for a god such as Zeus or Poseidon, with arms raised to hurl a spear or thunderbolt. These attacking natives are imbued with the ideal of the "noble savage" so popular in late-eighteenth-century thought. They are heroic examples of the natural man who shares an innate kinship with the idealized, high-minded figures of classical antiquity.

The Parisian "savages," in contrast, do not partake of this natural dignity. John

Williams, it will be recalled, had gone so far as to assert that in *Plundering* the "savage assemblage of monsters are denied the possession of human lineaments."[17] While he exaggerated, the bodies of these celebrants are indeed deformed in comparison with those of the Hawaiians, and their poses mock, rather than echo, the heroic examples drawn from the classical past. Whereas Zoffany calls attention to the similarity between the Discobolus and the Hawaiian chief in *The Death of Captain Cook,* he is more concerned with the differences between the awe-inspiring grandeur of Laocoön (Fig. 75), where the priest of Apollo provides an exalted image of divine retribution, and the puking black boy in *Plundering* (Fig. 76). The classical statue is monumental and heroic, an exemplum of official culture that authoritatively embodies "universal" values. The black boy is a grotesque inversion, the sublime individual literally having been removed from his pedestal, crumpled, and brought low. In another example of bathos, the heroic vigilance of Bernini's *David* (Fig. 77) becomes the ungainly tugging of a sansculotte at the wine basket (Fig. 78). Zoffany's use of body imagery reflects his class consciousness. Unlike the poses of the noble savages, those of the lower-class Parisians are deliberately awkward, expressive of an antiheroic aesthetic.[18]

Coincidentally, Theodore Price, a counterrevolutionary writer whose pamphlets addressed the English working classes, also compared the French to the Hawaiians. Writing in December 1792 in the character of Job Nott, a Birmingham buckle maker, Price has Nott balk at his employer's offer to teach him French: "Who in his senses would have any connection with such a nation, while rul'd by such bloody minded barbarians, why they are worse than the Antipoads that kill'd and chop'd our brave sailor Captain Cook to pieces."[19] Nott goes on to divide the world into two parts, those who read the Bible (i.e., English Protestants) and those who do not, either because they are not allowed (the Roman Catholics) or because they have none (the Hawaiians). Zoffany, however, instead of seeing only minor differences between the French and the Hawaiians, sees these cultures as polar opposites, a perspective that is again not meant to flatter the French.

Zoffany changes not only the body types and the way in which he poses his barbaric participants, but also the way he applies paint to canvas, emphasizing a coarse vigor over his usual polish. While it could be suggested that this crudity is the result of an unsteady hand, enfeebled by age and illness, one detects no such hesitancy in *The Death of Captain Cook,* executed at approximately the same time. The coarseness is deliberate. Zofanny's painting *Colonel Mordaunt's Cock Match* (see Fig. 4), executed for Warren Hastings in the mid-1780s, shows differences in treatment between the figures intended as portraits and some of those secondary figures of the surrounding crowd, the portraits being rendered with greater precision than the more broadly brushed attendants. In the two paintings of the French Revolution, the background figures, the *menu peuple,* have now taken over, and Zoffany employs a rougher, "degraded" style to depict them.[20]

In his play with scale in his two paintings, Zoffany also exhibits a deliberately ex-

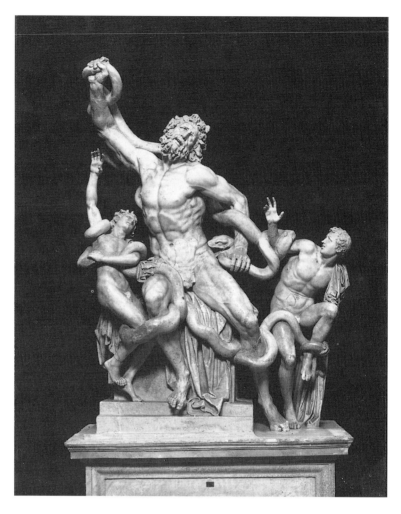

FIGURE 75
Laocoön. Marble, approx. 2.4 m. (7 ft.
10½ in.) high. Musei Vaticani, Rome.

pressive crudity. For example, the duc d'Orléans and the men directly beside him in *Celebrating* (see Fig. 67) tower over the figures in front of them, just as the sansculotte in the center of *Plundering* is oversize in comparison with most of the other figures. Thus size partly determines importance and emphasis, the artist unwilling to limit himself to strictly rational proportions.

As in contemporary history painting, Zoffany's two canvases focus on a momentous event: indeed the subject must be an extraordinary one to warrant an elevated treatment. But what if the subject is extraordinary only for its horror and degradation? What happens when the historical event to be depicted is one of de-

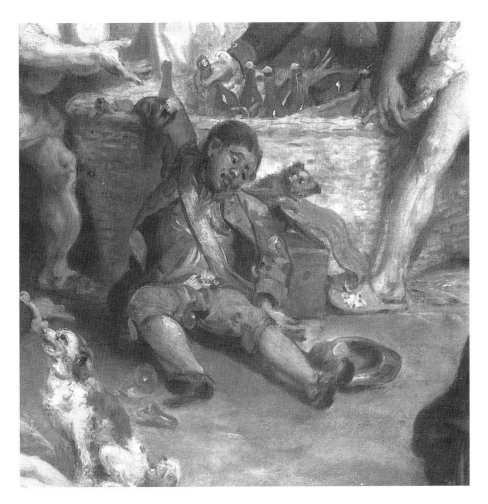

FIGURE 76
Detail of Plate 1.

spicable outrage rather than ennobling action? The painful distance between the heroic world of productions such as West's *Death of General Wolfe* or Zoffany's own *Death of Captain Cook* and these Francophobic scenes of the French Revolution is all too apparent. Coarse and barbarous, these latter paintings represent the obverse of the noble grandeur extolled in contemporary history painting. But this ignoble world does not challenge its dignified counterpart; rather the antitheses proves the validity of the thesis. Zoffany creates two antiheroic or antithetical contemporary history paintings that demonstrate, rather than undercut, the need for maintaining the heroic standards of the grand manner in modern life.

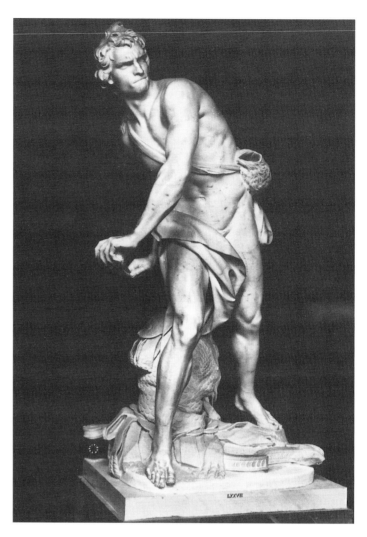

FIGURE 77 (*above*)
Bernini, *David*. Life-size marble, 1623–24.
Galleria Borghese, Rome.

FIGURE 78 (*opposite*)
Detail of Plate 1.

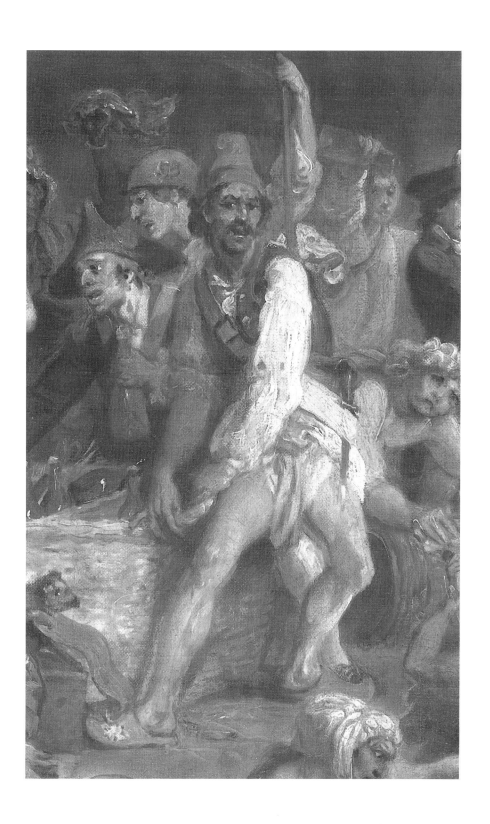

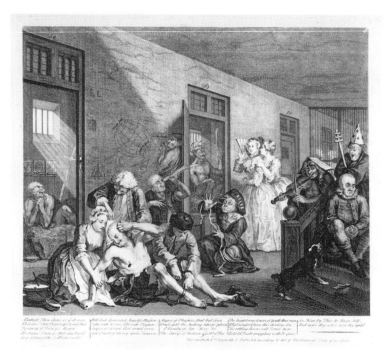

Remedying Hogarth's "Flawed" Example

From the beginning of Zoffany's English career, Hogarth had proved a strong influence. The German artist's choice of conversation pieces and theatrical conversation pieces as subject matter, as well as his treatment of these subjects—multiple figures, narrative incidents that are psychologically insightful, and animating brushwork—all show his indebtedness to Hogarth's example. In offering his version of contemporary events as they had unfolded during the French Revolution, he can also be seen to revert to Hogarth's style, one suitable for genre scenes that focus on the lower classes. It is not surprising that both Zoffany's contemporaries and modern critics have cited Hogarth as a source of inspiration for *Plundering*.

The two contemporary reviewers whose analyses of *Plundering* I have already quoted both invoke Hogarth, the critic for the *Morning Chronicle* noting that "some of the characters bear a striking resemblance to characters we have seen in HOGARTH" and John Williams finding that in conception Zoffany "evidently labours to tread in the steps of Mr. Hogarth."[21] In individual details, Hogarth's influence extends to *Celebrating* as well. Both paintings, for example, quote from figures in the eighth and last plate of *A Rake's Progress* (Fig. 79). The woman being robbed and murdered in the center foreground of *Plundering* (Fig. 80) echoes the figure of the mad Rakewell in Hogarth's design,[22] and the woman with the fan in front of her face in *Celebrating* (Fig. 81) is reminiscent of the woman who pretends to shield herself

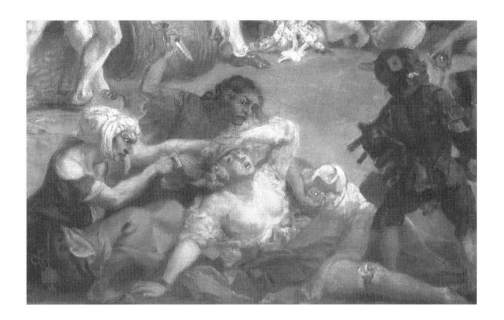

FIGURE 79 (*opposite*)
William Hogarth, *A Rake's Progress,* 8.
Engraving, 35.6 × 41 cm. (14¹/₁₆ × 16¹/₈
in.), Second State, June 25, 1735. British
Museum, London.

FIGURE 80 (*top of page*)
Detail of Plate 1.

FIGURE 81 (*above*)
Detail of Plate 2.

FIGURE 82
After William Hogarth, *The March to Finchley.* Engraving by Luke Sullivan
with retouching by Hogarth, Eighth State, 43.2 × 55.9 cm. (17¹/₁₆ × 21¹⁵/₁₆
in.), December 1750. British Museum, London.

from the sight of obscene male nudity when in reality she is titillated by the spec-
tacle. Hogarth's subject is a madhouse, and Zoffany wants his viewer to make this
connection with his paintings, the area around the Tuileries Palace having become
an outdoor insane asylum.

Zoffany's conception is reminiscent of Hogarth in the use of multiple figures en-
gaged in a variety of activities. The viewer is invited to scrutinize each character for
his or her story. Ronald Paulson appropriately compares *Plundering* to Hogarth's
March to Finchley (Fig. 82), which shows soldiers and civilians carousing together.[23]
The March to Finchley is an example of what Hogarth describes as his "modern moral
subjects" (for other examples see Figs. 79 and 86) and what his friend Henry Field-
ing called "comic history paintings." By including the word "moral" in his phrase,
Hogarth identifies his work with the moral purpose underlying high art, but still the
word "modern" signals the insuperable distance, as does Fielding's inclusion of the

word "comic." No matter how serious Hogarth's themes and purposes, his humorous presentation would never be confused with that of a Michelangelo or a Poussin.

It is in Zoffany's differences from Hogarth that his purposes again become clear. Whereas Hogarth's *March to Finchley* evokes the viewer's mirth, Zoffany's *Plundering,* as described by one reviewer, "is too horrid to be contemplated."[24] Zoffany is critical of the conceptual basis underlying "comic history painting," which, in showing how modern man falls short of the heroic standards of history painting, also suggests that those standards are becoming increasingly irrelevant to modern life. He does not feel any of Hogarth's ambivalence toward these high-minded values. His paintings are deadly serious in expressing righteous indignation. As we have seen, antiheroic contemporary history painting fully embraces the positive pole for which it is the negative. Whereas Hogarth's "modern moral subjects" assert the inappropriateness of the grand manner to depictions of contemporary life, Zoffany's antiheroic paintings offer a counterpoint to the adoption of the grand manner in scenes of modern life.

Zoffany actually includes Hogarth in his painting *Plundering,* in a reference not meant to be flattering. As Paulson points out, the figure angrily gesturing over the basket of wine bottles (Fig. 83) "bears a striking resemblance to the best-known contemporary likeness of Hogarth,"[25] that of the self-portrait in the 1748 painting *The Roast Beef of Old England,* which enjoyed wide circulation in the print after it (Fig. 84). Zoffany's characterization is one more in a long line of caricatures based on this image, many of which are by Paul Sandby,[26] and, like his predecessors, he delights in distorting Hogarth's stocky frame, showing him in this instance as a hunchback with a prominent goiter.[27] He also shows him wearing a bowl with an indented rim (it hangs from a cord around his neck) and a scabbard or sheath with three protruding handles. As can be seen in a print by Cornelis Dusart of 1695 (Fig. 85), where a buffoonish surgeon works on a man's arm, with his scabbard for lancets and scalpels hanging from his waist and his notched bleeding bowl resting on the window ledge beside him, these items identify Hogarth as a barber-surgeon.[28] In casting England's most famous satiric artist in this role, Zoffany returns to a standard Renaissance analogy in which "the satirist's most common metaphorical pose was that of the barber-surgeon."[29] As pointed out by Mary Claire Randolph, this association of satiric theory with medical imagery was double-edged: while the satirist could metaphorically flay, cut, bleed, and purge his subject to effect a cure, there is also an older tradition where he intends "to destroy his victim, flesh, bone, nerve, and sinew."[30] Hogarth as a barber-surgeon would rather quarrel with than assist those who require his skills. His brand of satire leads literally to a bloodbath. In addition, by presenting Hogarth as afflicted, Zoffany is perhaps also alluding to the proverb Physician, heal thyself.

Presumably Zoffany makes Hogarth shoulder some blame for the criminal conduct of the lower classes because he had portrayed them so sympathetically,

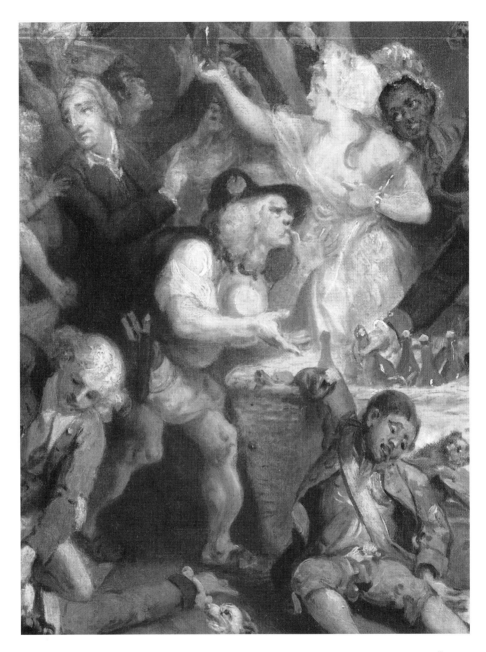

FIGURE 83
Detail of Plate 1.

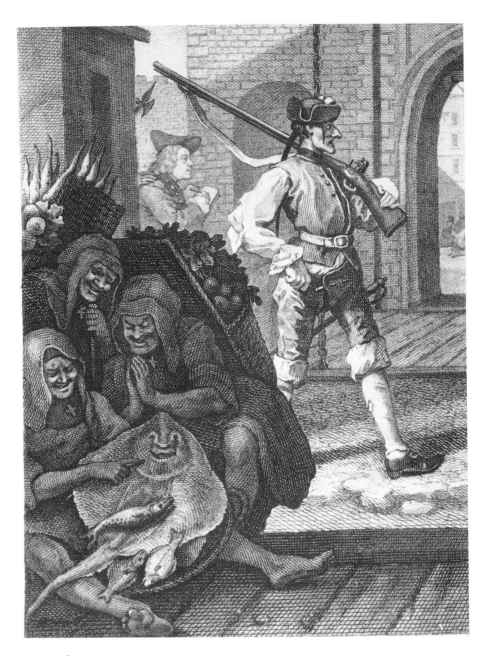

FIGURE 84
William Hogarth and C. Mosley, detail of *The Roast Beef of Old England.*
Engraving, 38.2 × 45.7 cm. (15¹¹/₁₆ × 18 in.), March 1748/49. Tate Gallery,
London.

HEELMEESTER

De duyvel Meester Hans, is dat myn arm verbinden:
Riep Teuwes, op die schreeu trok Griet een scheve bek.

Je praat ze, wat zei Hans, ik moet het kwaad eerst vinden,
Zal ik 't geneezen. wel hoe baarje, ben je gek.?
A.B.

thereby encouraging their unruly behavior. In a print such as *Noon* (Fig. 86), a gutter divides the boisterous and undisciplined figures on the left, engaged in eating and drinking, from the better-behaved parishioners, elegantly attired in French fashions, exiting the chapel on the right. The two worlds are clearly demarcated, but Hogarth, if anything, makes the life on the left more attractive than that of the mincing and deformed figures on the right. The black servant and the beautiful maid with the overflowing pie dish make a far more appealing couple than the two old women kissing at the right. It is just these *menu peuple,* including blacks and lower-class women, who are most culpable in Zoffany's French Revolution pictures.[31] Hogarth's celebration of the *menu peuple* over the French refugees on the right may have made

FIGURE 85 (*opposite*)
Cornelis Dusart, *The Village Surgeon.*
Etching, 26 × 18 cm. (10¼ × 7 in.), 1695.
Philadelphia Museum of Art: Charles
M. Lea Collection.

FIGURE 86 (*above*)
William Hogarth, *Noon.* Engraving,
First State, 48.7 × 40.6 cm. (19³⁄₁₆ × 16
in.), March 25, 1738. British Museum,
London.

him, for Zoffany, a radical sympathizer decades before the slogan Liberty, Fraternity, and Equality had been coined.

Zoffany may have introduced himself into his painting *Celebrating* as the old man (Fig. 87) positioned above and to the right of the *fédéré* about to strike a kneeling mother. Because this figure is small and sketchily rendered, any identification is tentative, but late self-portraits show the artist with the same bald crown and with long hair bunched on the sides. Furthermore, he is accompanied by a well-dressed woman wearing a bonnet and carrying a green parasol, who, given their discrepancy in age, could easily be Mrs. Zoffany.[32] The man, like the priest to his left (see Fig. 65), has either a thumb or a finger in his mouth, a gesture of nervous anxiety that perhaps also hints at defiance, since it refers back to Hogarth's combative pose in *Plundering.* If this is a self-portrait, Zoffany surely intended it to be seen as in opposition to Hogarth's image: if the catastrophe of riot and revolution is in part Hogarth's fault, he will now set it right.

The Crowd in Satiric Prints and Festival Imagery

Zoffany, as we have seen, also turned to the political caricaturists for inspiration, artists such as Gillray, Rowlandson, and Isaac Cruikshank, who, in their turn, had built on Hogarth's example. His indebtedness to the traditions of political satire, however, has more to do with the appropriation of specific details than to his over-

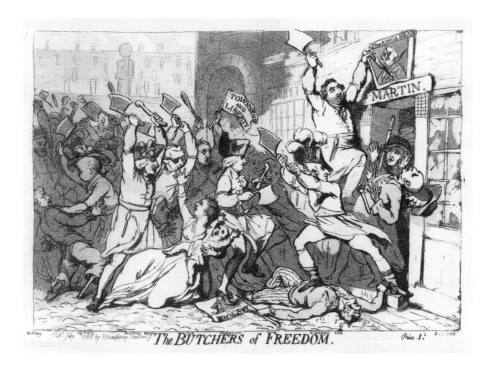

The BUTCHERS of FREEDOM.

FIGURE 87 (*opposite*)
Detail of Plate 2.

FIGURE 88 (*above*)
James Gillray, *The Butchers of Freedom*. Etching and aquatint, 23.2 ×
34.3 cm. (9⅛ × 13⁷⁄₁₆ in.), July 1788. British Museum, London.

all conception. In her chapter "The Crowd in Caricature," Diana Donald writes of
eighteenth-century satiric prints that "again and again, they take as their subjects the
democratic equality of the streets, the licensed pandemonium of elections, the re-
laxed mingling of different social ranks in public resorts. Above all, satire celebrated
the individualism and absurd eccentricities of the English—caricature functioned as
self-congratulation."[33] When the crowd became a "mob," however, political satire
entered unfamiliar territory: "There was . . . no appropriate mode in which to pic-
ture such a confused, unprecedented and disturbing phenomenon as the political
crowd in violent insurrection on the streets. Especially was this true of the Gordon
riots, which challenged rather than affirmed the libertarian attitudes of the period."[34]
In the decade following these riots, political caricaturists were more likely to show
authority trampling or impinging on the traditional rights and liberties of the Lon-
don crowd,[35] but James Gillray's *Butchers of Freedom* (Fig. 88), a glaring exception
published in July 1788, depicts a mob wielding cleavers in murderous support of its
candidate, Lord John Townshend. At the upper right, with his cleaver breaking the
picture frame, Charles James Fox, the leader of the government opposition, vigor-

ously lacerates an image of the king, while in the left foreground, Richard Brinsley Sheridan and Edmund Burke even prepare to strike a defenseless mother and child.[36] Although there were melees involving the supporters of the two candidates, Gillray's depiction of these distinguished gentlemen rampaging in the streets is entirely fictitious, making it permissible for him to indulge all the more in wild imaginings. But after 1789 such imagery of lawless carnage cut too close to the bone and was better left unexpressed. In the 1790s, as Donald points out, prints seldom portrayed the actual mass meetings or riots spawned by artisan- and laboring-class political activism: "As the labouring class began to flex its political muscle for the first time in earnest so, paradoxically, the exuberance of the English crowd and the free mingling of the ranks lost their popularity as artistic subjects."[37]

When Zoffany was at work on his two canvases, the English satirists were equally reticent about showing French mob scenes. Gillray again comes closest to anticipating Zoffany's images in a print contrasting a happy, fecund, rural English scene with an urban French mob, whose participants are about to violate a beautiful woman, stab her elderly father, and brain a priest with his own sacred objects, after having already skewered two infants. But Gillray's print remained unfinished, presumably rejected by its sponsors.[38] Rather than avoid such uncomfortable subject matter, Zoffany squarely confronts it. Unlike the political satirists, moreover, he was not confined to a topical subject: he could afford to exhibit in 1795 a moment that had occurred in 1792. He also stands alone in attempting such imagery in oils on canvas. In this context there is a question of appropriateness or, as Zoffany's contemporaries would have phrased it, of decorum. It is one thing to satirize the "mob" in political prints, quite another in painting. Furthermore, in their exaggeration, the political caricatures of Gillray *et alii* are leavened with humor. The comedy may indeed be macabre, but it was wryly humorous nonetheless. Again Zoffany stands alone in the grim seriousness of his response.

Another type of picture to which Zoffany's paintings are related is genre scenes of fairs and festivals.[39] In its reporting, the journal *Révolutions de Paris* had instinctively compared August 10 to a holiday: "Tous les travaux interrompus, le commerce suspendu, les atteliers deserts comme dans un jour de fête" (All work ceased, business suspended, shops deserted as on a holiday).[40] Images of carnival, the traditional time for the suspension of hierarchies and prohibitions, are related to the theme of the topsy-turvy world, and such imagery may indeed underlie Zoffany's conception. But traditionally these scenes of debauchery and excess, where moralizing is cast in a comic mode, are understood to depict moments of short duration that are interpreted benignly as therapeutic and regenerative. Such carnivalesque imagery is about challenging and inverting authority in a celebration of change and renewal. Zoffany's conception is about carnivalesque man gone mad, a "festival" where role reversals reflect only the substitution of evil for good.

Although Zoffany's paintings depict a contemporary event, they differ from the genres of comic history painting, political caricature, and scenes of grotesque cele-

bration. While indebted to these types, they are ultimately more in tune with the conventions of high art, showing the reverse side of the heroic world of contemporary history painting. In these two paintings, Zoffany, who was only thirteen years older than Goya, anticipates the work of this Spanish master, who responded with equal vehemence to the horrors spawned by revolution, though with a nihilistic despair not found in Zoffany's work. But both artists stretched and reconfigured the conventional boundaries of art to express profound reactions to the new, alienating historical forces engulfing Europe.

6

COUNTERREVOLUTIONARY PROPAGANDA

Zoffany's Audience

In executing his two pictures, Zoffany pursued a clear motive: he attempted to paint the meaning, as he perceived it, underlying the events of the French Revolution, an explanation of both its causes and the conduct of its perpetrators as well as its relationship to the nation's social fabric, to its claims as a civilized state. Yet for whom were his pictures intended?

In their biography of Zoffany, Manners and Williamson paraphrase a comment made in the *Morning Herald* when *Plundering* was on exhibit at the Royal Academy: "It was painted in accordance with a very broad hint given to Zoffany by the Royal family and was intended as a sort of moral lesson or warning."[1] In a footnote the authors immediately offer the disclaimer that "there is little or no evidence for the accuracy of this statement."[2] Having enjoyed early in his career a close relationship with the royal family, Zoffany might well have hoped to ingratiate himself again in the 1790s. But whatever the role of royalty in the genesis of these two works, the paintings themselves convey such a sense of personal outrage, such a carefully articulated polemic, that Manners and Williamson are surely correct in discounting as their purpose that they were merely to please the powerful. That *Plundering* and, by extension, *Celebrating* were "intended as a sort of moral lesson or warning," however, is entirely convincing. But again the question arises, Who was being warned? Zoffany's paintings are about the French, but his primary audience was English. In these paintings, he held up a mirror to the English public, reflecting back what it could become should it foolishly follow the French example.

Zoffany's canvases are a continuing part of the loyalist campaign in England against republican reforms.[3] This campaign, though orchestrated by the government, also reflected the sentiments of the majority and produced a genuine outpouring of patriotic feelings. The conservative reaction found its voice with the Royal Proclamation against Seditious Writings and Publications issued on May 21, 1792, which invited the public to serve as watchdogs against treasonous activities.

In response to August 10 and the September massacres the government's efforts

against the reformers began in earnest. The nation itself was galvanized to fight against French infection. To counter the radical organizations, the Association for the Preservation of Liberty and Property against Republicans and Levellers was founded in November 1792. This association, with government support, mounted a patriotic defense of the constitution against reformers, whom it viewed as enemy collaborators. Part of its strategy was to employ caricature in the service of its reactionary ideology, commissioning and ensuring wide distribution of counterrevolutionary, propagandistic prints (for examples, see Figs. 57, 58, 89, and 90).[4] The French declaration of universal revolution of November 19, 1792, which promised assistance to any country wishing to overthrow an oppressive government, added fuel to the fire. In December 1792 an English court found Thomas Paine, who had escaped into France, guilty in absentia of seditious libel. When France declared war on England and Holland on February 1, 1793, many Britons saw the struggle, not just as a fight against another state, but as an ideological crusade against poisonous republican ideals that threatened English liberties as embodied in its constitution, the product of tradition and experience rather than sterile, abstract reasoning. The English already had a long tradition of Francophobia, but French culture and thought were now more feared and reviled than ever before.

In March 1794 the government called for volunteers for home service in response to fears of an impending invasion by the French and also to foil any revolutionary activities that English sympathizers might plan. The concerns over these external and internal threats to national security also prompted the government in May to seize several prominent citizens, who were charged with treason. If one recalls that the print after *Plundering* bears the publication date January 1, 1795, and Joseph Farington reported seeing Zoffany at work on *Celebrating* in August 1794, it seems plausible that Zoffany began his paintings around this time of heightened anti-French hysteria in the spring of 1794.

Zoffany's paintings support the ongoing campaign on behalf of England's status quo. The French government, recognizing the persuasive value of art, had long seen painting as fulfilling a political function. State support had been a well-established feature of the ancien régime, and the republican government funded the production of prorevolutionary subjects.[5] The word "propaganda,"[6] originally coined as a religious term, came to have a political meaning as well at this time, when the English used it to characterize the proselytizing zeal of the republicans.[7] From its founding in 1768, the English Royal Academy, as its name indicates, had received George III's support, but the British government had no tradition of state patronage comparable to that of the French. In creating his canvases, Zoffany acted as a private citizen. In a sense his paintings can be seen as part of the conservative propaganda intended to counteract that of republican France, albeit on a far more personal and imaginative level than the imagery engendered by such agencies as the Association for the Preservation of Liberty and Property against Republicans and Levellers.

Plundering and *Celebrating* were not the only pair of paintings Zoffany thought of executing as a commentary on contemporary social upheavals. On December 14, 1794, Joseph Farington recorded a tantalizingly brief account of two other works that Zoffany had mentioned to Nathaniel Marchant, the gem engraver and medalist who was at that time an associate member of the Royal Academy: "Marchant, came in the evening. He dined today with Zoffany, who has begun two pictures, the subjects *Peace & War*. He [Zoffany] likes the Idea but not Hodges manner of treating the subjects."[8] Farington's allusion is to William Hodges's two landscapes, *Peace, Exemplifying the Happy State of England in the Year 1795* and *War, Shewing the Misery of Internal Commotion,* the first depicting a happy and prosperous view, the second showing the same scene with the ruinous effects of war.[9] These large pictures, first conceived in May 1794, were the primary focus of a one-man exhibition that Hodges opened at Mr. Orme's Room, 14 Old Bond Street, on December 1. Although intended to run for three months, the exhibition was closed on or around January 26, 1795, when Frederick, duke of York, took offense at the subject matter, which he felt reflected democratic principles.[10] Apparently, this royal prince, who had recently suffered defeat at the head of the British army in Flanders, thought the contrast smacked of defeatism.[11]

James Gillray, presumably inspired by Hodges's example, issued his print *The Blessings of Peace / The Curses of War* (Fig. 89) on January 12, 1795. His contrast of the contented domesticity of an English family with the calamity imposed on a Continental family by the marauding French army supports the English government's campaign against its republican enemy. The scenes appear in adjoining circles, a format that resembles a map showing the two hemispheres that together offer a choice of global views.[12] Exactly what Zoffany intended in his projected pair cannot now be known, but like Gillray's example, his pictures, one suspects, would have unambiguously proclaimed traditional English values. The lack of such subjects in his posthumous sale suggests that he abandoned this project at an early stage, but he did continue to support conservative causes, for he appeared in the List of Subscribers to the 1798 English edition of the highly sympathetic account of the last days of Louis XVI written by his valet de chambre.[13]

While Zoffany responded strongly enough to Hodges's didactic premise to contemplate his own interpretation of pendants showing peace and war, *Plundering* and *Celebrating* constitute his major statement on the conflict arising from the French Revolution. But with the purpose of this pair to indoctrinate, why did Zoffany complete only one of the two works? Having addressed the principal issues in *Plundering,* he must have found it difficult to summon the energy to complete its pendant *Celebrating,* a work that, lacking the dynamic architectural backdrop of the first, is less successful in composition. Perhaps, however, the question is best phrased the other way around: How was he able to complete either? These works were conceived when he was semiretired; other ambitious pictures, such as *Peace* and *War,* may never have gotten beyond the most elemental planning stages,

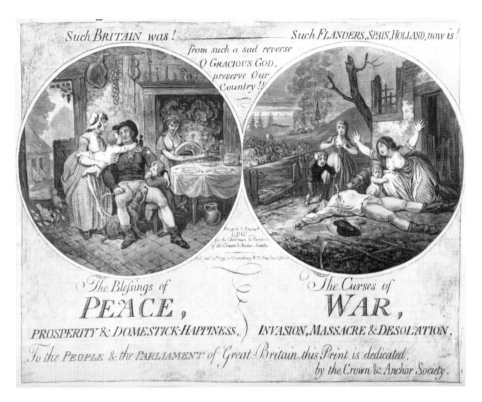

FIGURE 89

James Gillray, *The Blessings of Peace / The Curses of War*. Etching and aquatint, 28.9 × 36.2 cm. (11⅜ × 14¼ in.), January 12, 1795. British Museum, London.

and even his *Death of Captain Cook* remained unfinished. Zoffany must have cared passionately about the subject matter of *Plundering* and *Celebrating* in that he completed and exhibited one of the pictures as well as having Earlom execute a print after it, a rare example of a print that the artist published himself. In addition, this mezzotint is unusually large: of the 492 works appearing in Wessely's catalogue of Earlom's prints, only one is larger.[14] Surely the artist was fiercely intent on getting his message across.

In his influential book *The Structural Transformation of the Public Sphere: An Inquiry into a Category of Bourgeois Society*, Jürgen Habermas supplies a helpful perspective from which to assess the audience Zoffany was attempting to address. Habermas demonstrates how in the eighteenth century the formation of a bourgeois public sphere created new forms of political discourse in the capitalist economies of major urban centers. Increasingly, the state's authority came to be identified, not with the king, the representation of absolutism, but with a state bureaucracy, responsive to the new phenomenon of public opinion. Public opinion itself had arisen as newspapers, journals, coffeehouses, clubs, and other public spaces gave pri-

vate persons forums in which to debate public issues. Whereas the authoritative state had operated in secrecy, the bureaucratic state needed to publicize its deliberations to counter the negative publicity generated by its opposition.

The rational-critical public debate of private persons—a reasoned effort to discover fundamental, universal truths—added an important dimension to political and civic discourse. If the rhetoric of such debate emphasized rational discourse and the equality of the debaters, in reality only educated individuals possessing property could participate. Women were excluded de facto from the debates because of their exclusion from many of the spaces where such debates took place. Zoffany, however, participated actively in a number of these forums, frequenting such male bastions as the coffeehouse and the Masonic lodge, where he could engage in social and political intercourse on equal footing with the nobility. At the annual exhibitions of the Royal Academy, moreover, artists as private persons could exhibit works that formed part of the public political discourse. Zoffany's message may have been reactionary, but his methods were highly progressive. In his painting *Plundering the King's Cellar at Paris* and the print after it, he addressed the public sphere made up of propertied, educated males, intending, in doing so, to help formulate, as well as support, state policy. Although the account in the *Morning Herald* suggests that Zoffany's exhibited work addressed the court at Windsor, its audience was rather the court of public opinion.

Solidarity

By its nature, political caricature is topical, conveying the freshness of a newspaper headline. Whereas August 10, 1792, was immediately recognized as one of the Revolution's most important *journées,* it had little impact on the arts in England, for the September massacres and the beheading of the king soon followed. The design that the amateur caricaturist John Nixon submitted to the Association for the Preservation of Liberty and Property against Republicans and Levellers in December 1792, subsequently etched by Thomas Rowlandson (Fig. 90), is one of the few works to depict August 10, though only as a part of the background.[15] This *journée*, which, Nixon wrote, "will ever remain a Stigma on the Annals of France,"[16] is rendered as a performance held in a church that has been converted into a theater. Above the cathedral's west entrance is a sign on a balcony labeled "THE MASSACRE AT PARIS," with a large-eared fool presiding over it. Two other figures on the balcony call attention to a banner showing Punch basting a roasting monk beneath the inscription "Religion, A Farce."[17] Although these elements point to the French attack on religion, August 10, 1792, also reminded Zoffany's contemporaries of the Saint Bartholomew's Day massacre of August 24, 1572, when Catholics murdered Huguenots, and in his sign above the door of the "theater" Nixon presumably echoes *The Massacre at Paris,* the title of Christopher Marlowe's Elizabethan play that dra-

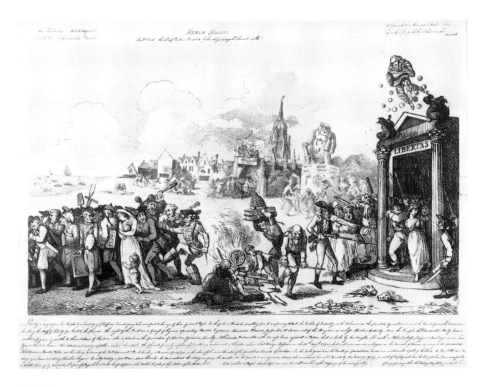

FIGURE 90
Thomas Rowlandson, after John Nixon, *French Liberty.* Hand-tinted proof etching, 35.8 × 56.2 cm. (14³⁄₁₆ × 22⅛ in.), ca. December 1792–summer 1793. British Museum, London.

matizes the earlier episode. The English press had already linked the two events, as in the following passage: "On this day [August 10], as upon the ever-memorable massacre of St. Bartholomew, the wanton acts of cruelty upon unarmed and defenceless individuals, excite more horror, and are more disgraceful to human nature, than the general transaction itself."[18] Such an association serves as a reminder that such violence was nothing new in Europe,[19] and one could even point to parallels between the duke de Guise, Marlowe's villain, who instigates the massacre to gain control of the throne and eventually dies because of his own murderous conniving, and the role of the duc d'Orléans in Zoffany's interpretation of contemporary events. While the Saint Bartholomew's Day massacre was only the most famous of many bloodlettings perpetrated over a long period by both sides, Protestant England was concerned only with Catholic atrocities.

Zoffany, who although a member of the Church of England was presumably still at heart a Catholic or, at the very least, sympathetic to Roman Catholicism, had little incentive to connect the events of 1792 with those of 220 years earlier. But he presumably had had firsthand experience with "mob" violence in the Gor-

don riots of 1780, and such an encounter so close to home must have helped to shape his reactions. One can sense some of the consternation felt by members of the foreign community of artists then in London in an account written years later by Stephen Francis Dutilh Rigaud, the son of the Royal Academician John Francis Rigaud:

> They [the rioters] proceeded to commit the most lawless acts of violence and incendiarism, destroying Newgate, the Sardinian Ambassador's Chapel in Lincolns Inn Fields, and various other buildings public and private; and threatening to burn every house inhabited by Roman Catholics: in short, for a whole week They remained masters of the Metropolis. It was an awful time for the public in general, but particularly for the poor Roman Catholics, and those supposed to be such. . . . I also remember seeing a cross marked with white chalk on my fathers (street) door, supposing from the foreign name that he was a Roman Catholic; and Mr. Pastorini, who really was one, and who lived the other side of the way in the same street, coming over to consult with my father on what was best to be done for he had a similar mark on his door, which doomed them both to destruction. They determined to be as quiet as possible, but as soon as it became dark, to wash off the marks from their doors.[20]

Zoffany's house in Albemarle Street may well have been targeted in the same manner, and to his fears of personal safety would have been added the stress of seeing the destruction of the Sardinian Chapel, the very building in which, at least at one time, he worshiped.

Protestantism lay at the core of England's sense of national identity, and Zoffany's taint of Roman Catholicism, more than his German birth, prevented him from participating fully in this shared purpose. The Gordon riots would have reminded him of his status as an outsider, if any reminder were needed. While many of the English saw the massacres of 1792 as continuing Catholic France's bitter legacy of bloody persecution, Zoffany, by way of contrast, depicts the *menu peuple* attacking religion itself. His inclusion of a Jewish clothesman's desecration of the Host links the mob's actions to the anti-Semitic fables of his youth, a tradition older than the battle of Catholics against Protestants. He shows the mob's conduct as a continuation of the sacrilegious assaults on society's most sacred beliefs. In stressing the conduct of debauched atheists against Christians instead of echoing past atrocities of Catholics against Protestants, Zoffany could include himself in the English response to this new French villainy.

Defining Equality

The first article of the Declaration of the Rights of Man and of the Citizen, adopted by the French National Assembly on August 26, 1789, declares in imitation of the

American Declaration of Independence, "Les hommes naissent et demeurent libres et égaux en droit" (All men are born and live free and equal in rights). For English conservative ideology this equality constituted the Revolution's gravest threat. Conservatives interpreted equality, not as an affirmation of uniform treatment under the law, but as an overturning of existing social hierarchies. George Huddesford's anti-republican verse, which went through two editions in 1793, takes this traditionalist approach:

> For EQUALITY, WELL UNDERSTOOD,
> MEANS TO TURN ALL THE WORLD TOPSY-TURVY.[21]

An anonymous English author who had been in Paris on August 10 offered a similar caution: "Let the People be upon their guard, to avoid the malicious doctrines of those, who, by spreading the levelling principle of absolute *Equality,* endeavour to stir up in them the passion of *Envy;* which would destroy their own peace, and at the same time the peace, order, and existence of Civil Society."[22]

In the world Zoffany depicts, equality has led to the reversal of hierarchies, the lower classes having usurped the power that belongs by right to their "betters." The unruly women in the image belong to the traditional imagery of the world turned upside down, where, in an inversion of the "natural" order, women assume command. The opening paragraph to Natalie Zemon Davis's 1975 essay "Women on Top" effectively encapsulates the threat of women's assertiveness, so much more fundamental than that of men:

> The female sex was thought the disorderly one par excellence in early modern Europe. . . . Female disorderliness was already seen in the Garden of Eden, when Eve had been the first to yield to the serpent's temptation and incite Adam to disobey the Lord. To be sure, the men of the lower orders were also believed to be especially prone to riot and seditious unrest. But the defects of the males were thought to stem not so much from nature as from nurture: the ignorance in which they were reared, the brutish quality of life and conversation in the peasant's hut or the artisan's shop, and their poverty, which led to envy.[23]

The participation of women in political life alarmed the majority of Englishmen.[24] They had already reacted against the increasing involvement of women in the public sphere when Georgina, the duchess of Devonshire, was attacked in numerous prints for her unseemly audacity in campaigning for Charles James Fox in the Westminster election of 1784. One (Fig. 91) shows her usurping the masculine role while her cuckolded husband, the duke, is left to manage domestic affairs.[25] The duchess's phallic staff, with Fox's head and two foxtails on it, eerily foreshadows Rowlandson's later image of French Liberty (see Fig. 57). From the conservative point of view, the French Revolution only made more emphatic the dangers of female participation in

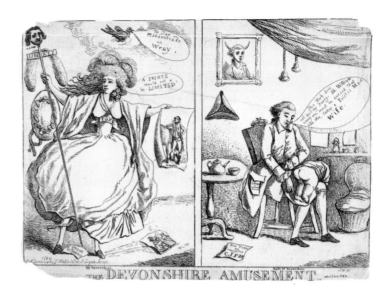

FIGURE 91

J. M. W., *The Devonshire Amusement.* Etching, 25.1 × 36.2 cm. (9⅞ × 14¼ in.), June 24, 1784. British Museum, London.

public life—as we have seen, the French republicans themselves resisted the participation of women in public affairs, moving in 1793 to curtail their activities and suppress their organizations. The Revolution fought in the name of Liberty and Equality did not extend citizenship to females, the other element of the revolutionary litany—Fraternity—already suggesting their exclusion. Outside their preordained private, domestic sphere, women created anxiety in males across the political spectrum.

In the contrast between his treatment of women in the French Revolution with that of women in *The Death of Captain Cook* (see Fig. 74), Zoffany makes explicit what social organization he considers natural and right. The Hawaiian women, living in a state of nature, passively observe the war-making activities of the men. The woman standing beside the seated chief Terreeoboo on the ledge at the upper right is a serene Venus witnessing the attack. In the artist's eyes the more barbaric culture is that of Paris, where women zestfully assist the men in accomplishing bloody deeds. The Hawaiians, moreover, have carefully distinguished hierarchies, whereas the Parisians are a rabid mob of leaderless men and women. The duc d'Orléans appears in *Celebrating* only as a clandestine instigator of anarchy. Whereas Zoffany's *Death of Captain Cook* shows noble savages instinctively organizing their culture around the principles of subordination by social rank and by gender, his two paintings of the French Revolution show a topsy-turvy world where the "rightful" hierarchies have been reversed.

Just as the dominance of women signals the reversal of the "natural" hierarchy, so does the participation of blacks.[26] If a well-regulated society as defined by con-

servative ideology subordinated women to men, then one that still condoned the en-slavement of one race by the other vehemently insisted on subordinating blacks to whites. Some English conservatives connected the events of August 10 and the subsequent September massacres in France with the push for the abolition of the slave trade in England. As asserted in the *Oracle* of September 13, 1792, the political and social trauma created by the Parisian revolt discredited the notion of equality that was the basis of the antislavery campaign:

> SLAVE TRADE.—The zealots for Abolition *here,* have been defeated by the ill-timed wickedness of their brethren in FRANCE.—Men of all ranks now readily rend the imposing veil of false Philanthropy, in which these men have wrapped themselves; and discern, under the sanctimonious covering, a view to the universal destruction of all ORDER and SUBORDINATION. They wish for *havoc;* and their mad notions of EQUALITY are calculated to arm the Servant against the Master, and, for protection and culture, inculcate the *gratitude* of the DAGGER.[27]

Zoffany's paintings show the servant armed against his master and, by the inclusion of so many blacks, implicitly criticize the notion of emancipation.

The artist's inclusion of numerous blacks is also another indication that his audience is English rather than French. Some blacks may have been involved in the insurrection of August 10, but Zoffany is the only artist to show them as participants, and he depicts a far larger number than is warranted. In the late eighteenth century, blacks in England may have constituted a percentage of the population ten times larger than in France;[28] these images reflect Zoffany's fears of what an English insurrection might look like.[29]

On February 4, 1794, around the time the artist was presumably conceiving his subjects, the French Convention had taken the decisive step of abolishing slavery entirely. Not altogether altruistic in its motives, the French government was more concerned with attracting blacks to fight for the Republic against the English threat in the Caribbean than it was in living up to the rhetoric of the Declaration of the Rights of Man, but at least the French, if only for a time, established universal emancipation, which many of the English found unpalatable. In contrast, for British conservatives, to whose ideology Zoffany subscribed, liberty sanctioned the power of the propertied segments of society over the disenfranchised, of males over females, and of whites over blacks, thereby upholding those traditional inequalities based on class, gender, and race.

The unsympathetic but astute John Williams, who recognized the political agenda of Zoffany's depictions, writes of the artist's Indian subject exhibited at the Royal Academy in 1796 under the title *Hyderbeg on His Mission to Lord Cornwallis, with a View of the Granary Erected by Warren Hastings, Esq., at Patna* (Fig. 92):

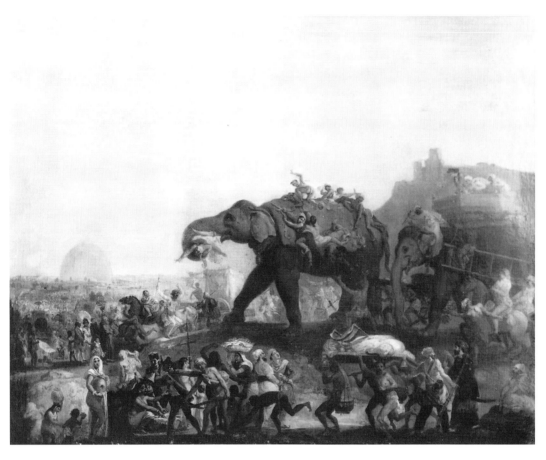

FIGURE 92
Zoffany, *Hyderbeg on His Mission to Lord Cornwallis, with a View of the Granary
Erected by Warren Hastings, Esq., at Patna.* Oil on canvas, 39 × 49½ in., exh. Royal
Academy, 1796. Victoria Memorial Hall, Calcutta.

In the management of this picture (as in that he exhibited last year, of the
Parisians plundering the King's Cellar at Paris), he has laboured hard to sac-
rifice the dignity of humanity, to the pride and parade of aristocracy; indeed
he seems so familiar with slavery, and so enamoured of its effects, that we
doubt if even the black catalogue of governing infamy can furnish a subject
equal to his hunger of degradation.[30]

Zoffany depicts the exotic cavalcade, an Indian version of the Canterbury pilgrims,
on its way to entreat Lord Cornwallis, the English governor in Calcutta, to reduce
the contributions required by Asaf-ud-daula of Oudh. He uses this scene to offer a
kaleidoscope of Indian life from the ruling class to its varied minions,[31] but the In-

dian ambassador Haidar Beg Khan is placed atop a distant elephant (at the far left in the middle ground); the lower orders, often somewhat grotesquely portrayed, occupy the foreground. The primary incident around which the composition is constructed shows an Indian fatally losing control of his animal, while on the elephant following him Sir John Kennaway, an official of the East India Company, instructs his Indian driver to steady his animal, as Zoffany, riding alongside Sir John's elephant, imperturbably maintains control of his horse. Looming in the distance at left is the granary ordered by Hastings as a protection against famine, a symbol of progressive and benign European rule. Williams is right: there is no meaningful distinction between the rhetoric of social hierarchy in *Plundering* and the colonial rhetoric of *Hyderbeg on His Mission to Lord Cornwallis.*

For Zoffany, as for many of his contemporaries, the debate between the English and French systems of government was about far more than competing political ideologies. Republican France and its supporters preached the superiority of reason over authority, maintaining that progress for mankind was possible once the outmoded concepts of the old order were swept aside. The English conservatives, in contrast, rejected such a theory of perfectibility, seeing man instead as inherently sinful and therefore needful of the constraints of a divinely sanctioned social framework. For them, the concept of the rights of man meant barbarism, the destruction of civilization itself, as it placed its faith in the judgment of man rather than in the religious principles a conservative theology held to be God's will. Writing on October 3, 1792, one Englishman put into perspective what "the total destruction of all authority and subordination" taking place in France might signify: "It really seems as if Heaven had determined to expose the folly and arrogance of human wisdom, which piques itself on its POLITICAL skill, and to demonstrate how inadequate man is to form any permanent system on the strength of his own abilities."[32] Zoffany enthusiastically endorses the individual's acceptance of whatever position he or she is given in society's existing hierarchy, which itself reflects God's plan for a fallen humanity. In this political and religious framework, the individual is a subject rather than a citizen as in the French model.

The Massacre of the Innocents

In his *Reflections on the Revolution in France,* first published in November 1790, Edmund Burke wrote with fiery eloquence of the calamities of October 6 of the previous year, when a ferocious mob, resembling "a procession of American savages," led the royal family in triumph from Versailles to Paris. With biting sarcasm aimed at the Reverend Richard Price, he lamented that the day's full promise had not been realized:

> The actual murder of the king and queen, and their child, was wanting to the other auspicious circumstances of this *"beautiful day."* The actual murder of

the bishops, though called for by so many holy ejaculations, was also wanting. A groupe of regicide and sacrilegious slaughter, was indeed boldly sketched, but it was only sketched. It unhappily was left unfinished, in this great history-piece of the massacre of innocents. What hardy pencil of a great master, from the school of the rights of men, will finish it, is to be seen hereafter.[33]

On August 10 and in its aftermath, the French radicals fulfilled Burke's prophecy by acting to complete this picture they had only sketched three years before. Zoffany fixes it on canvas for all to see. His two pictures are indeed great history pieces of the Massacre of the Innocents, and even the author of the verse accompanying Earlom's print after *Plundering the King's Cellar* instinctively evokes imagery suitable to the biblical story, although this particular incident does not appear in either of the two compositions:

> Ah! vainly from the fatal knife;
> The MOTHER begs her Infant[']s life.[34]

Alone of the major artists of his period, Zoffany responded to Burke's challenge, creating two history pieces that encapsulate the statesman's vitriolic reaction to those forces unleashed by revolutionary ardor. In the humanistic tradition of *ut pictura poesis* (as is painting, so is poetry), where a history painting requires a text, it is Burke's *Reflections on the Revolution in France* that provides the philosophical underpinning and epic dimensions for the artist's conception. Like Burke, Zoffany attempted to strip away the obfuscating rhetoric about the rights of man to show what he felt was the true meaning of the French Revolution. His paintings ignore the organized military engagement to dwell instead on the barbarous behavior of the victors over the vanquished.

Both the artist and the writer are masterly propagandists for the conservative ideology; indeed, Burke is in large part responsible for formulating the terms of the debate. To convince the public of the validity of their point of view, both indulged in hyperbole. Thomas Paine had complained of Burke's emotionally charged discussion of the French Revolution:

> As to the tragic paintings by which Mr Burke has outraged his own imagination, and seeks to work upon that of his readers, they are very well calculated for theatrical representation, where facts are manufactured for the sake of show, and accommodated to produce, through the weakness of sympathy, a weeping effect. But Mr Burke should recollect that he is writing History, and not *Plays;* and that his readers will expect truth, and not the spouting rant of high-toned declamation.[35]

Paine is right in arguing that Burke writes more fiction than fact, but he misses the point in thinking it should be otherwise. Neither Burke's book nor Zoffany's paint-

ings are intended as factual histories. Burke, for example, did not hesitate to exaggerate the effects of the siege of Versailles, maintaining that the king, the queen, and their "infant" children were "forced to abandon the sanctuary of the most splendid palace in the world, which they left swimming in blood, polluted by massacre, and strewed with scattered limbs and mutilated carcases."[36] Burke and Zoffany deliberately adopted an impassioned rhetoric meant to persuade, not to instruct, and each took perverse delight in exuberantly portraying the violence he deplored.

By refusing to limit himself to an accurate portrayal of events in France, Zoffany could more clearly epitomize what he felt was the ugly essence of the Revolution: the bloody massacres were not an aberration, the unfortunate by-product of one group's misunderstanding the motives of the other, but the logical outcome of the revolutionists' belief that the nation must be reborn in cleansing and nurturing blood. The French Revolution could be interpreted as a movement in which youthful energy unleashes forces that result in violent upheaval, the excising the old to ensure the purity of the new. Zoffany wished to portray this violent energy for what he felt it really was—a bestial, destructive force. His paintings are the product of an old man, repulsed and outraged over the self-righteous hypocrisy of the new ideology. In these works he strikes back with a grotesque and diabolical vision of his own.

7

RELIGIOUS TRANSCENDENCE

Zoffany's paintings of the events of August 10, 1792, and their aftermath are more than just a grotesque recitation of plebeian atrocities. The artist infuses these works with elements of religious imagery, thereby inscribing present-day realities into a framework of sacred history. There is more at stake here than a reflexive, superficial bow to Christian iconography: by layering the paintings with references to imagery of sacrifice and salvation and to events associated with the end of time, Zoffany transposes his portrayals of contemporary history into a realm of eternal truth. The full significance of this world of bloody violence can be fully comprehended only in a Christian context: indeed, the religious dimensions of these paintings, more than any other, reveal the artist's reading of the events he had chosen to depict.

Announcing the Apocalypse:
The Blood of Martyrs and the Grapes of Wrath

On one level, Zoffany's two pictures of the French Revolution can be read as heralding the Apocalypse, a Christian interpretation that the artist's contemporaries would hardly have found surprising or unconventional: for them, it was second nature to relate the French Revolution to biblical prophecy. Thus many saw these seemingly unprecedented events as announcing the end of the world, whose blueprint was the apocalyptic prophecies of the Book of Revelation and the Book of Daniel, as well as Jesus' gloomy prediction as recorded in Matthew 24:3–14:

> And as he sat upon the mount of Olives, the disciples came unto him privately, saying, Tell us, when shall these things be? and what *shall be* the sign of thy coming, and of the end of the world?
> And Jesus answered and said unto them, Take heed that no man deceive you.

For many shall come in my name, saying, I am Christ; and shall deceive many.

And ye shall hear of wars and rumours of wars: see that ye be not troubled: for all *these things* must come to pass, but the end is not yet.

For nation shall rise against nation, and kingdom against kingdom: and there shall be famines, and pestilences, and earthquakes, in divers places.

All these *are* the beginning of sorrows.

Then shall they deliver you up to be afflicted, and shall kill you: and ye shall be hated of all nations for my name's sake.

And then shall many be offended, and shall betray one another, and shall hate one another.

And many false prophets shall rise, and shall deceive many.

And because iniquity shall abound, the love of many shall wax cold.

But he that shall endure unto the end, the same shall be saved.

And this gospel of the kingdom shall be preached in all the world for a witness unto all nations; and then shall the end come.

Such verses can be cited to account for famines and pestilence, and the devastating earthquakes in Lisbon (1755) and in Sicily (1783) readily fit into this same perception that the world had entered into its preordained sorrows. From a conservative perspective, the French Revolution had produced numerous false prophets, and the massacres of both August 10 and the following September, along with mass murders outside Paris, gave proof that the righteous were now being delivered up to be killed. In Zoffany's painting *Plundering,* David Bindman singles out this "note of apocalyptic hysteria," which, as he says, is "no more extreme than much of the anti-Jacobin literature of the period."[1]

The conservatives hardly had a monopoly on interpreting the French Revolution in the light of prophecy. Because the loyalists were temperamentally more interested in maintaining the status quo than in welcoming seismic changes to the social order, it was left to the liberals to claim that the time was ripe for a cataclysmic resolution of world history.[2] The period of tribulation foretold in the Book of Revelation was to be followed by the millennium, when Satan would be bound up for a thousand years, the prelude to "a new heaven and a new earth: for the first heaven and the first earth were passed away" (Revelation 21:1).

In England, intellectuals such as Richard Price and Joseph Priestley embraced the French Revolution as ushering in the millennium, a time of redemption and progress for humanity. William Blake's prophetic work of the 1790s was permeated with apocalyptic imagery linking current affairs to the Book of Revelation, and even Benjamin West may have intended a radical political commentary in some of his designs for William Beckford's proposed Revelation Chamber at Fonthill Abbey.[3] The less sophisticated lower echelons of English culture also embraced the prospect of the millennium. Early in 1794, Richard Brothers published his *Revealed Knowledge of the*

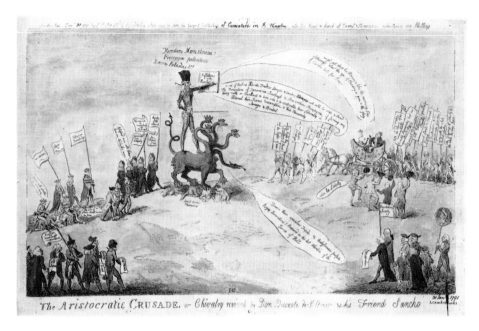

FIGURE 93
Isaac Cruikshank, *The Aristocratic Crusade.* Colored etching, 23.8 × 30.3 cm.
(9⅜ × 11¹⁵/₁₆ in.), January 31, 1791. British Museum, London.

Prophecies and Times, a confrontational millenarian work that identified the social elite with the Antichrist and the Whore of Babylon of the Book of Revelation.

In his *Reflections on the Revolution in France,* Burke had explicitly rejected the millenarian views of Price by sarcastically pretending to accept them: "I allow this prophet to break forth into hymns of joy and thanksgiving on an event [the procession of the royal family from Versailles] which appears like the precursor of the Millennium, and the projected fifth monarchy [of Daniel], in the destruction of all church establishments."[4] Cruikshank depicts Burke standing on the back of this very beast (Fig. 93), its fifth head still to be crowned, from which vantage point he can counter the Versailles procession while trampling down the "base born Plebeians."[5] Biblical prophecies could indeed be used by both parties.

John Williams, in the long critique I have already quoted of Zoffany's painting *Plundering,* pointedly saw the picture in apocalyptic terms: "The virtuous artist slept in November, charged with repletion and indigestion, and imagined in his dormitory, that he saw a *sansculotte* befouling the threshold of the millennium, and scratching his buttocks with the regalia."[6] Williams is describing the conservative's instinctive revulsion at these violent acts of the lower classes, but he is willing to tolerate excesses that he feels will lead to a common good. Again both the artist and

his critic interpret August 10 in chiliastic terms: whether this event should be reviled or celebrated simply depends on one's position on the political spectrum.

Zoffany's apocalyptic vision is a negative one that focuses, not on the millennium to come, but rather on present sorrows. From this perspective, *Plundering the King's Cellar* is more concerned with the grapes of wrath of Revelation than with the prospect of future glory.

Images of Sacrifice and Salvation

Although one can view *Plundering* and *Celebrating* as images of the last days seen from a conservative point of view, the Christian context offers a more meaningful, more original layer of interpretation. Zoffany is less interested in describing God's wrath, which is the prelude to a new heaven and a new earth, than in explaining the atrocities vis-à-vis the Gospels. It is not the Second Coming of Christ that interests him, but rather how the events of August 10 take on meanings from Jesus' first ministry.

Religious echoes in both paintings invoke an association with Christ's sacrifice on the cross. In *Celebrating*, the prominent corpse at the lower left has a wound in his side trickling blood, and the grieving woman (see Fig. 64) evokes images of Mary Magdalene mourning over the body of Christ. In *Plundering*, the staff with the *bonnet rouge* is flanked by the pikes with severed heads (see Frontispiece), just as Christ on the cross was flanked by the two thieves who were crucified with him. Three years after Zoffany's painting was exhibited, James Gillray portrayed a similar configuration, showing Charles James Fox worshiping in his home at Saint Anne's Hill (Fig. 94). Fox's domestic altar offers an infernal parody of Christian principles: the traditional crucifix is transformed into a *bonnet rouge* labeled "EGALITE," with its base wittily inscribed "EXIT HOMO" in place of "Ecce Homo." Busts of Robespierre ("Robertspeire") and Napoleon flank this revolutionary crucifix, and a pair of bleeding hands, nailed to Robespierre's wooden post, is a reminder of the indelible stain of his guilt as well as of violent dismemberment. While Gillray's altar features a rogues' gallery, Zoffany's earlier interpretation is highly sympathetic to the two victims whose heads flank the *bonnet rouge*. In addition, he treats the liberty cap (Fig. 95) with an imposing dignity. The anguished concern expressed in the faces of the sansculotte on the ladder raising this cap and the blue-coated man beside him, who reaches down to the wine basket as if to stop the revelry, provides a solemn and respectful response. Zoffany offers other clues that the *bonnet rouge* flanked by heads on pikes alludes to the Crucifixion. The ladder on which the sansculotte holding the liberty cap is perched recalls scenes of the Descent from the Cross. In addition, the red uniforms of the Swiss soldiers recall Christ's scarlet robe, and the division and bartering away of the soldiers' clothes echoes the dividing of Christ's garments by the casting of lots.

Zoffany's thematic conception resembles that of a French print showing Louis XVI on a cross topped by a *bonnet rouge*, where the king is the victim of Robespierre

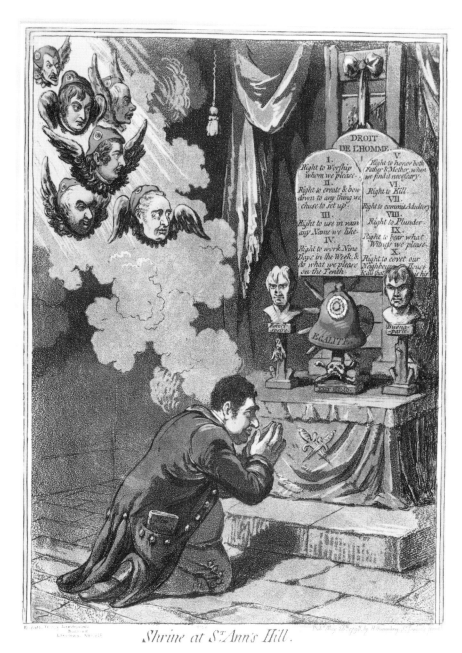

Shrine at St Ann's Hill.

FIGURE 94
James Gillray, *Shrine at St. Ann's Hill.*
Etching and aquatint, 34.3 × 25.1 cm.
(13½ × 9⅞ in.), May 26, 1798. British
Museum, London.

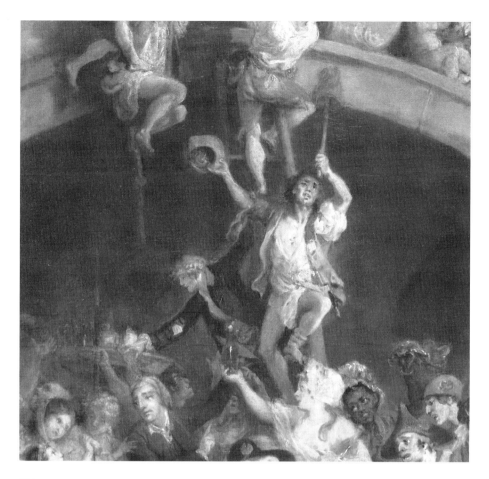

FIGURE 95
Detail of Plate 1.

and the sansculottes (Fig. 96). In the print *Exercice des Droits de l'Homme et du Citoyen Français,* one encounters a configuration even closer to Zoffany's. At the upper right (Fig. 97), three heads on pikes are seen against the backdrop of a blazing church, a clear allusion to the Crucifixion, with the head of the bad thief on the left facing downward with downturned mouth and darkened eyes, the good thief rapturously looking toward the elevated central head, which gazes heavenward. In Zoffany's conception, however, it is just as pointless to debate which is the good thief and which the bad as it would be to make such a distinction between the king's two brothers crucified beside him in *Le Nouveau Calvaire.*

Typically, as in Figure 96, counterrevolutionaries depict Louis XVI as a Christian martyr. Yet Louis's retreat to the safety of the Manège on August 10, and the ongoing political realities of his situation that had led to compromise and indecisiveness,

FIGURE 96
Artist unknown, *Le Nouveau Calvaire* (The new Calvary).
Etching and aquatint, 22.5 × 17.5 cm. (8⅞ × 6¹¹/₁₆ in.), by April
1792. Bibliothèque Nationale, Paris.

made his later martyrdom more ambiguous and less noble than that of his defend-
ers. Zoffany focuses instead on the anonymous victims: the loyal Swiss soldiers, the
refractory priests, the aristocrats who stood by their king, and the royal retinue, par-
ticularly the women and children. His paintings do indeed show the Massacre of the
Innocents, these victims offering a contemporary counterpart to the slain infants of
the New Testament who are commonly viewed as the first Christian martyrs.

FIGURE 97
Detail of Fig. 62.

FIGURE 98
James Gillray, *The Corsican-Pest;—or—Belzebub going to Supper*. Etching, 40 × 32.4 cm. (15¾ × 12¾ in.), October 6, 1803. British Museum, London.

The two paintings are also closely tied to the central Christian rite of Holy Communion, the consecration of the bread and wine that reenacts that of the Last Supper:

> And as they were eating, Jesus took bread, and blessed *it,* and brake *it,* and gave *it* to the disciples, and said, Take, eat; this is my body.
>
> And he took the cup, and gave thanks, and gave *it* to them, saying, Drink *ye* all of it;
>
> For this is my blood of the new testament, which is shed for many for the remission of sins.
>
> (Matthew 26:26–28)

Communion, as the name insists, is a sharing, the participants joining in fellowship as well as in a union with Christ, where they are subsumed into the eternally transcendent.

Reports on the behavior of the French revolutionaries often depicted them as cannibals,[7] conduct that can be interpreted as a perverse parody of Communion. During this period it was a commonplace to associate blood with wine, toasts of blood being drunk out of wine glasses, and Gillray later shows one of Beelzebub's bottles of choice French wine, labeled "Sang des Swisse" (Blood of the Swiss), as part of a private stock he keeps in hell in the wine cooler beside his table (Fig. 98).[8] In addition, all the elements of a perverted Mass being enacted on August 10 were already present in the accounts of French acts of cannibalism, as in Twiss's report, already quoted,[9] and Fennell's shocking assertion: "Some of the females went so far, as to cut off pieces of flesh, chew them, and suck the blood, praising its delicious taste."[10] The Parisian correspondent for the *St. James's Chronicle* wrote back to the newspaper on August 16, giving his account of how the victors treated the vanquished:

> If any thing could add to the vile reputation of the French savages, perhaps the following traits might: I myself, with above 50 others, saw a mason have a bottle of Swiss blood in his hand, and taste it now and then, saying, *"C'est le plus excellent vin de ma Cave!"* [It is the finest wine from my cellar!]—the Parisian women, you may guess of what class, did nothing else the whole day but strip the dead Swiss of their shirts! above 100 of their hearts were devoured by the cannibals.[11]

According to the *Evening Mail,* such cannibalistic savagery continued after the September massacres:

> Several pastry cooks, particularly one by the *Palais Royal,* have Pies *de la viande des Suisses—des Emigrants—des Pretres*—made of the flesh of the Swiss—the Emigrants and the Priests.—I was present when four Marseillois at the *Restaurateur Bouvilliers,* in the Palais Royal, sent for two of these pies, and eat [sic] them, crying out—*Vive la Nation.*[12]

This same report maintains that the mob built a fire in the Place Dauphin, where it roasted alive men, women, and children. After cutting flesh from one of the victims, Countess Perignan, it ordered six priests to eat it, in a blasphemous parody of the rituals of the Mass.[13]

In Zoffany's interpretation, the French Revolution does not offer an alternative to the existing order. While revolutionary principles could destroy, they could not supplant, for they were only the negative pole of the positive one. Evil momentarily triumphs as cannibals inherit the earth. There is hope of retribution, however. As we have seen, the punishment by death of the duc d'Orléans is already foreshadowed, and the implication is that these demons and furies who have created a hell on earth will eventually be exorcised. In this context, the Hell's Mouth formed by the dark, cavernous opening to the wine cellar will reclaim its savage denizens. Those who would eat the righteous will themselves be consumed.

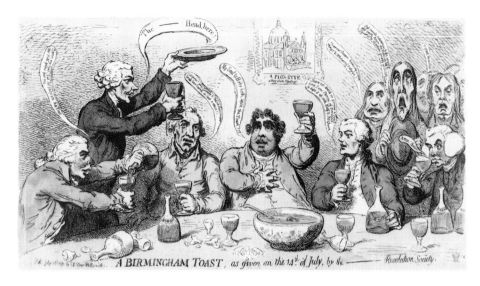

FIGURE 99
James Gillray, *A Birmingham Toast, as given on the 14th of July, by the——*
Revolution Society. Etching, 27.1 × 50 cm. (10⅝ × 19½ in.), July 23, 1791. British
Museum, London.

As early as July 23, 1791, Gillray had characterized the English supporters of the
French Revolution as participants in a depraved Communion. His print *A Birm-*
ingham Toast (Fig. 99) shows the Constitutional Society of Birmingham meeting to
celebrate the second anniversary of the fall of the Bastille.[14] Dr. Joseph Priestley holds
the Communion plate in his left hand as he makes the toast, "The———[King's]
Head, here!" while in his right hand he holds the chalice, the viscous and globular
nature of the overflowing wine suggesting blood. The scene is a parody of the Last
Supper, with the satanic inversion made clear by Richard Brinsley Sheridan's re-
joinder, "Damn my Eyes! but I'll pledge you that Toast tho Hell gapes for me." Gill-
ray depicts another satanic Communion, where three members of the earlier cast of
characters happily wait on the French general Charles Dumouriez, a wish fulfillment
of his boastful prediction that he would conquer England (Fig. 100). Charles James
Fox serves up the government in the form of William Pitt's head, Sheridan serves
up the crown, and Priestley the church. The chalice on the table is filled with wine,
Christ's blood, while more wine awaits in the decanter marked "Vin de Paris," the
blood of the Revolution's innocent victims.

Reports of the culinary habits of the Parisian mob gave Zoffany ample reason to
evoke Eucharistic imagery in his two paintings; Gillray had helped to prepare the
way by branding the English who supported French revolutionary ideals participants
in a Black Mass. *Plundering* counts on the viewer's recognizing the well-established
relationship of wine to blood; in *Celebrating* we have already seen how the artist as-

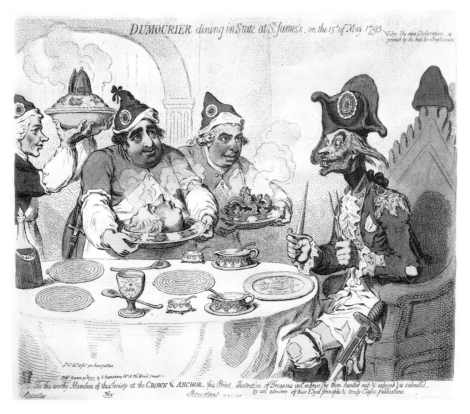

FIGURE 100

James Gillray, *Dumourier dining in State at St. James's, on the 15th of May, 1793.*
Colored etching, 28.6 × 35.9 cm. (11¼ × 14⅛ in.), March 30, 1793. British
Museum, London.

sociates pieces of the soldiers' bodies with bread. Together these two paintings allude
to the Blessed Sacrament. Christ's historical sacrifice is reenacted in the Mass at the
moment when the Host, in an act of supernatural renewal, becomes his body and
his blood. As we have seen, Christ himself is present in the form of the Host in the
lower right corner of *Plundering.* Zoffany's two paintings reconfirm the Christian
ritual of Communion, a religious symbolic system that gives meaning to a fallen
world.

In his two pictures of the French Revolution, Zoffany is not interested in re-
portage: his paintings depict neither what he thought had happened on August 10
and 12, nor what he wanted his audience to think had happened. His images, more
than angry denunciations of riot and revolution, attempt to inscribe a higher sym-
bolic purpose. Although he incorporates into his vision the diabolic energies repre-
sented in the low art of political caricature, forcing his viewers to experience the
mob's coarse brutality and obscene vulgarity, he wishes ultimately to transcend car-

icature. His images achieve the high-minded seriousness associated with contemporary history painting without losing the energy of the earthier categories of art. In doing so, they transcend literal truth to present a higher one, capturing what for him is the reality of the sovereign mob's depraved soul. As we have seen, Zoffany depicts the revolutionaries not only behaving barbarically but also blaspheming as they reenact such biblical martyrdoms as the Crucifixion and the Massacre of the Innocents and even abet in defiling the Host. His pictures, examples of what I have termed antiheroic contemporary history paintings, validate, rather than challenge, the assumptions on which the grand manner is based.

The artist, investing in these works an imagination more religious than historiographical, produced paintings that, like altarpieces, mournfully commemorate and give meaning in a Christian context to the atrocities of August 10, 1792. Reasserting the truth of the Eucharistic mystery at Christianity's core, *Plundering the King's Cellar at Paris* and *Celebrating over the Bodies of the Swiss Soldiers* offer viewers modern versions of such sacred subjects as the Crucifixion, the Massacre of the Innocents, and the Last Supper, conveying the Christian themes of sacrifice, redemption, and regeneration epitomized in these subjects in a radically new format.

Zoffany responds to the French Revolution more profoundly than any other artist who reacted to it from a conservative vantage point, his works achieving in painting the passion and depth of his primary source of inspiration, Burke's *Reflections on the Revolution in France*. Although the artist also draws on his Continental roots, grounding his images in a Roman Catholic perspective, albeit one necessarily hidden from his English audience, his artistic sources are thoroughly English. At a time when Hogarth, "the father of English art," was considered an outdated vulgarian in comparison with the succeeding generation of artists, represented by such luminaries as Reynolds and Gainsborough, Zoffany in his two pictures creatively extended Hogarthian formulas. Although he criticized Hogarth in the cameo role he gave him in *Plundering* and employed his style to champion aristocratic causes, Zoffany, a foreigner, was nonetheless Hogarth's aptest pupil.

As propaganda, *Plundering the King's Cellar at Paris* and *Celebrating over the Bodies of the Swiss Soldiers* carry a powerful message of revulsion against the *menu peuple,* and most viewers—like Zoffany's contemporary John Williams, who offered a political critique of *Plundering*—did not see beyond this surface reading. But the paintings convey a deeper religious message that must be comprehended if they are to be fully understood. In his history pieces of the Massacre of the Innocents, Zoffany, in his old age, offered viewers a narrative as challenging as any he had ever attempted, inventing, in response to the crisis of the French Revolution, a new form to express traditional sacramental values.

APPENDIX: CATALOGUE OF ZOFFANY'S

PAINTINGS OF THE FRENCH REVOLUTION

1. *Plundering the King's Cellar at Paris, August 10, 1792*, 1794
 Oil on canvas
 103 × 126.5 cm.; 40½ × 49¾ in.

Provenance: London, Robins, *A Catalogue of . . . the Valuable Property of that Distinguished Artist Johan Zoffany,* May 9, 1811, lot 94, as "THE IOTH OF AUGUST—at the time of the Parisian Populace breaking open the King's Wine Cellars; strongly characteristic of the furor of the French Revolution, and the Outrages then committed. This picture is engraved," bought by Mulgrave, Henry Phipps, 1st Earl of, 12 guineas; sold by C. Wolley (this name is annotated into Christie's copy of the catalogue), Christie, Manson & Woods, November 30, 1867, lot 88, as "THE 12TH AUGUST, 1789. *Painted for Mr. Morant, and engraved*" (if one accepts the date of August 12, then this is painting No. 2; if one accepts this as the engraved picture, then it is No. 1; the allusion to a Mr. Morant is surely incorrect, as is the reference to 1789); bought by Graves for £20.9.6 (Graves is presumably the dealer Graves & Co. listed in the index to the volume containing this catalogue at Christie's); first recorded as in the possession of the earl of Rosebery when exhibited in 1951 (entered the Mentmore Collection at an unknown date but probably at some time in the first half of the twentieth century, since it is not listed in the privately printed Mentmore catalogue of 1883, which was compiled by Hannah Rothschild, the daughter of the builder of Mentmore and the wife of the fifth earl of Rosebery); London, Sotheby Parke Bernet, Mentmore sale on behalf of the executors of the sixth earl of Rosebery and his family, May 25, 1977, lot 2423, repr.; London and New York, Noortman & Brod, *18th and 19th Century British Paintings,* 1983, no. 30, repr. in color; purchased from Colnaghi, London, 1984.

Exhibitions: London, Royal Academy of Arts, 1795, no. 18, as "Plundering the King's cellar at Paris, Aug. 10, 1793"; London, Royal Academy of Arts, *The First Hundred Years of the Royal Academy, Winter Exhibition, 1951–52,* no. 63, repr. in *Il-*

lustrated Souvenir of the Winter Exhibition 1951–52, p. 46; London, 1977, no. 108; Paris, 1989, vol. 2, no. 785.

References: *Morning Herald,* 1795 (paraphrased in Manners and Williamson, 1920, p. 120); *Morning Chronicle,* May 6, 1795, p. 3; Williams, *Ireland,* 1796, pp. 35–36 n; Dayes, 1805, p. 359; Manners and Williamson, 1920, pp. 120–21; Webster, 1975, p. 191; Waterhouse, 1981, pp. 432, 434, repr.; Paulson, 1983, pp. 152–53, repr. p. 154; Sutherland, 1985, detail repr. in color on cover; Bindman, 1988, pp. 92–94, mezzotint repr.; London, 1989, pp. 105, 152; Ashton, 1996, p. 695.

Engravings: Mezzotint by Richard Earlom published by the artist, January 1, 1795, 57.1 × 68.5 cm.
 State 1, scratch letter proof, impressions of which are in the British Museum Print Room (1856.10.11.106; exhibited, London, 1989, no. 46, as "Invasion of the Cellars of the Louvre, 10 August 1792") and the Library of Congress.
 Extreme left: "J Zoffany Esqr pinxt"
 Center: "Publish'd as the Act directs by J Zoffany. Jany 1st. 1795"
 Extreme right: "R Earlom Scupst."
 State 2, as published, impressions of which are in the British Museum Print Room (1850.10.14.210), the Bibliothèque Nationale (the Smith-Lesouëf collection, 201), and the collection of the Hon. Christopher Lennox-Boyd; one was sold at London, Sotheby's, November 13, 1997, lot 620, on which the "3" in "1793" of the title has been scraped out and replaced in pen with a "2." The primary changes are to the lettering in the margin, although in the image itself the hole in the elbow of the shoeblack has been lightened and altered to a more circular shape.
 Extreme left: "J: Zoffany Esqr. pinxt. R.A"
 Verse at left:

Say, where is sacred FREEDOM gone!
From GALLIA's realm forever flown!
Now DISCORD waves the flaming brand!
Hark! RIOT pours the savage yell,
And MURDER rushing from his hell,
Plunges in streams of blood, his hand.

 Center: "THE TENTH OF AUGUST 1793. / Published as the Act directs Jany. 1st. 1795 by J. Zoffany. No. 7, Bennet Street St. James's." (The artist is first listed as living at this address in the 1796 Royal Academy exhibition catalogue. No address had been given in the 1795 catalogue.)
 Verse at right:

Ah! vainly from the fatal knife;
The MOTHER begs her Infants life.
To earth they fall by many a wound!

Lo, MERCY forc'd the scene to fly!
The tear is dash'd from PITY's eye,
And HORROR, HORROR howls around.

Extreme right: "R. Earlom, Sculpt."

Location: Wadsworth Atheneum, Hartford, Connecticut

2. *Celebrating over the Bodies of the Swiss Soldiers, August 12, 1792,* c. 1794
 Oil on canvas, unfinished
 92 × 125 cm.; 36¼ × 49¼ in.

Provenance: London, Robins, the artist's sale, May 9, 1811, lot 85, as "A Scene in the Champ de Mars on the 12th of August, with a Portrait of the Duke of Orleans," 5 guineas; sold by Larkin at London, Edward Foster, December 16, 1824, lot 47, as "A sketch, The Day after the Memorable 10th of August, at Paris, with Portraits of the Duke of Orleans, and other remarkable Characters," bought by Dyson, £5.15.0; possibly sold Christie's, November 30, 1867, lot 88 (see listing in No. 1); London, Sotheby's, the Property of a Gentleman, March 18, 1981, lot 47, as "A Scene in the Champ de Mars on August 12th, with the Duke of Orleans," repr.; purchased 1981.

Exhibitions: Paris, 1989, vol. 2, no. 607, as "Le Massacre du Champ-de-Mars le 17 juillet 1791," repr. in color.

References: Farington, 1794, p. 223 (quoted on p. 73); Paulson, 1983, p. 153 n, as "A Scene in the Champ de Mars . . ."; London, 1989, p. 60, as "The women of Paris dancing on the bodies of the Swiss Guards after the assault on the Tuileries, 10 August 1792," repr.; Bordes, 1989, p. 442, as possibly representing the Parisians at Versailles on October 5, 1789.

Location: Museum der Stadt, Regensburg

3. *The Triumph of Reason*
 Unfinished [oil] sketch

Provenance: London, Robins, the artist's sale, May 9, 1811, lot 59, as "The Triumph of Reason, French Revolution"; sold by Gill at London, Edward Foster, May 27, 1819, lot 112, as "A sketch of the Revolution," bought in at 6 shillings; sold by Gill at London, Edward Foster, June 19, 1819, lot 150, as "A Sketch of the Revolution," bought by Adams, 6 shillings.

References: Paulson, 1983, p. 153 n; London, 1989, p. 60.

This piece is recorded in the section "Unfinished Sketches" of the 1811 sale catalogue. Presumably the works included in this group were in oil, since Indian subjects appear here that had not been listed in the earlier section "Drawings in Chalk, Illustrative of the Country and Manners of India." Perhaps *The Triumph of Reason* showed the Festival of Reason held on November 10, 1793, in Notre-Dame Cathedral, an important moment in the movement toward de-Christianization, or possibly one of the festivals held on the Champ de Mars, the setting incorrectly referred to in the 1811 catalogue entry on *Celebrating over the Bodies of the Swiss Soldiers.* The Festival of Unity and Indivisibility, which was held on August 10, 1793, the anniversary of the sacking of the Tuileries and the date originally given the exhibited picture, is one such candidate, as is the Festival of the Supreme Being of June 8, 1794. (The various festivals are discussed in Ozouf, 1988. Also see Leith, 1991.) However, as discussed on p. 4, these works in "Unfinished Sketches" were presumably intended only as preparatory studies for larger compositions, and *The Triumph of Reason* may well have been a study for either No. 1 or No. 2.

Location: Unknown

NOTES

Introduction

1. Walpole, 1793, vol. 31, p. 392.
2. For a helpful, brief summary of the impact of the French Revolution on the work of those major artists of the British School who sympathized with its ideals, see London, 1989, pp. 66–74.
3. For a discussion of West's apocalyptic imagery of the late 1790s in the context of contemporary political thought, see San Antonio, 1983.
4. For examples of paintings depicting the misfortunes of the royal family, see the section "The Portrayal of the French Revolution in British Painting" in Chapter 2.
5. Robins, London, *A Catalogue of . . . the Valuable Property of that Distinguished Artist Johan Zoffany,* May 9, 1811, lot 94. The catalogue is reprinted in Manners and Williamson, 1920, pp. 287–94.
6. For a list of states and impressions, see the entry "Engravings" under this picture in the Appendix.
7. Wessely, 1886, no. 96, pp. 39–40. Manners and Williamson, Zoffany's biographers, list the mezzotint's title as *Plundering the King's Cellar at Paris on August 10, 1793* (p. 259), but in this they were simply repeating the inaccurate citation in the Royal Academy catalogue for the painting it reproduces.
8. See Videodisc, 1990, no. 2267. Ten details are also included, nos. 2268–77.
9. Robins, London, May 9, 1811, lot 85.
10. Presumably, both canvases were originally approximately 40 × 50 inches, the standard measurements for a half-length.
11. Paulson, 1983, pp. 151–53.

Chapter 1

1. See Pressly, 1995, for a summary of Zoffany's surviving early works.
2. See the entry in Washington, 1985, no. 281.
3. Sitwell, 1936, p. 41.
4. Paulson, 1975, p. 148.

5. See Paulson's analysis in his book of 1975 and my own article of 1987. Both Paulson and I interpreted the container beneath Titian's *Venus of Urbino* as a child's sarcophagus. It is in fact the lower part of an Etruscan cinerary urn, presumably that of an adult. The question, of course, is what Zoffany intended by this object, and I continue to agree with Paulson that it alludes to the death of his son. For a treatment of the painting's content more in tune with Sitwell's conception of Zoffany's intentions, see Millar, 1966.

6. For an introduction to the history of this work since its discovery, see Haskell and Penny, 1981, pp. 154–57. In his commentary on Zoffany's painting, Paulson associates the sculpture of the Knife Grinder with Smollett's comment in his *Travels through France and Italy* of 1766 that the figure is shown accidentally overhearing the conspiracy of Catiline (Paulson, 1975, p. 140).

7. For a helpful introduction to this subject, see Wyss, 1996.

8. Manners and Williamson, 1920, p. 49.

9. The picture's date has been disputed. Zoffany presumably began Hastings's version of the cockfight in 1784 but could not have finished it before 1786, judging by the cast of characters. In February 1788 he shipped it to Hastings, who for some time had been back in England. Thomas Elmes, writing in 1825, maintained that the picture was lost at sea and that the surviving canvas, now at the Tate Gallery, was Zoffany's replacement, executed after his return to England (see Webster's entry in London, 1977, no. 104, for a succinct summary of the documentation). The question arises, then, whether the Tate picture dates to 1784–86 (the opinion of Webster in the 1977 exhibition catalogue and Archer, 1979) or is a later version of ca. 1789. Elizabeth Einberg, the Tate's assistant keeper of the British Collection, has kindly supplied information in a letter of July 16, 1997, pointing out that the recent conservation of the picture revealed sufficient pentimenti to suggest that this work is not a second attempt but the original picture of 1784–86. The painting, though, possesses a curious anomaly. Although it is an oil on canvas, its bottom edge is composed of a thick wooden strip, which must be a later addition because no one would begin work on such a bastardized support. This addition is by Zoffany himself, but it is unclear when and why it was introduced. It predates Earlom's execution of his 1792 mezzotint after the painting: grid lines are still visible along the wood, as well as the top and right-hand side of the canvas, and, since these lines were put down on top of the paint surface, they presumably were made in preparation for the engraving. Einberg has suggested two possible scenarios: the picture's bottom edge could have been entirely replaced after the canvas had sat in water on its journey to England (water damage that later gave rise to Elmes's exaggerated account of its total destruction), with Zoffany making the necessary repairs after his return in 1789; or, at some point after receiving an undamaged canvas, Warren Hastings, objecting to the abrupt cutting of the foreground edge, required Zoffany to add this small strip to complete the foot of the Indian cock fighter to left of center.

10. Zoffany painted a version of the cockfight for Asaf-ud-daula. Although it has not survived, a copy after it depicts a much simpler space, which one presumes is closer to the scene's actual appearance (repr. in Archer, 1979, fig. 91).

11. Williams, *Ireland*, 1796, p. 34 n.

12. For studies of Zoffany's self-portraits, see Pressly, 1987 and 1995.

13. Manners and Williamson, 1920, p. 15.

14. Angelo, 1828, vol. 1, pp. 139–40. If Mortimer sat to Zoffany for inclusion in a painting, Angelo incorrectly identifies the canvas, because Mortimer, who was then a member of the Society of Artists, does not appear in the painting to which he refers. Martin Postle, however, has made the suggestion that the picture *The St. Martin's Lane Academy* (his new title) at the Royal Academy of Arts might be by Zoffany, and an early key identifies Mortimer as one of the sitters (see Postle, 1991).

Zoffany, in his turn, may be one of the figures in Mortimer's painting *Caricature Group,* executed in the middle to late 1760s. For the most recent discussion of this painting, see Sunderland, 1988, cat. no. 34, fig. 50). In this picture, the figure at the left with a raised wine glass has formerly been identified as Dr. Thomas Arne (put forward by Dr. Philip Traub in 1968) and as Henry Fuseli (Peter Tomory's identification of 1972), but I would suggest that the lean, chiseled features and receding hairline identify him as Zoffany.

15. Reproduced in Pressly, 1995.

16. Zoffany shows only the left side of the print after Titian. The cropping of the photographic original for Figure 6 somewhat obscures the similarity between the torn flap of the print and the prophylactic.

17. See Manners and Williamson, 1920, pp. 100–101. Zoffany was not the first to depict an enemy as Judas. Around 1710, Dr. Welton, rector of Whitechapel, commissioned an altarpiece of the Last Supper from an unidentified artist in which the offending White Kennett, bishop of Peterborough, was introduced as Judas. The picture proved popular until the bishop of London ordered its removal (see Nichols, 1812, vol. 1, pp. 396–97 n).

18. See Manners and Williamson, 1920, pp. 118–19. The artist donated the rejected altarpiece to Saint George's Church, Brentford. It now hangs on the north wall of the chancel of Saint Paul's, Brentford.

19. Not only had Zoffany cheated frequently on his first wife after she had returned to Germany (see Papendiek, 1887, vol. 1, p. 86), but Williams suggests that the artist's conduct was something less than chaste during the time he was away from his family in India (see Williams, *Ireland*, 1796, pp. 34–35 n). In later years the congregation, apparently not amused, disposed of this work at Christie's on March 21, 1904. More recently the painting appeared at Sotheby's on November 20, 1985, lot 92, reproduced in color, and again on May 14, 1986, lot 227.

Chapter 2

1. The term *sansculotte,* while derived from the male dress of the Parisian working class, encompasses a broader and more complex political movement than the name itself suggests. For an introduction to the sansculottes, who are defined as both a social class and a political group, see Rose, 1983. For their English counterparts, see Williams, 1969. Two helpful articles that pinpoint aspects of this movement are Andrews, 1985, and Sonenscher, 1984. Andrews offers an interesting corrective to Albert Soboul's monumental study of the Parisian *sansculottes,* arguing that they were not an autonomous popular movement. Rather, their elite was predominantly bourgeois in composition and had close ties to the central government. Sonenscher argues that although the language of the sansculottes helped form the language of republicanism, this did not occur in the ways that have traditionally been assumed. This public, political discourse did not reflect the corporate idiom of prerevolutionary France or the actual reality of artisanal production. It was based instead on one aspect of that condition, that of the informal bargaining that had existed between journeymen and masters, a type of bargaining that linked the world of the workshop with that of the retail trades. Thus, one aspect of the informal, private conventions of the workshop helped give the political vocabulary of the sansculottes a strong artisanal cast, and this presumably helps to explain "the abiding importance of the artisan as a symbol of freedom within the political culture of nineteenth-century France" (p. 328). Zoffany's understanding of the sansculotte movement surely was not as finely tuned as these modern studies, but it would also be a mistake to assume he saw it purely as a monolithic, working-class culture.

2. See Gilchrist and Murray, 1971, p. 195.

3. Two books devoted exclusively to this *journée* are Mathiez, 1931, and the more recent and authoritative Reinhard, 1969. For a contemporary account by one of the king's ministers who accompanied him from the Tuileries, see Bigot de Sainte-Croix, 1793.

4. This is the number given in Rudé, 1964, p. 257.

5. The name itself is derived from the clay soil that formerly had been used for the making of tile, *tuile* being French for "tile" and *tuilerie* for "tile-works."

6. As eloquently expressed by Edmund Burke, "They were . . . lodged in one of the old palaces of Paris, now converted into a Bastile for kings" (Burke, 1790, p. 165).

7. These numbers are based on the account given by Reinhard, 1969, pp. 397–98.

8. Rudé, 1964, pp. 204, 205.

9. This English translation of the French inscription is based on the one in Québec, 1989, p. 251. The identical inscription also appears in the lower margin of the print *Journée du 10 Aoust 1792. Aux Braves sans Culottes,* a more sophisticated rendering of the fighting issued by the Parisian publisher Villeneuve probably in 1792 (see Videodisc, 1990, no. 2074, and London, 1989, no. 45). This account of the fighting is similar to the one reported in *Révolutions de Paris,* 1792.

10. For the exception, see Figure 56. Figure 42, of course, shows women among the people streaming toward the palace, but the assault itself is relegated to the distance. For other reproductions of images showing the assault of August 10, see Lévêque, 1987, p. 64; Bordes and Michel, 1988, p. 41; London, 1989, no. 45; New York, Colnaghi, 1989, plate 19b; Paris, 1989, no. 780. Fragments of an allegorical painting saluting this event are reproduced in Paris, 1989, no. 826. All the prints in the Bibliothèque Nationale, Paris, are available in Videodisc, 1990, section 1, chapter 2, subsection 5, "The Fall of the Monarchy: The *Journée* of 10 August 1792."

11. In the edition of the *Révolutions de Paris* in the Library of Congress and at Princeton University, after p. 240 the pagination, in a printer's error, begins again at p. 237. The print should follow the first p. 238, not the second as in the LC copy, since it is this first page that contains the text repeated in the print's margin. The first print *Fusillade du Château des Thuilleries* faces p. 230, although it depicts the action described on p. 234. In addition to a map of the departments of Paris which closes this issue, there are three pages offering six views of the toppling of statues of the French kings, an unusually large number of illustrations for this journal. One of these pages is reproduced in Hamburg, 1989, fig. 243t.

12. For works that are listed as having passed through the auction houses, two of which are of revolutionary scenes, see the entry on Béricourt in Emmanuel Bénézit, *Dictionnaire critique et documentaire des Peintres, Sculpteurs, Dessinateurs et Graveurs,* nouvelle édition (Paris, 1976), vol. 1, p. 661.

13. In the Videodisc, 1990, this work (no. 2088) is given the title "[*Prise des Tuileries (The Capture of the Tuileries)*)]."

14. The other works by Béricourt in the graphic collections of the Bibliothèque Nationale focus primarily on camp life, revolutionary festivals, and the burlesque processions of looted religious objects. The artist, however, was clearly drawn to macabre subject matter, depicting such scenes as executions performed by the revolutionary army at Nantes (Videodisc, 1990, no. 9419) and the grisly pillaging of an inn (no. 11472). Also of interest is a watercolor in the Musée Carnavalet, Paris, which has been reproduced twice: once as showing the aftermath of the September massacres (see New York, 1987–88, no. 8), and a second time as *Unloading Victims after a Revolutionary Journée* (see Furet and Ozouf, 1989, following p. 106). I would suggest that it instead depicts the carting away of the bodies of the Swiss guards from the Tuileries Gardens. The stripped bodies, the uniforms spread on the ground beside them, are being loaded like cordwood onto carts, with a crowd of curious spectators at the left and an official delegation at the right. The ordered rows of trees and the terrace at the right suggest the scene may indeed be the Tuileries Gardens. If the courtyard view offers a more spontaneous celebration arising from the disposal of bodies, the pastoral garden view is all the more horrifying because of the bureaucratic efficiency with which this large-scale operation is managed.

15. This same artist also issued a third print illustrating the September massacres. See Paris, 1989, vol. 2, no. 784. Three decades later, a monument to the Swiss guards

still evoked controversy. Carved out of a sheer rock face, *The Lion of Lucerne,* designed by Bertel Thorvaldsen, offers a moving testimonial to the Swiss soldiers who died defending Louis XVI. Yet on its completion in 1821, some saw the memorial as a defense of monarchy rather than as a tribute to the Swiss guards' loyalty.

16. Price, 1789, pp. 49–50.

17. Ibid., pp. 50–51.

18. The text quoted here is from the published edition, of 1850. For this and the two earlier manuscript versions, see William Wordsworth, *The Prelude: 1799, 1805, 1850,* Norton Critical Edition, ed. Jonathan Wordsworth, M. H. Abrams, and Stephen Gill (New York and London, 1979).

19. For a summary of the prints commenting on *The Reflections,* see Lock, 1985, pp. 141–43, and Robinson, 1996, chapter 6. One should mention that James Gillray's famous print *Smelling Out a Rat* of December 3, 1790, showing Burke as a monstrous apparition intruding on Price in his study, also casts Price as the villain, even if Burke is a somewhat equivocal hero.

20. Young, 1793, p. 4. Some English writers, such as Charles James (1792), offer a sympathetic defense of the assault's excesses, but these reactions are in the minority.

21. *Times,* August 15, 1792.

22. *Times,* August 16, 1792.

23. *Short Account,* 1792, pp. 10–11.

24. Peltier, 1792, vol. 1, p. 274.

25. *Times,* August 16, 1792.

26. *Times,* August 17, 1792.

27. Rudé, 1964, pp. 8, 9.

28. Lucas, 1994, p. 69. Lucas offers a particularly helpful overview of various perspectives on the revolutionary culture of violence. See also Ozouf, 1994.

29. In the same exhibition of 1792, a painter listed as Van Regemonté entered his picture *Rendezvous of the Brabantine Patriots* (no. 11). This is the Amsterdam artist Petrus Johann van Regemorter, and his now-missing image, judging from the title, also embraced the theme of liberty. In 1789, following on the heels of the fall of the Bastille, unrest in the Austrian Netherlands led to the Brabantine Revolution against Emperor Joseph II. To escape the emperor's troops, the conservative faction, led by Hendrik van der Noot, emigrated to Breda in Dutch Brabant, where it was soon joined by the liberal faction under the leadership of J. F. Vonck, presumably the rendezvous of van Regemorter's title. Starting from this base, the rebellion proved successful, overthrowing, although only for a time, Austrian rule.

30. The print after it is reproduced in London, 1989, no. 21, and Paris, 1989, vol. 2, no. 498.

31. Gillray coupled this print with one of his earlier productions, *The Triumph of Benevolence* of April 20, 1786, showing John Howard visiting prisoners in his ongoing crusade to alleviate their conditions.

32. As a student in Rome in 1797, the artist William Artaud began sketches for a prorevolutionary painting, never completed, entitled *Liberty Tearing the Veils of Ignorance and Superstition from His Eyes,* a political allegory based on lines from Erasmus Darwin's "Economy of Vegetation" of 1791, part 1 of his poem *The Botanic Gardens.* One of Artaud's studies for the figure of Liberty is based on the pose of Barry's Satan (see the right-hand portion of fig. 28 in Sloan, 1995).

33. The earliest depictions were of scenes of preparation. At the Royal Academy in 1793, Robert Ker Porter exhibited *The Guards on Their March to Greenwich* (no. 814), presumably a depiction of the festive procession of the three battalions that marched from London on February 23, 1793, to embark for the fighting in the Netherlands. At the same exhibition, Francis Wheatley exhibited *Scene from the Camp at Bagshot Heath* (no. 326), an opportunistic recycling of a military encampment painted in 1788. In her book on Wheatley, Mary Webster identifies this picture either as *Scene from a Camp with an Officer Buying Chickens* or its pendant *Scene from a Camp with an Officer Buying Ribbons* (see Webster, 1970, nos. 66, 67).

In 1794 Sir Francis Bourgeois exhibited at the Royal Academy this conflict's first picture of an army battle, a work entitled *Sans Culottes taken prisoners by a detachment of His Royal Highness the Prince of Wales's light dragoons* (no. 210). In 1793, in the duke of York's Flanders campaign, the Light Dragoons had distinguished themselves on a number of occasions, with the most likely moment depicted by Bourgeois being their overwhelming success on October 28 at Lannoy. The title testifies to the British contempt for the French troops as mere sansculottes, a dismissal of their abilities that became harder to maintain. In the same Royal Academy exhibition of 1794, Lieutenant Thomas Yates, R.N., an amateur contributor since 1788, exhibited the war's first two pictures commemorating a naval engagement, each showing a dramatic moment in the fight on June 18, 1793, between the British frigate *Nymphe* and the conquered French ship *Cléopâtre* (nos. 31 and 44).

After the 1794 exhibition, pictures of land battles disappear, a reflection of the souring of the Flanders campaign, which completely unraveled in the winter retreat of 1794–95. However, an unending parade of images celebrating the Royal Navy's impressive string of victories more than made up for their absence.

During this time, two important competing programs of paintings of military engagements were also exhibited independently of the Academy. Philip James de Loutherbourg executed on commission *The Grand Attack on Valenciennes,* illustrating the successful allied assault under the command of the duke of York on this French stronghold on July 25, 1793. The painting was on view at the Historic Gallery by April 21, 1794, and on March 2 of the following year it was joined by its pendant *The Glorious First of June,* showing the British fleet defeating its French counterpart in 1794. In 1794 at Orme's Gallery in Old Bond Street, the American Mather Brown exhibited *The Attack on Famars,* a colossal picture about 17 feet in length, showing the engagement of May 23, 1793, just south of Valenciennes, and on January 1, 1795, he added *Lord Howe on the Deck of the "Queen Charlotte,"* choosing,

as had de Loutherbourg, a naval subject featuring "The Glorious First of June" to complement his land battle. Images of both de Loutherbourg's and Brown's paintings are reproduced and discussed in Evans, 1982, pp. 124–30.

This interest in military scenes depicting the fighting that began between the British and French in 1793 is a continuation of well-established practice in light of such earlier pictures as West's *Death of General Wolfe* (1770), focusing on an event of the Seven Years' War; Copley's *Death of Major Peirson* (1784), featuring a sideshow to the American Revolution; or the numerous images devoted to the siege of Gibraltar, including Copley's own colossal painting (almost 18 by 25 feet), first exhibited in 1791. Copley had also already shown the way in the marketing of such programs, combining independent exhibition with subscriptions for the prints to be engraved after them.

34. At the Royal Academy in 1798, Julius Caesar Ibbetson exhibited a painting that in some ways was the reverse of Zoffany's. The event it depicted had taken place the year before on February 23, when a body of about fourteen hundred French troops disembarked at Fishguard Bay only to surrender almost immediately to detachments of the militia and local levies under the command of Lord Cawdor. Ibbetson's long title in the exhibition catalogue makes clear that England's working classes could be trusted, having shown their immunity to French infection: "Miners setting out from the great lead mine belonging to Lord Cawdor, in Carmarthenshire, to encounter the French banditti at Fishguard" (no. 305). Rotha Mary Clay gives the measurements of the untraced painting as 19 × 25½ in. (Clay 1948, p. 49 n. 4).

35. *A Graphic History of Louis the Sixteenth, and the Royal Family of France; represented in Six Large Engravings from Celebrated Pictures, Painted on the Spot by D. Pelegrini and Engraved by M. Bovi* was published in London in 1806. The six subjects were the arrest of Louis XVI at Varennes; the king's departure from his disconsolate family on the eve of his execution; the royal family on January 24, 1793, three days after the king's execution; the dauphin forced from his mother; the queen taken from prison; and Marie-Antoinette's trial on October 14, 1793. However, the exact nature of Pellegrini's connection with this series is unclear. In his case, "Painted on the Spot" would appear to be false advertising, but of greater concern is that his name does not appear on the prints themselves, and one of the engravings, *The Royal Family of France*, first published in October 1793, is ambiguously inscribed "Dessiné au Temple par &c." (Drawn at the Temple by et cetera). In any case, a number of prints by Luigi Schiavonetti after Pellegrini's lost paintings, such as *The Dauphin taken from his Mother* (published March 1794) and *The Princess Elizabeth taken from the Conciergerie, 1796* (March 20, 1796), leave no doubt concerning the artist's royalist sympathies.

36. It is hardly surprising, given the symbolic importance of the king, that those seeking to visualize the Revolution's meaning should focus on him and his family. Lynn Hunt's provocative analysis of revolutionary politics in her book *The Family*

Romance of the French Revolution demonstrates how family relationships provided all participants with models for comprehending fundamental social and political change. Although the following hardly does justice to the range and subtlety of her argument, it is worth noting that the king always played a central role in these familial narratives. As Hunt points out, "The killing of the king was the most important political act of the Revolution and the central drama in the revolutionary family romance" (Hunt, 1992, p. 2). For the counterrevolutionaries, Louis XVI, possessing the sacred, immortal body of kingship as well as his mortal one, was the father of his country, which was perceived as a patriarchal family. For the revolutionaries, the king represented the tyrannical father who must be killed, to be replaced by a fraternal model, where the brothers must share their Oedipal guilt and their newly won powers. The unfortunate queen, the "bad mother," became, in her turn, a focus for numerous revolutionary concerns, including the status of women in general within a republican state dedicated to masculine virtues.

37. For a discussion of this work and two smaller versions, see Evans, 1982, pp. 117–21.

38. As a pendant to *Louis XVI Saying Farewell to His Family,* Brown embarked on a painting entitled *The Massacre of Madame, the Princess Lamballe, at the Prison de la Force, at Paris* (see Evans, 1982, pp. 121, 250). This painting, showing one of the more gruesome moments of the September massacres of 1792, may never have been finished, and it remains untraced. Brown may have come to feel that a large history painting was an unsuitable vehicle for such a horrific subject.

39. For catalogue information on Hamilton's picture, see Bordes and Chevalier, 1996, no. 28.

40. Burke, 1790, p. 165.

41. In particular, one is reminded of Reynolds's *Portrait of Frederick, 5th Earl of Carlisle* (Castle Howard) of 1769, in which the earl elegantly descends stairs in a pose inspired by the Apollo Belvedere.

42. If Hamilton perceived that Barry was clandestinely supporting rebellious fervor, his adaptation of his imagery is similar to Zoffany's use of the republican Hercules, where he transforms a Jacobin symbol back into a conservative one.

43. Walpole to George Nicol, August 30, 1792, vol. 42, p. 373. Soon after the execution of Louis XVI, Walpole coined the phrase *"inferno-human* beings" to describe the French. See Walpole to Hannah More, February 9, 1793, vol. 31, p. 377.

44. Quoted in Paulson, 1983, p. 66.

Chapter 3

1. London, 1977, p. 17.

2. *London Chronicle,* August 14–16, 1792. The travel writer Richard Twiss also mentions in his account published in 1793 that the people "set fire to all the *casernes*

(barracks) in the *carousel,* and afterwards got at the wine in the cellars of the chateau, all of which was immediately drank" (Twiss, 1793, p. 80).

3. *World,* August 21, 1792, p. 3. Three days earlier, Horace Walpole had written Lady Ossory expressing his dismay: "Atrocious *frenzy* would till these days have sounded too outrageous to be pronounced of a whole city—now it is too temperate a phrase for Paris, and would seem to palliate the enormity of their guilt by supposing madness the spring of it—" (Walpole, 1792, vol. 34, p. 152).

4. *Star,* August 16, 1792, p. 3. This anecdote was repeated in *The Diary or Woodfall's Register,* August 17, 1792, p. 4; *Public Advertiser,* August 17, 1792, p. 3; *London Chronicle,* August 16–18, 1792, p. 163; and *E. Johnson's British Gazette,* August 19, 1792, p. 4, the last two giving the date of the letter as August 13 instead of August 12.

5. For a discussion of the *bonnet rouge,* see Harris, 1981. The classical Roman *pileus* cap, symbolizing the manumission of a slave, appeared in more than one shape, and in the eighteenth century the meaning underlying the more exotic Phrygian cap, the shape of the *bonnet rouge,* was conflated with that of the *pileus* (see Korshak, 1987). In the second half of his article of 1983, Hertz argues for "the interchangeability of the Phrygian cap and the head of Medusa." Schama mentions that liberty-hat symbolism also appeared "in the form of a wide-brimmed round form with a flat crown" (1989, p. 603). Two such hats appear in *Plundering,* one resting on the ledge of the entrance to the wine cellar at the upper left and the other with a cockade worn by the nearly nude figure reclining on the same ledge to the right of the escutcheon. A number of plates in Ribeiro, 1988, show such hats but with higher crowns.

6. See the account of a National Guardsman quoted in Reinhard, 1969, p. 585. Also see Fennell, 1792, p. 358, and *Plain Truth,* 1792, p. 23; and *Lloyd's Evening-Post,* August 13–15, 1792, p. 160: "The number of heads parading the streets is prodigious."

7. Aumont, 1792, p. 28. I have not been able to find out any more about J. B. (presumably "Jean-Baptiste") d'Aumont beyond this one letter, which was edited by T. Cooper and published as a short book in 1792 by M. Falkner and Co., Manchester. This account was written expressly to counteract the "official" reports of August 10: "In this detail of facts I have adhered closely to the truth, hoping by a genuine account, to counteract the effect which your lying ministerial papers may have produced" (p. 33). The reports in the newspapers were highly critical of the events in Paris, but some did testify to the revolutionaries' integrity: "The mirrors, and part of the furniture in the Palace, were destroyed; but those who attempted to carry away any thing privately, were punished with instant death" (*The Diary or Woodfall's Register,* August 17, 1792, p. 4).

8. *Short Account,* 1792, pp. 33–34. James Fennell gave a similar description: "When the massacre of every one found in the palace was entirely completed, the mob began to pillage it: but, although they brought some part of the money, jewels and plate to the National Assembly, who received these rebels, murderers and plunderers with shouts of approbation and applause, it is very certain, that three fourths, at least, of the King's property, was ever after missing" (Fennell, 1792, p. 385).

9. *London Chronicle,* August 14–16, 1792. This observation was repeated in the newspaper's next issue (p. 163). It is also remarked on in the *World,* August 17, 1792, p. 2; *The Diary or Woodfall's Register,* August 17, 1792, p. 4; *Public Advertiser,* August 17, 1792, p. 3; and *E. Johnson's British Gazette,* August 19, 1792, p. 2. Moore confirms this report: "In the streets I met with great numbers of the national guards and fœderés, returning home, all of them with pieces of the red uniform of the Swiss guards who had been killed, stuck as trophies on the point of their bayonets" (1793, vol. 1, p. 44).

10. *Short Account,* 1792, pp. 31–32.

11. Again Zoffany's interpretation runs counter to contemporary descriptions. At least one newspaper account had made the reverse argument, commenting on the ridiculous appearance of the *menu peuple* who chose to wear their looted clothes rather than sell or surrender them:

> What private booty these Raggamuffins might have made, independent of that share of the robbery which, after storming the *Thuilleries,* they gave to the NATIONAL ASSEMBLY, cannot be estimated; but the freedom which they took with the Royal Wardrobe, was, of all their depredations, considering their miserable nakedness, the most excusable.
>
> One could scarcely conceive how any thing highly ludicrous could intermingle itself with scenes of so much horror; and yet there was something provokingly laughable in seeing a miserable little Frizeur returning from the Palace, arrayed in one of the Royal *inexpressibles,* large enough to make him a Surtout [overcoat]—in observing another fellow perfectly *sans Culottes,* as bare in that respect as he was born, wearing an embroidered velvet coat with diamonds, foil-stones, &c. &c. and, what was equally ridiculous, in surveying men-milliners dressed up in the spoils of slaughtered *Swiss.*
>
> The *Poissardes* of course were equally familiar with the dresses found in the Wardrobe of Her MAJESTY, and came out decorated with hats, bonnets, caps, bandeaus, &c. all adorned with beautifully fancied flowers, superb feathers, and every costly ornament. These, with various magnificent dresses, made the most burlesque appearance imaginable upon the brawny shoulders of *offensive* Fishwomen without either shoes or stockings.
>
> (*Oracle,* August 21, 1792, p. 3)

12. The general tenor of the gesture, where the thumb is placed to the mouth and the fingers are extended, as one of combative defiance is clear, although I have not found an exact corollary in the art of this period. More commonly when an individual places his thumb to his mouth, his fingers are closed. This latter gesture has several possible meanings. In Calbris, 1990, it is described as the thumbnail-tooth flick, where the thumbnail is flicked off an upper tooth. This can be a gesture both of vengeful refusal ("Que dalle! Pas un sou!" [Nothing! Not a cent!]) or vengeful

repartee ("Et vlan! Dans le baba!" [Wham! Right in the ass!]). One of the better-known instances in art can be found in Edgar Degas's pastel on monotype *Femmes devant un café* (Women in front of a café) of 1877, where a prostitute makes such a gesture to her companion. This same attitude of thumb to mouth with fingers closed can also symbolize drinking. This would appear to be the intent in a revolutionary work entitled *Le Dévouement héroïque de Mademoiselle de Sombreuil* (The heroic devotion of Mademoiselle de Sombreuil) of ca. 1800, where a sansculotte is depicted during the September massacres of 1792 apparently suggesting to the heroine that she drink blood (repr. in Paris, 1982, no. 55). Perhaps Zoffany intended his figure to be giving both messages: "Fuck you" and "May you drink till you puke."

13. Twiss, 1793, p. 68.

14. At first glance this dark-skinned youth looks like any number of Gillray's depictions of chimney sweeps, who are white children turned black by soot. The boy's stool, however, identifies him as a shoeblack. The board with the handle beside the stool is also a part of shoe-shining equipment. See Gillray's print *A Pair of Polished Gentlemen* of March 10, 1801, where what I take to be a cake of black polish sits on top of just such a board. For a bibliography of street criers and tradesmen, see Stanford, 1970. There are as well numerous illustrations in Beall, 1976. In his print *The National Assembly Petrified / The National Assembly Revivified* of June 28, 1791, Gillray introduces a white shoeblack as a prominent member of the plebeian government. The shoeblacks I have seen in French prints of this period are also white and, like Zoffany's figure, are boys: see Videodisc, 1990, nos. 9185 and 9881. Yet, from an early date, blacks were also associated with this trade (see Hindley, 1884, pp. 153–54).

15. Twiss, 1793, p. 81. In a slightly later passage, Twiss was even more specific: "The barracks were still in flames, as well as the houses of the Swiss porters at the end of the gardens; these last gave light to five or six waggons which were employed all night in carrying away the dead carcases" (p. 84). The year before, Fennell had already commented on the lurid carts operating near the barracks: "In all the walks of that fine garden, in the basons, at the foot of every statue, and almost every tree, lay mangled carcases, hacked, even after death, in the most brutal and disguising [*sic*] manner: while, at the further end, as if to give the last dread touch to this most horrid spectacle, the wooden barracks of the Swiss, all burning at the same time, cast their livid light on cart loads of dead bodies, which the citizens were hurrying from the spot of slaughter" (Fennell, 1792, p. 391). Both Twiss and Fennell echo the account found in *Révolutions de Paris,* 1792, p. 239. A newspaper report adds other details: "Towards evening, I saw 1000 bodies and upwards lying in the garden of the *Thuilleries,* put into waggons and carts, mixed with the broken furniture of the Palace, and carried to the *Carousel,* where one general bonfire was made, and in a few hours the bodies were burnt to ashes" (*Evening Mail,* September 14–17, 1792, p. 1). According to this correspondent, in contradiction to other reports, "At seven o'clock all was clear, and not a body or trace of blood was to be seen in the town, so well was this business managed."

16. Twiss, 1793, p. 79. Another eyewitness report gave an even higher body count: "a day in which not less than seven or eight thousand people perished" (*Plain Truth*, 1792, p. 26). The highest count I have seen was the one given by *Lloyd's Evening Post:* "The killed in Paris, on the 10th of August, we are now assured, were nearly 12,000, of whom more than 8000 were of the people" (September 3–5, 1792, p. 228).

17. This frame bears the caption "DEMOCRATIC GRATITUDE. Buonaparte, heading the Regicide Banditti which had dethron'd & Murder'd the Monarch, whose bounty had foster'd him." Gillray here combines the dethronement of the king on August 10, 1792, with his execution in January of the following year. He also exercises poetic license in showing Napoleon as a leader of the revolt. Although the young lieutenant witnessed the attack on the Tuileries, his sympathies were not with the "mob." That Gillray associated Bonaparte with the events of August 10 is reaffirmed by his later print *The Corsican-Pest* of October 6, 1803 (see Fig. 98), where one of the papers spilling out of the sack containing evidence of Napoleonic crimes is inscribed "Assasination of Captive Swiss," and where a bottle of Beelzebub's wine bears the label "Sang des Swisse" (Blood of the Swiss). The British Museum catalogue, on the other hand, associates *Democratic Gratitude,* incorrectly in my opinion, with the events of October 5, 1795, when Napoleon "commanded the troops by which the Convention was defended from an insurrection which was partly royalist" (George, 1942, no. 9534, p. 619).

18. This reversal also appears in the coat of arms on the royal carriage as shown in an English print entitled *The Kings Entry into Paris on the 6 of October 1789,* published on November 20 of that same year (Videodisc, 1990, no. 1888). In this latter case, one presumes that the reversal was indeed a mistake because the caption, in proclaiming that the image was "drawn on the spot by an eminent artist," is intent on stressing its accuracy as a historical document.

19. This stamp is reproduced in Lafaurie, 1981, p. 50, no. 10. The engraver's name "Gatteaux" appears within the design. Zoffany's image is closer to that of the stamp than Gatteaux's is to Guido Reni's painting *Hercules and the Hydra,* its presumed source of inspiration. The stamp is mentioned in the context of the revolutionary Hercules by James A. Leith (see Québec, 1989, p. 102). The importance of Hercules as a republican symbol is also discussed in Hunt, 1983. In his essay, Leith points out flaws in Hunt's argument. Also see Leith, 1991, for discussions of the uses to which Hercules was put in revolutionary architecture and festivals.

20. Reproduced in Los Angeles, 1988, no. 130.

21. One of the prints commemorating this work is reproduced in Québec, 1989, fig. 28.

22. Because of its republican as well as royalist associations, the entry in the Paris bicentennial catalogue sees the interpretation of this statue of Hercules as ambiguous, an ambiguity it extends to the meaning of the well-stocked wine cellar which it feels, again incorrectly in my opinion, can also refer to the king's excesses: "La

présence de la *Statue d'Hercule terrassant l'hydre,* qui fut utilisée par les deux partis durant la Révolution, est d'interprétation ambiguë et le choix de l'épisode ne l'est pas moins: le peuple français est cruel et débauché mais son roi était un ivrogne" (The presence of the *Statue of Hercules crushing the hydra,* which was employed by both sides during the Revolution, has an ambiguous interpretation and the choice of subject is no less so: the French people are cruel and debauched but its king was a drunkard) (Paris, 1989, vol. 2, no. 785).

23. Two images of the aristocratic Hydra are reproduced in Québec, 1989, plates 25 and 26.

24. See, for example, Christopher Hill's essay of 1965 on references to the many-headed monster in English political thought at the end of the sixteenth century and the beginning of the seventeenth.

25. *Short Account,* 1792, p. 29.

26. Ibid., 1792, p. 33. James Fennell and John Moore specifically mention the abbé who was the preceptor of the prince royal being killed along with those Swiss soldiers he had attempted to hide in his palace apartment (Fennell, 1792, pp. 380–81, and Moore, 1793, vol. 1, p. 48), and Peltier mentions money that was taken from a priest's body (vol. 1, p. 344). An Englishman, sympathetic to the revolutionaries, wrote from personal experience: "There are several Abbes and Priests among the slain. I had an appointment with one belonging to the Court at ten on this morning, the events hindered me from meeting him at the place agreed on. I found him, however, three or four hours after extended on the Terrace of the Tuilleries, covered with wounds and dead" (*Star,* August 30, 1792, p. 2 n. 5). This last account appears in the form of a letter based on a translation of the description of August 10 given in *Révolutions de Paris* with the correspondent's personal observations added as footnotes. The entire letter with an introduction was published as a pamphlet, where the letter itself is given the heading "Paris, Hotel d'Yorck, Aug. 22, 1792" (see *Circumstantial History,* 1792).

27. Burke, 1790, p. 166.

28. Unlike the "Marseillaise," a battle song composed by Rouget de Lisle, "Ça ira" formed part of a popular oral tradition. First appearing in July 1790, its verses could be easily altered to reflect changing sentiments. Laura Mason's essay "Songs: Mixing Media" offers a helpful overview of the role played by songs in revolutionary culture (see New York, Library, 1989, pp. 252–69).

29. Writing in 1797, Louis-Sébastien Mercier pointed out how the verb *lanterner* changed its meaning at the advent of the Revolution, even though this new meaning was soon supplanted by *guillotiner:* "Ce mot [lanterner] signifioit autrefois perdre son tems à ne rien faire . . . au commencement de la révolution, il signifioit pendre un homme à une lanterne. *Guillotiner* et *guillotine* ont pris un tel ascendant que ces mots ont totalement effacé ceux de *lanterne* et de *lanterner.* . . . [This word (*lanterner*) meant in former times to waste one's time by loitering . . . at the beginning of the revolution it meant to hang a man to a lamp-post. To guillotine and the

guillotine have taken such an ascendancy that these words have completely replaced those of *lanterne* (street-light) and *lanterner*]" (quoted in Cobb, 1970, p. 88).

30. *Ten Minutes Reflection,* 1792, pp. 25–26.

31. *Public Advertiser,* August 18, 1792, p. 1.

32. Rowlandson had also executed a bawdy print showing two Jewish clothesmen suggestively holding up a pair of breeches supplied by a winsome housemaid. This print, *Traffic,* is reproduced in Grego, 1880, vol. 1, p. 323, as having first been published in 1791. It, along with other related images, is also reproduced in Fuchs, 1921. In addition, see Felsenstein, 1995, for a detailed treatment of English attitudes toward Jews at this time.

33. The first published mention of Zoffany's being Jewish occurs in 1796:

> He is indubitably one of the flowers of Benjamin, although his name may not be enrolled in the schedule of Duke's place, and notwithstanding his apparent backslidings from the most revered statutes of Israel.
>
> He arrived in England about thirty years since, and then lodged in the attic tenement of a Mr. *Lyons,* a kind of hebrew, who resided in Shire-lane near Temple-bar; his fortunes were then so low, that his cates were more scarce than rare. The harp of his fathers was hung on a willow in the desert, and there was no musick in his soul.
>
> (Williams, 1796, p. 34 n)

Although this account postdates the creation of the painting, presumably such insinuations were not made up for this occasion but had already been in circulation.

In their biography of 1920, after pointing out that they know of no documentary evidence, Manners and Williamson write, "We are told that his father was a Bohemian Jew, a cabinet-maker and decorator at Prague, and that he was employed upon some decoration or internal fittings in the Hradshin of that famous Bohemian city, where his skill attracted attention and he was advised to seek a wider scope for his talent" (p. 3). They go on to report that this success led him to study architecture in Ratisbon, where he entered the service of the prince of Thurn and Taxis. More recently, in his article "A Restless Jew," Louis Lipman states, presumably on the basis of the 1920 account, that "Zoffany's father had thrown off the bonds of ghetto life when he took up the position of architect to the Prince of Thurn and Taxis" (*Jewish Chronicle,* London, November 18, 1960, p. 30).

34. Zoffany's monstrance most closely resembles baroque examples. For reproductions of a range of Rhenish types, see Kampmann, 1995.

35. The only other explanation is that the object is a coin, but the inclusion of only a single coin seems an unnecessary detail without much monetary or pictorial value. If, as I have argued, Gillray's image *Democratic Gratitude,* one of eight contained in *Democracy* (see Fig. 38), is to some degree inspired by Zoffany's design, then Gillray did indeed interpret this object as a coin, but it is meaningful that he felt the

necessity of multiplying it by three in addition to including a sack spilling out an entire hoard.

36. For a historical overview of the traditions of Host desecration and ritual murder, see R. Po-Chia Hsia, 1988.

37. This Parisian story was widely retold in various versions. In an article of 1967, Marilyn Lavin describes the important role it plays in an imposing fifteenth-century altarpiece created for Urbino's confraternity of Corpus Domini. For another recent discussion of Host desecration with a helpful bibliography, see Biddick, 1993.

38. James Gillray envisioned a Hell's Mouth similar to Zoffany's in his print *A Peep into the Cave of Jacobinism* of September 1, 1798 (George, 1942, no. 9243), where the monster Jacobinism lurks at the entrance of a dark cave from which emerges Hades' Lethean Stream.

As already mentioned, the statue on top of the right-hand side of the arched entrance in Zoffany's painting shows Hercules clubbing the Hydra. Zoffany, however, may also have intended a second allusion. The Hydra's heads resemble those of Cerberus, and Hercules is sometimes shown battling this three-headed dog with his club (for two examples, see Zurbaran's *Hercules and Cerberus* in the Prado Museum, Madrid, and Antonio Tempesta's seventeenth-century print *Cerberum domat Hercules* [*Hercules conquers Cerberus*]). Such a reference to Cerberus is also appropriate to French monarchy, since Jean-Louis Desjardin's prominent statue of Louis XIV in the Place des Victoires had shown the king triumphantly standing over this mythological creature. If Zoffany intended this dual reading of the beast as Cerberus as well as the Hydra, it would further associate the overarching entrance with the Mouth of Hell: Cerberus, of course, stood guard at the entrance to Hades.

39. *Morning Chronicle,* May 6, 1795, p. 3.

40. Williams, *Ireland,* 1796, pp. 35–36. Since the book is supposedly confined to artists who had practiced in Ireland and Zoffany had never been there, he is relegated to a footnote, albeit a long one.

Chapter 4

1. Robins, London, May 9, 1811, lot 85.

2. Sotheby's, London, March 18, 1981, lot 47. This entry cites its indebtedness to the assistance of Dr. T. C. W. Blanning of Sidney Sussex College, Cambridge. Ronald Paulson, who did not then know that the painting had survived, made a similar suggestion based on the 1811 sale catalogue's title *A Scene in the Champ de Mars on the 12th of August, with a Portrait of the Duke of Orleans:* "The reference here is probably to the fifteenth of July 1791, the massacres by the National Guard on the Champ de Mars following the king's flight and capture, one of the issues of the confrontation being whether power should go to the duc d'Orléans. The final outcome of these outrages was the storming of the Tuilleries a year later, which is the subject of *Plundering the King's Cellar at Paris*" (Paulson, 1983, p. 153 n. 70).

3. Paris, 1989, vol. 2, no. 607.

4. In his review of the Paris exhibition, Phillipe Bordes rejected the title given the painting in the catalogue, suggesting instead that "it is more than likely that the ruined Zoffany unearthed in Regensburg (No. 607) represents the Parisians at Versailles on the 5th October 1789 rather than the Massacre on the Champ-de-Mars of July 1791" (Bordes, 1989, p. 442). Bordes is certainly right in questioning the Champ de Mars massacre as Zoffany's subject.

5. London, 1989, p. 60.

6. Farington, 1794, vol. 1, p. 223.

7. Aumont, 1792, p. 7. For an account of the closing of the gardens sympathetic to the king, see National Guard, 1792: "On the morrow of this day of terrors [June 20, 1792], the palace and the gardens of the Thuilleries were shut. This became a new ground of advantage to the factious, who represented the most humane of Kings as a ferocious tyrant shut up from the view of his people" (p. 2). Disputes involving the gardens were illustrated in *Révolutions de Paris* just prior to the issue focusing on August 10, 1792 (see nos. 159 and 160). One of these prints is reproduced in Hamburg, 1989, fig. 243r.

8. Moore, 1793, vol. 1, pp. 34–35. Peltier defends the closure from the king's point of view: "The garden of the Thuilleries, a part of the king's property left him by the constitution, had been kept shut. This precaution was become necessary, on account of the daily insults to which the king and queen were so much exposed" (vol. 1, p. 39). Richard Twiss also points out that the barrier on the north side of the garden was hardly a formidable one: "At this time no person was permitted to walk in any other part of the *Tuileries* gardens than in the terrace of the *Feuillans,* which is parallel to the *Rue St. Honoré,* and under the windows of the *National Assembly:* the only fence to the other part of the garden was a blue ribband extended between two chairs" (Twiss, 1793, pp. 30–31). As reported in a dispatch of August 3 by the English ambassador, this barrier was more mental than physical: "They [the leaders of the populace] may have had the good policy to form this silken separation, which strengthened by opinion is stronger than one of stone or iron, for whoever should venture to pass those limits would be regarded by the rest as an Austrian or an *aristocrate* and treated accordingly" (Gower, 1792, p. 205). The barrier had been put in place after Jean-Jacques Duval d'Eprémesnil, a conservative politician, had been violently attacked when he had ventured onto the Terrace des Feuillants. Also see the account of this assault carried out by "ferocious cannibals" in National Guard, 1792, p. 3.

9. Moore, 1793, vol. 1, p. 51.

10. Peltier, 1792, vol. 1, p. 416.

11. Twiss, 1793, p. 92. He had earlier described how on the tenth the streets were filled "with troops of the *sans-culottes* running about, covered with blood, and carrying, at the end of their bayonets, rags of the clothes which they had torn from the bodies of the dead Swiss, who were left stark naked in the gardens" (p. 81).

12. *The Diary or Woodfall's Register,* August 27, 1792, p. 2.

13. Peltier, 1792, vol. 1, p. 173.

14. For examples, see Paris, 1977, nos. 68, 74, and 75. These and numerous other prints showing women seated on cannons are included in the sections "The Women's March on Versailles" and "The Return of the King to Paris" in Videodisc, 1990.

15. *World*, August 17, 1792, p. 2, bearing the dateline of August 13. These lines were also reported in *The Diary or Woodfall's Register*, August 17, 1792, p. 4; *Public Advertiser*, August 17, 1792, p. 3; and *London Chronicle*, August 16–18, 1792, p. 163. Moore's reactions were similar:

> I went this morning to see the places where the action of yesterday happened. The naked bodies of the Swiss, for they were already stripped, lay exposed on the ground. I saw a great number on the terrace, immediately before the palace of the Tuileries; some lying single in different parts of the gardens; and some in heaps, one above another, particularly near the terrace of the Feuillans.
>
> The garden and adjacent courts were crowded with spectators, among whom there was a considerable proportion of women, whose curiosity it was evident was fully equal to their modesty.
>
> The bodies of the national guards, of the citizens of the fauxbourgs, and of the fœderés, have been already removed by their friends; those of the Swiss only lie exposed in this shocking manner.
>
> (1793, vol. 1, pp. 57–58)

16. *St. James's Chronicle*, September 1–4, 1792, p. 1.

17. *Times*, August 16, 1792. In its edition of September 5–7, 1792, the *Evening Mail* gave the number of soldiers at eighty and maintained that their children were butchered with them (p. 1).

18. Peltier, 1792, vol. 1, p. 254. Richard Twiss also graphically describes the mutilation of corpses: "Many men, and also many women, as well of the order of *Poissardes* (which are a class almost of the same species and rank with our fishwomen, and who are easily distinguished by their red cotton bibs and aprons) as others, ran about the gardens, ripping open the bellies, and dashing out the brains of several of the naked dead Swiss" (Twiss, 1793, pp. 82–83). In an account published after Zoffany had completed his painting, Louis XVI's valet de chambre reports what he had witnessed on the Place de Louis XV: "Of the men, some were continuing the slaughter, and others cutting off the heads of those who were already slain; while the women, lost to all sense of shame, were committing the most indecent mutilations on the dead bodies, from which they tore pieces of flesh, and carried them in triumph" (Cléry, 1798, p. 16). One might add that these shocked descriptions of the women as mutilators, castrating their fallen enemy, is hardly an innovation, such characterizations being part of an old tradition. An English audience would surely have been reminded of Shakespeare's retelling of the earl of Westmoreland's unhappy report to King Henry IV:

A post from Wales loaden with heavy news,
Whose worst was that the noble Mortimer,
Leading the men of Herefordshire to fight
Against the irregular and wild Glendower,
Was by the rude hands of that Welshman taken,
A thousand of his people butchered.
Upon whose dead corpse there was such misuse,
Such beastly shameless transformation,
By those Welshwomen done as may not be
Without much shame retold or spoken of.

(*Henry IV, Part I*, I.1.37–46)

19. Fennell, 1792, p. 387. The author goes on to offer his own gory account of the soldiers' dismemberment: "The dead bodies of the Swiss were stripped, and their clothes, dipped in the still warm blood, distributed about as trophies of the glorious victory. Many of the bodies were cut limb from limb, and flesh from bone; and, according to the different inclinations of the murderers, each took a hand, a heart, a head, or a piece of flesh, to carry about on a bayonet, in sanguinary and diabolical triumph" (p. 388).

20. *World*, August 21, 1792, p. 3.

21. *World*, August 24, 1792, p. 2.

22. *World*, August 27, 1792, p. 2. A letter to the editor commenting on the events of August 10 and September 2 offered another attack on Parisian women, but its attempt at cleverness is trite and ineffectual: "—the *Jolies Dames* of Paris are metamorphosed into devils. The ladies of Paris were once celebrated for killing with *their eyes*, they are now as celebrated for killing with poinards and daggers" (*World*, September 11, 1792, p. 2).

23. *St. James's Chronicle*, September 4–6, 1792. This account also appears in *The Diary or Woodfall's Register*, September 6, 1792, p. 4, and *Oracle*, September 6, 1792, p. 3. It is later expanded on in the *London Chronicle*, September 6–8, 1792.

24. Quoted in Zantop, 1992, p. 222.

25. See Burke, 1790, p. 159; quoted in chapter 5, n. 11.

26. Burke, 1790, p. 165.

27. Ibid.

28. David Bindman, after reminding his reader that "petit soupers" as used by Burke in his *Reflections* refers to brothels, points out that Gillray is depicting a bawd and her team in an "unnatural intermingling of family and brothel life" (see Bindman, 1992, p. 135).

29. *A Republican Belle* is the companion piece to *A Republican Beau*, her male companion also making a fierce figure. Both works are reproduced in London, 1989, no. 148. These images had their textual counterparts. The newspapers regularly reported snippets on the latest French fashions, and on September 13, 1792 (p. 2),

shortly after the massacres, the *World* published a satirical piece entitled "Parisian Dresses":

GENTLEMEN.

Coats dyed with *blood*—stockings stained with *brains*—a dagger in one hand, and the head of an Aristocrat in the other—red knight cap—no breeches, and the hair tied in a *scull,* instead of a bag. The whole forming so bloody an appearance, that every Gentleman is afraid of himself.

LADIES.

No gloves or stockings—*rouge* is exploded for the *blood* of a Princess—a pike in one hand, to tickle the wounds of the dying victims—their *perfume* is of a *fishy* nature, and they powder with the ashes of the dead—a *gash* on the forehead, *blood-shot eyes, red fist,* and *foam* at the mouth, finish the appearance of a modern French Lady!

30. Kromm, 1987, p. 299.

31. Agulhon, 1981, p. 29.

32. The colors of the woman's dress are perhaps meant to recall the tricolor, although admittedly her apron is more gray than blue.

33. See Clark, 1980, for a discussion of witchcraft as ritual inversion.

34. The other print of a sorceress in the service of the Revolution appears in *Magicienne consultée sur la revolution de 1789* (A Sorceress Consulted on the 1789 Revolution) (Videodisc, 1990, no. 5266), an image known in a number of versions (see nos. 15252, 16030, and 16032).

35. Van de Velde's print is reproduced in Hollstein, 1989, vol. 34, no. 142.

36. A reproduction of van de Velde's image, along with a translation of its Latin inscription, appears in the exhibition catalogue *Landmarks in Print Collecting: Connoisseurs and Donors at the British Museum since 1753,* ed. Antony Griffiths (London, British Museum Press in association with The Museum of Fine Arts, Houston, 1996), no. 22.

37. Burke, 1790, p. 169.

38. For examples of the use of such terms, see Levy and Applewhite, 1980; Soboul, 1988; and Levy, Johnson, and Applewhite, 1973. A French print has for its caption of a working-class woman *Madame sans Culotte* (repr. Gutwirth, 1992, p. 304, fig. 80).

39. An anonymous print (Bibliothèque Nationale, Hennin 11220) shows at least two women in the crowds being fired upon by the Swiss guards emerging from the gate to the Court Royal. These women, however, do not appear to be combatants.

In this pro-republican rendition, they, like many of the men, appear to be unarmed spectators who are the victims of a grossly excessive counterattack.

40. Boime, 1987, p. 468. Lacombe in fact continued to fight even after having been shot through one arm (see Sokolnikova, 1932, p. 158).

41. Zantop points out how cannibalistic associations permeate the concept of the Amazon, arguing at one point that "allegorical depictions of the New World in the form of bare-breasted cannibalistic amazon queens . . . metamorphose directly into bare-breasted goddesses of liberty wearing a Phrygian cap instead of feathers" (Zantop, 1992, p. 225).

42. Moore, 1793, vol. 1, p. 117. An English gentleman in Paris, calling her "Mademoiselle Terroin," also praises her conduct in the *Star* (August 30, 1792, p. 2 n. 4).

43. An article entitled "Mademoiselle Theroigne" appeared in several newspapers. It details alleged atrocities, while calling her "this infernal monster" and "this devil incarnate" (see *Evening Mail,* September 12–14, 1792, p. 1; *Oracle,* September 15, 1792, p. 4; *Lloyd's Evening Post,* September 14–17, 1792, p. 268; and *London Chronicle,* September 15–18, 1792, p. 266). An anecdote of her cutting down a pleading Swiss soldier had appeared earlier in *Lloyd's Evening Post,* where she is called "Fernigue" (August 27–29, 1792, p. 207). Other negative stories can be found in *Short Account,* 1792, p. 23, and Peltier, 1792, p. 211.

44. For an insightful Freudian analysis of this print, see Hertz, 1983.

45. *Short Account,* 1792, pp. 31–32. The account published in the *Plain Truth* of 1792 comments as well on the different ways in which the insurrectionists treated the fallen: "They were also particularly careful in preserving their dead; while the bodies of the Swiss were left on the spot, and afterwards cut in small pieces by the enraged populace" (pp. 22–23). While Zoffany presumably could not have known of Thomas Blaikie's account, since it was not published until this century, the Scotsman's description supports those of other observers: "Many of those anthrophages passed in the Street and stopt to shew us parts of the Suisses they had misacred some of whom I knew and certainly before that would not have thought of any such thing. However the example seemed a rage and every one seemed to glory in what he had done and to Show even their furrie upon the dead body by cutting them or even tearing their clothes as monuments of triumph, so that this seemed as if the people were struck with a sort of Madness" (Blaikie, 1792, pp. 238–39).

46. Levy, Johnson, and Applewhite, 1973, p. 264.

47. See Hufton, 1971, and Graham, 1977.

48. Gutwirth, 1992, p. 307. This is part of the opening sentence to the chapter "The Maenad Factor; or Sex, Politics, and Murderousness."

49. Revolutionary women were not the only females to be condemned. Olwen H. Hufton writes eloquently about the counterrevolutionary women, who, in the nineteenth century, were depicted as having undermined a rational republican state because of their superstitious allegiance to the church. In this narrative, they, more

than the female sansculottes, were painted as the real threat to social progress (see Hufton, 1992).

50. For all four versions of this obviously popular image, see Videodisc, 1990, nos. 6826, 6828, 6831, and 6833.

51. The cheering crowd is further dehumanized because it appears only as a sea of liberty caps held high. Because women were forbidden to wear such caps, the crowd must be exclusively male.

52. In the paragraph whose beginning has already been quoted ("It is now sixteen or seventeen years since I saw the queen of France"), Burke goes on to state, "Little did I dream that I should have lived to see such disasters fallen upon her in a nation of gallant men, in a nation of men of honour and of cavaliers. I thought ten thousand swords must have leaped from their scabbards to avenge even a look that threatened her with insult.—But the age of chivalry is gone.—That of sophisters, oeconomists, and calculators, has succeeded; and the glory of Europe is extinguished for ever" (Burke, 1790, pp. 169–70).

53. Isaac Cruikshank also clearly had Reynolds's image in mind, presumably in the form of the mezzotint after it, when he introduced the duc d'Orléans into his print *Assassination* (see Fig. 69).

54. For an image of a butcher as a threatening revolutionary, see the print of 1790 *Tremblez aristocrates voila les bouchers* (Tremble aristocrats, behold the butchers), Videodisc, 1990, no. 2225.

55. Ascribing Orléans's motive to his having been reprimanded for propositioning Marie-Antoinette, the author of the popular book *Flower of the Jacobins* offers the following summary of his conduct:

> Having raised a considerable loan in Holland for the accomplishment of his views, it is a matter of notoriety, that the great Revolution of 1789, was brought to maturity by the distribution of his treasures. It was with his money that his army was corrupted; with his money the people were inflamed to revolt; with his money all the agents of rebellion were supplied. The first blow being struck with success, he had not the courage to ascend the height he looked up to with desire and with envy. If his cowardice had not been still stronger than his wickedness, I believe there is but little room to doubt, but what France, instead of being ruled by a Convention of Tyrants, would have been governed by a single Heliogabalus. But he dared not what he would: and, on the 6th of October, 1789, when a hired and directed populace assaulted the palace of Versailles, in the dreary hour of night, he was trembling in disguise, and pointed to the mob the secret passages leading to the apartments of the Royal Family.
>
> (*Flower of the Jacobins*, 1793, pp. 4–5)

Writing in 1794, even the reformer Mary Wollstonecraft was ill-disposed toward the October Days uprising, laying the blame at Orléans's feet: "Whilst nature shud-

ders at imputing to any one a plan so inhuman [as the murdering of the king and queen], the general character and life of the duke of Orleans warrant the belief, that he was the author of this tumult" (Wollstonecraft, 1794, p. 45).

56. See George, 1938, no. 7560. The catalogue entry accompanying the videodisc also associates the duc d'Orléans with this image (see Videodisc, 1990, no. 1847).

57. Peltier, 1792, vol. 1, p. 18. Peltier was hardly alone in seeing the duc d'Orléans as an instigator. According to the correspondence of the then counterrevolutionary Emmanuel-Henri-Louis Alexandre de Launay, comte d'Antraigues, the duke was said on August 10 to have gone to the Place du Carrousel to urge on the attackers to seize and butcher the king and queen. The presence in the insurrectionist commune of Choderlos de Laclos, the chief agent of the Orleanist faction, added further evidence of the duke's involvement for those already predisposed to believe the worst (see Reinhard, 1969, p. 417).

58. Zoffany's membership in the Freemasons was first researched and brought to light by Major Malcolm R. Morris. I would like to thank Carla Lane and her sister Marna Jones, who formerly lived in Zoffany's house on Strand-on-the-Green, for bringing this information to my attention. I would also like to thank John Ashby, librarian at Freemason's Hall, for confirming the dates of Zoffany's membership in the various lodges. On December 19, 1763, soon after his arrival in London, the artist joined the King's Arms Lodge, and on February 21, 1780, shortly after his return from the Continent, he joined the Lodge of the Nine Muses, one that included other foreign artists such as Bartolozzi and Cipriani. One suspects Zoffany benefited from contacts he made through the Calcutta lodge, Star in the East, when working in India, and after his final return to London, he joined the Pilgrim Lodge on March 27, 1793. This last remains the only German-speaking lodge in England, the artist in his last years reverting more to his native roots.

59. Cruikshank had earlier shown Louis standing beside the guillotine uttering his purported last words in a print of February 1, 1793 (George, 1942, no. 8297).

60. Cruikshank's print is similar to one published on February 1, 1793, with the title *The Victim of Equality,* which shows Orléans standing on the steps of the guillotine and holding up the king's head (George, 1942, no. 8298).

Chapter 5

1. The number of dead and wounded is taken from the account of Mrs. Samuel Hoare, an eyewitness who lived opposite Mr. Donovan's house. See Hibbert, 1958, p. 105.

2. Quoted in ibid.

3. Ibid., p. 104.

4. James Fennell was one of several who remarked on the fact that all the Swiss were targeted by the mob: "But the massacre was not confined to one spot; the unfortunate Swiss [soldiers] were pursued and hunted like wild beasts, wherever they

had fled for shelter. . . . Nor was the fury of the mob confined to those who had endeavoured to defend the palace; they carried their barbarous cruelty so far as to murder every Swiss, of whatever occupation, they could find: the porters of the palace, of hotels and churches, were murdered, with their wives and children, without mercy or regard to innocence" (Fennell, 1792, p. 382). The "mob" even sought to decapitate the Swiss porter who worked for Lord Gower, the British ambassador to France (see Burley, 1989, p. 169).

5. Watson, 1960, p. 239.

6. Romney exhibited his painting in London at the Free Society in 1763, and Penny exhibited his the following year at the Society of Artists. While Romney's picture has not survived, Penny's is now in the Ashmolean Museum, Oxford, with a version of it at Petworth House. For the most recent discussion of the images depicting Wolfe's death, see McNairn, 1997.

7. In San Diego, 1992, the picture's dates are given as falling between 1789, when Zoffany returned from India, and 1797 (p. 8). However, a later *terminus post quem* is more likely. The pose of the Hawaiian chief in the foreground is based on that of the Discobolus, and the presumption is that it was inspired by the copy belonging to Charles Townley that Zoffany added to his painting of Townley's collection. Recent research reveals that this statue probably did not reach London until 1793 (see Cook, 1985, p. 43), thereby making an earlier dating of *The Death of Captain Cook* unlikely.

8. These were the characteristics pointed out by Edgar Wind for West's picture (see Wind, 1938–39).

9. Heinrich Zimmermann, writing in Zoffany's native German, mentions that on Cook's first meeting with the king, four attendants brought him to the captain, "each of them holding a handful of sugar-cane over his head as a parasol" (Zimmermann, 1781, p. 28).

10. For earlier depictions of Cook's death, see the frontispiece in Rickman, 1781; John Webber's versions in Joppien and Smith, 1988, catalogue, nos. 3.304–3.305A; prints after works by D. P. Dodd and John Cleveley, and George Carter's painting, all three of which are reproduced in Smith, 1979, figs. 8–10; and the engraving *The Apotheosis of Captain Cook,* which combines a drawing of his death made by Webber with an apotheosis by de Loutherbourg (reproduced in Joppien and Smith, 1988, text, plate 201).

11. Burke's full quote is as follows: "It was (unless we have been strangely deceived) a spectacle more resembling a procession of American savages, entering into Onondaga, after some of their murders called victories, and leading their captives, overpowered with the scoffs and buffets of women as ferocious as themselves, much more than it resembled the triumphal pomp of a civilized martial nation" (p. 159). The burning of an old Swiss gentleman during the September massacres led one commentator to remark on how "the sanguinary Monsters . . . danced around the fire singing themselves, in the true spirit of North American Savages" (*Oracle,* September 11, 1792, p. 2).

12. *Times,* August 15, 1792: "At least 300 Cannibals were howling for blood near the *Barrieres.*"

13. Twiss, 1793, p. 100.

14. *Times,* August 17, 1792.

15. *World,* August 18, 1792, p. 2.

16. See Mitchell, 1944.

17. Quoted on p. 70.

18. For an original analysis of the importance of body language in the French Revolution, see Outram, 1989. She is interested primarily in the *homo clausus,* or "closed body," of the bourgeoisie, which is based on classical standards of heroic masculinity and is in contrast to the peasant, "carnivalesque" body. Zoffany's canvases are excellent illustrations of the negative aspects of the latter grotesque body, one that challenges and inverts images of authority. For a positive treatment of this Rabelaisian type, see Bakhtin, 1968.

19. Price, 1793, pp. 4–5.

20. Some of the artist's contemporaries offered a different interpretation of the coarse quality to be found in his late style. Edward Dayes, writing when Zoffany was still alive, gave this opinion:

> but though he came home [from the East Indies] with a heavier purse, his
> faculties appear to have suffered as an artist, which is sufficiently evinced in
> those miserable works, the Plundering of the French King's Cellar, and the
> Asiatic Embassy. Indeed, his abilities have decayed to such a degree, as to
> leave few traces of his former great powers.
>
> (Dayes, 1805, p. 359)

While one accepts that there is a diminution in the technical brilliance in Zoffany's late works, the coarseness of *Plundering* and *Hyderbeg on His Mission to Lord Cornwallis* (see Fig. 92) is intentional.

21. Quoted on pp. 68 and 70. Two decades earlier, when Zoffany was in Italy, Horace Walpole had written to Sir Horace Mann, the British envoy at Florence, "He [Zoffany] is the Hogarth of Dutch painting, but, no more than Hogarth, can shine out of his own way" (Walpole to Mann, April 17, 1775, vol. 24, pp. 92–93).

22. This connection was first pointed out by Paulson, 1983, p. 151.

23. See ibid.

24. Quoted on p. 68.

25. Paulson, 1983, pp. 151–53 n.

26. Some of Sandby's caricatured portrayals of Hogarth, where he appears in such guises as a devil or as half man, half dog, are reproduced in Paulson, 1971, vol. 2, figs. 236–43 and 301–2.

27. Although in the previous century goiters that rounded out the neck had often been considered aesthetically pleasing, particularly in women (see Wilkins,

1960, and Gillie, 1971), they were at times also viewed in a negative light. Then in the eighteenth century, when writing in *The Annual Register, 1779,* William Coxe firmly connected goiter with malformation and idiocy in the inhabitants of the Vallais in Switzerland, becoming the first to identify this particular species of idiots as cretins (see Coxe, 1780). Thus by portraying Hogarth as goitrous and stunted, Zoffany may also be suggesting that he was mentally deficient.

28. An eighteenth-century print by Martin Engelbrecht of a barber-surgeon carrying the tools of his trade shows the figure wearing the indented bowl by a rope around his neck just as in Zoffany's picture. This last work is reproduced in Lyons and Petrucelli, 1978, p. 480, fig. 743.

29. Randolph, 1971, p. 148.

30. Ibid., pp. 137–38.

31. For a general account of Hogarth's attitude toward blacks in his art, see Dabydeen, 1987. The signboards in Hogarth's print featuring the head of Saint John the Baptist and the Good Woman, who is mercifully silent because missing her head, take on an unintended irony when viewed through the lens of the excesses of the French Revolution.

32. For late self-portraits, see Sotheby's, London, July 13, 1988, lot 189, and the family group portrait, which also includes Mrs. Zoffany, reproduced in Manners and Williamson, 1920, facing p. 132. A pencil drawing showing the artist in old age in profile, though wearing a hat, is in the National Portrait Gallery, London. Although depicted as a younger man, Zoffany's self-portrait in *The Death of the Royal Tyger* (Earlom's 1802 mezzotint after it is reproduced in Archer, 1979, plate 107) also recalls the head of the old man in *Celebrating.*

33. Donald, 1996, p. 110.

34. Ibid., p. 118.

35. For examples, see James Gillray's *March to the Bank* of 1787 and William Dent's *Magisterial Vigilance* of 1790, reproduced in Donald, 1996, plates 126 and 127.

36. Sailors also figure prominently among the victims, since Townshend was running against Admiral Hood. The fallen sailor at the lower right appropriately recalls the anguished, floundering figure of Brook Watson in Copley's famous picture *Watson and the Shark,* which he had exhibited at the Royal Academy in 1778.

37. Donald, 1996, p. 140.

38. Reproduced in ibid., plate 168.

39. Wendy Roworth (1993) points out the relationship of paintings of markets and fairs to paintings depicting a peasant uprising of 1647 in Naples. These seventeenth-century pictures by Domenico Gargiulo and Michelangelo Cerquozzi recount aspects of Masaniello's revolt in terms of numerous small figures scattered over a large urban square. While these works offer interesting parallels with Zoffany's images, they do differ in tone: Cerquozzi adopts a mock-heroic point of view, and Gargiulo's primary canvas is to be seen within the context of a series of three pictures depicting recent disasters that had befallen Naples, the other two being the

eruption of Vesuvius in 1631 and the plague of 1656. Even so, there are interesting points of similarity in Zoffany's and Gargiulo's exploration of "mob" psychology, for, in the work of both painters, the *menu peuple* are treated seriously as the primary subject.

40. *Révolutions de Paris,* 1792, p. 238.

Chapter 6

1. Manners and Williamson, 1920, p. 120.

2. Ibid., p. 120 n. 3.

3. For a helpful overview and bibliography of the reactions of conservatives and radicals in England during the time of the French Revolution, see Dickinson, 1985. Particularly good on the loyalist reaction is Dozier, 1983, and Schofield, 1986, and for the democratic movement, Goodwin, 1979. Also see Hole, 1983, for a discussion of English counterrevolutionary tracts. More recent are the helpful essays gathered in Philp, 1991. For visual imagery in addition to the publications already cited, see Amherst, 1989, and for French counterrevolutionary imagery, Langlois, 1988.

4. An excellent summary of the role played by caricature in the ideological battles during this time can be found in the chapter "'John Bull bother'd': The French Revolution and the Propaganda War of the 1790s" in Donald, 1996.

5. For an overview of art as propaganda in France, see Leith, 1965.

6. "Propaganda" is derived from the Roman Catholic committee of Cardinals, called the *Congregatio de propaganda fide* (Congregation for propagating the faith), founded in 1622 to oversee foreign missions.

7. See *Oxford English Dictionary.*

8. Farington, 1794, vol. 1, p. 275.

9. These two paintings, now missing, are discussed in Stuebe, 1979, pp. 69–77. Her catalogue entries for these works, nos. 641 and 643, offer an extensive bibliography.

10. See Farington, 1794, vol. 1, p. 266 (November 30), and 1795, vol. 2, pp. 296, 301, 302 (January 26 and February 3 and 7).

11. Edward Edwards, in a book published not long after this episode, elaborates,

The Duke of York and the Prince of Gloucester visited the room; and his Royal Highness, upon seeing the pictures, very pertinently observed, that he thought no artist should employ himself on works of that kind, the effects of which might tend to impress the mind of the inferior classes of society with sentiments not suited to the public tranquility; that the effects of war were at all times to be deplored, and therefore need not be exemplified in a way which could only serve to increase public clamour, without redressing the evil.

(Edwards, 1808, pp. 250–51)

12. Stephen Deuchar argues that the duke of York was also liable to have interpreted Gillray's print "as an endorsement of Hodges's apparent anti-war senti-

ment" (Deuchar, 1988, p. 158). Deuchar also maintains that the print was probably "at the same time intended as a humorous satire on Hodges's paintings themselves, for it portrayed the blessings of peace and the curses of war with patently absurd overstatement" (ibid.). Gillray does indeed pull out all the stops in terms of English prosperity, although the observation that the cottager is "inadvertently spiking his faithful hound with the tip of the sickle" (pp. 158–59) is literally wide of the mark. But the sentiment of Gillray's print is clearly anti-French, and he may have been truly appalled by reports of French wartime atrocities.

13. See Cléry, 1798. Other foreign-born artists who subscribed were Bonomi, Maria Cosway, and de Loutherbourg. Zoffany's patron Charles Townley was also among the subscribers.

14. See Wessely, 1886. Wessely records *The Tenth of August 1792* as measuring 575 by 685 millimeters. The only larger print is the *Meleagar and Atalante* after Rubens, published by Boydell in 1781 (no. 81, 520 × 888 mm.). *Agrippina Lands at Brundisium with the Ashes of Germanicus* after West published by Boydell in 1776 (no. 94, 535 × 708 mm.) and *The Royal Academy of Arts* after Zoffany published by Robert Sayer in 1773 (no. 102, 505 × 717 mm.) are the only others that can compete in size. One should note that of the 492 prints, two large series after Claude Lorrain and Cipriani account for nos. 149–492.

15. Nixon himself requested that Rowlandson etch his complex design (see Donald, 1996, p. 150). The caption to the print sets out its program:

> Liberty is torn from her Temple, by a hired band of Ruffians, bound, & going to be Sacrificed to the rage of these Ignorant People; in the Centre a Poissarde or Fish Woman is burning a Spinning Wheel, the Emblem of Industry; an old Officer breaking the Staff of Liberty; with a Boy & French Porter, who are bringing Volumes of the Fine Arts, Agriculture, &c &c to add fuel to the flames. On the opposite side are a group of figures representing Music, Poetry, Painting, Weavers, Smiths, Carpenters, Husbandmen, &c. driven out of the Kingdom as useless Members of Society; near the Temple is erected a Statue, raised on the Foundation of Murder, Cruelty, Cowardice, Treachery, & Sedition, agreable to the French Idea of Freedom, this figure represents an intoxicated Female with a Blunderbuss in her right hand, & a dagger in her left, a bandage over her Eyes, as blind to Reason, leaning against a Pillar, that's broke by her weight, & at the Base is a party of Democrats dancing a Cotilion. The Church, once a place of Devotion, is now turn'd into a Theatre, in which that Bloody Massacre on the 10th of August, 1792, at Paris, is going to be represented. In the back Ground of this Picture, the Houses of Industrious Tradesmen are falling to ruin, their unhappy Tenants being driven from their Homes for want of Employment: some of the Banditti are destroying a Loom, & a Strong Herculean Fellow cruelly beating a poor Weaver, shews, when the Law of a Country is at an end, the strong gets the better of the weak, & Oppression takes [the] place of Justice: on the ground,

an Industrious artist who supported his aged Parents, is expiring through Want; over the Temple the Author of the Rights of Man is supported on bubbles that are blown up by two Devils; this represents his work to be Froth & Airy Vapour: tending to delude & mislead a Nation who it is hoped, are by this time so well convinced of the Blessing they enjoy, as to have no wish to change it for any other. The different Trades leaving the Kingdom close the Scene.

16. Nixon included this phrase in the inscription as it appears on the proof impression reproduced here. It was dropped from the published state (see George, 1942, no. 8334).

17. In the print's published state, the inscription has been amended to read "Religion, Law, & Equity, A FARCE," and the clouds above this part of the composition have been significantly darkened.

18. *Short Account,* 1792, p. 30. A letter in *Lloyd's Evening Post* associates August 10 with the Saint Bartholomew's Day massacre (August 29–31, 1792, p. 210), and Horace Walpole makes this same connection in his letter to Lady Ossory of August 18, 1792: "thank God! *it* is but one nation that has ever produced *two massacres* of Paris!" (Walpole, 1792, vol. 34, p. 152). Twiss includes an entire chapter, "Courage and Curiosity of the Fair Sex. Massacre in 1572," which relates the horrors of August 10 with those of 1572, particularly in terms of the cold-blooded curiosity displayed by women (Twiss, 1793, pp. 93–98). Those favorably disposed to the revolt attempt to turn the tables by accusing Louis XVI of having instigated this reenactment of the massacre of Saint Bartholomew (see, for examples, the English translation of a portion of Louis-Marie Prudhomme's radical weekly newspaper *Révolutions de Paris* in the *Star,* August 30, 1792, p. 2, and of course the caption to Figure 12 already quoted on pp. 25–26). Marie-Joseph Chénier's play *Charles IX,* performed in October 1789, had already identified Louis with Charles in the context of the massacre and Marie-Antoinette with Charles's cruel, scheming mother, Catherine de Médicis (see Gutwirth, 1992, pp. 236–37).

19. See the essay "The Rites of Violence" in Davis, 1975, pp. 152–87. Zoffany also may have been aware of a sixteenth-century pictorial tradition of scenes of massacres. For a reproduction of François Dubois's contemporary image of the Saint Bartholomew's Day massacre and of a painting of the related antique subject of the Roman massacre of the Triumvirs, see Ehrmann, 1972.

20. Rigaud, 1854, p. 65.

21. Huddesford, 1793, p. 6.

22. *Short Address,* 1792, pp. 20–21. This writer even attributes the killing of those who had looted the palace to a distorted sense of equality in which members of the lower orders turn on their own: "The Author has often heard the Mob of Paris highly commended for not having stript the Palace of the *Thuilleries* of all its valu-

able furniture. The spirit of Envy, and not the love of Justice, actuated them on this occasion. The man who had taken possession of any valuable article, excited jealousy in those who had been less fortunate; the superiority he had acquired raised him to the rank of an *Aristocrate,* and determined his execution" (p. 21 n).

23. Davis, 1975, p. 124.

24. For an account of the significance of the role played by women in the revolutionary demonstrations of 1792 in Paris, see Levy and Applewhite, 1990.

25. For an excellent summary of the reaction to women in politics in the late eighteenth and early nineteenth centuries, including a discussion of the role played by the duchess of Devonshire, see the chapter "Womanpower" in Colley, 1992.

26. Susanne Zantop points out how as early as 1789 in Germany a correlation was made between the behavior of transgressive women and that of blacks: "As Germany received the news that masses of 'unbridled' women were marching to Versailles to demand bread from the king and that 'black hordes' were massacring their masters [in Santo Domingo], depictions of revolutionary scenes abounded with references to 'amazons' and 'cannibals,' who, transgressing gender and moral taboos, declared war on the established order and patriarchal authority" (Zantop, 1992, p. 214).

27. *Oracle,* September 13, 1792, p. 3. *Very new Pamphlet* (1792) makes this same association between abolitionists and Republicans, both of whom wish to "reduce the Country to the situation of France, *so long their envy, their boast, and their model*" (p. 6).

28. Although his estimate of 20,000 blacks in England may be too high, Cohen argues for this ten-times-larger proportion: "The possible 5,000 blacks in France were part of a nation of 20 million inhabitants, whereas in England blacks represented 20,000 out of 8 million inhabitants" (Cohen, 1980, p. 112).

29. These fears would seem to have had little basis in fact given that only one of the Gordon rioters can be identified as black (see Shyllon, 1977, p. 88).

30. Williams, *Exhibition,* 1796, p. 20.

31. The way in which this picture is catalogued in the artist's posthumous sale acknowledges this purpose: "*The March of a Native Indian Army;* completely illustrating the different Casts of the Inhabitants by their Dresses, Employments, &c. and with which Mr. Zoffany was so completely acquainted by his long Residence in India and by his attentive observation—*engraved*" (London, Robins, *A Catalogue of . . . the Valuable Property of that Distinguished Artist Johan Zoffany,* May 9, 1811, lot 96).

32. Letter to the Editor by "B. P.," *Gentleman's Magazine,* October 1792, p. 895.

33. Burke, 1790, p. 166.

34. The lines are quoted in full in the Appendix.

35. Paine, 1791, pp. 49–50.

36. Burke, 1790, p. 164.

Chapter 7

1. Bindman, 1988, pp. 93, 94.

2. Two books that provide an introduction to this subject are Garrett, 1975, and Fruchtman, 1983.

3. For West's work at Fonthill, see San Antonio, 1983, pp. 57–73.

4. Burke, 1790, p. 166.

5. Cruikshank's beast is related to images of the many-headed aristocratic Hydra as depicted in French prorevolutionary prints. See, for example, Québec, 1989, plates 25 and 26. It is also related to the beast ridden by the Whore of Babylon in the Book of Revelation and, in Protestant England, was identified with "the beast of Rome" (see Robinson, 1996, p. 147).

6. Williams, 1796, p. 35 n.

7. One example, already illustrated, is Gillray's print *Un petit Soupèr* (see Fig. 19), where the cannibalistic nature of the repast is remarked on in the rhyming caption:

> Here as you see, and as 'tis known,
> Frenchmen mere Cannibals are grown;
> On <u>Maigre</u> <u>Days</u> each <u>had</u> his Dish
> Of Soup, or Sallad, Eggs, or Fish;
> But <u>now</u> 'tis human Flesh they gnaw,
> And ev'ry Day is <u>Mardi</u> <u>Gras</u>.

8. The photograph crops most of the extensive lower margin, which includes the title and eight quatrains.

9. See p. 110.

10. Fennell, 1792, p. 389. The author also claims that similar conduct was perpetrated during the September massacres: "Nor did the females less distinguish themselves on this occasion, than on the 10th of August: it is a certain, though disgusting truth, that they absolutely chewed the flesh of the mangled victims; and that it was a common practice to dip pieces of bread in human blood, and eat them with a ravenous delight" (p. 470).

 In her essay on German reactions to the French Revolution, Zantop documents the gendering of charges of French cannibalism, which implicated revolutionary, "amazonian" women far more than men (see Zantop, 1992). In a patriarchal society, female transgression is a particularly culpable sin.

11. *St. James's Chronicle,* August 18–21, 1792, p. 4. This report may have inspired the image of the banner showing the woman having cut out a naked man's heart in Rowlandson's print reproduced as Figure 58.

12. *Evening Mail,* September 10–12, 1792, p. 3.

13. As to the fate of the priests, the account makes clear they died as befits Christian martyrs:

> They all of them approached the horrid scene with their eyes shut, and did not speak a word in answer. The mob directly undressed the eldest of them, a man about 60, and roasted him; saying, they perhaps might like the flesh of their friends better that that of the Countess. The other five instantly threw themselves into the fire, and were burnt to death, embracing each other; and though the mob did every thing they could to get them out of the fire, in order a little to prolong their sufferings, they could not effect it, as the fire was extremely fierce.
>
> (*Evening Mail*, September 10–12, 1792, p. 3)

In his *Un petit Souper* (see Fig. 19), Gillray evokes as well elements of a Black Mass with the roasting baby tied upside down in a crucified posture, but, as Bindman points out, this "print is more comic than genuinely horrifying, and the black humor may be a comment, on Gillray's part, on the absurdity of Burke's extreme view of the French" (Bindman, 1992, p. 135). Zoffany, of course, finds Burke's sentiments all too accurate.

14. The gentlemen around the table are, from left to right, Sheridan, Dr. Priestley, Sir Cecil Wray, Fox, John Horne Tooke, and Dr. Lindsey. Not one of them was actually present at the dinner, though Dr. Priestley became the prime target of an angry mob that destroyed his house with all its contents. The painting on the wall of Saint Paul's Cathedral entitled "A PIG'S STYE / a View from Hackney" identifies Dr. Priestley's Dissenting congregation with Burke's "swinish multitude."

I. Eighteenth-Century Writings

Aumont, 1792 J. B. d'Aumont, *A Narrative of the Proceedings relating to the Suspension of the King of the French, on the 10th of August, 1792,* Manchester.

Bigot de Sainte-Croix, 1793 Louis Claude Bigot de Sainte-Croix, *Historie de la Conspiration du Août 1792,* London.

Blaikie, 1792 Thomas Blaikie, *Diary of a Scotch Gardener at the French Court at the End of the Eighteenth Century,* edited by Francis Birrell, New York, 1932.

Burke, 1790 Edmund Burke, *Reflections on the Revolution in France and on the Proceedings in Certain Societies in London relative to that Event,* edited with an introduction by Conor Cruise O'Brien, Harmondsworth, England, 1969.

Circumstantial History, 1792 *A Circumstantial History of the Massacre at Paris on the Tenth of August; plainly shewing the Perfidy of Louis XVI. and the General Unanimity of the People, in Defence of their Rights,* 2nd ed., London. Reprints, with an introduction, a letter first published in the *Star,* August 30, 1792, p. 2.

Cléry, 1798 Jean-Baptiste Cant Hanet Cléry, *A Journal of Occurences at the Temple, during the Confinement of Louis XVI, King of France,* translated from the French by R. C. Dallas, London.

Coxe, 1780 William Coxe, "An Account of the Vallais, and of the Goitres and Idiots of that Country. From Coxe's *Letters from Swisserland,*" *The Annual Register, or a View of the History, Politics, and Literature for the Year 1779,* vol. 2 89–93, London.

Farington, 1794 or 1795 *The Diary of Joseph Farington,* ed. Kenneth Garlick and Angus MacIntyre, vol. 1, *July 1793–December 1794,* and vol. 2, *January 1795–August 1796,* New Haven and London, 1978.

Fennell, 1792 James Fennell, *A Review of the Proceedings at Paris during the last Summer. Including an Exact and Particular Account of the Memorable Events, on the 20th of June, the 14th of July, the 10th of August, and the 2d of September: with Observations and Reflections on the Characters, Principles and Conduct of the Most Con-*

spicuous Persons concerned in Promoting the Suspension and Dethronement of Louis the Sixteenth, London, n.d. [preface dated November 14, 1792].

Flower of the Jacobins, 1793 *Flower of the Jacobins, containing Biographical Sketches of the Characters at Present at the Head of Affairs in France,* 4th ed., London.

Gower, 1792 *The Despatches of Earl Gower, English Ambassador at Paris from June 1790 to August 1792,* ed. Oscar Browning, Cambridge, 1885.

Huddesford, 1793 [George Huddesford], *Topsy Turvy: with Anecdotes and Observations illustrative of Leading Characters in the Present Government of France. By the Editor of Salmagundi,* London.

James, 1792 Charles James, *An Extenuation of the Conduct of the French Revolutionists, on the 14th of July, 1789, the 10th of August, and the 2d and 3d of September 1792. Being a Cursory Answer to the Manifold Misrepresentations industriously circulated to injure the general Character and Principles of a Long Oppressed People,* 2nd ed., London. The first edition, in which the author is identified only as "An Impartial Observer," is advertised in the *World* for September 26, 1792.

Moore, 1793 John Moore, *A Journal during a Residence in France, from the Beginning of August, to the Middle of December, 1792,* 2 vols., London.

National Guard, 1792 *An Historical and Political Account of the Events which took place at the Palace of the Thuilleries, and at Paris, on the 9th and 10th of August, 1792. Dedicated to the People of England, by a National Guard, then on Duty at the Palace,* London.

Paine, 1791 Thomas Paine, *Rights of Man,* Harmondsworth, England, 1984 (part 1 first published in London, 1791).

Peltier, 1792 J[ean Gabriel] Peltier, *The Late Picture of Paris; or, A Faithful Narrative of the Revolution of the Tenth of August; of the Causes which produced, the Events which preceded, and the Crimes which followed It,* vol. 1, London (vol. 2 published 1793). This work appeared soon after the event it describes; it was advertised in both the *World* and the *Gazetteer and New Daily Advertiser* on September 13, 1792.

Plain Truth, 1792 *Plain Truth: or, An Impartial Account of the Proceedings at Paris During the last Nine Months. Containing, among other interesting Anecdotes, a Particular Statement of the Memorable Tenth of August, and Third of September. By an Eye Witness,* London.

Price, 1789 Richard Price, *A Discourse on the Love of Our Country, Delivered Nov. 4, 1789, at the Meeting-House in the Old Jewry, to the Society for Commemorating the Revolution in Great Britain,* 4th ed., London, 1790.

Price, 1793 Theodore Price [pseud. Job Nott], *The Life and Adventures of Job Nott, Buckle-maker, of Birmingham,* Birmingham, 1798 (first published 1793).

Révolutions de Paris, 1792 Louis-Marie Prudhomme, ed., *Révolutions de Paris,* Paris, no. 161, August 11, 1792, pp. 229–72.

Rickman, 1781 [John Rickman], *Journal of Captain Cook's Last Voyage to the Pacific Ocean,* London. Reprint, University Microfilms, Ann Arbor, 1966.

Short Account, 1792 *Short Account of the Revolt and Massacre which took place in Paris on the 10th of August 1792. With a Variety of Facts relating to Transactions previous to that Date, which throw Light on the Real Instigators of those horrid and premeditated Crimes. To which is prefixed a Plan of the Palace of the Thuilleries, and it[s] Environs. By persons present at the Time*, London. This work was first advertised in the *Times*, September 12, 1792, p. 1, and was advertised in the next issue of at least seven other papers.

Short Address, 1792 *A Short Address to the Inhabitants of Great Britain by an Englishman just returned from Paris*, London.

Ten Minutes Reflection, 1792 *Ten Minutes Reflection on the Late Events in France. Recommended by a Plain Man to his Fellow Citizens*, London.

Twiss, 1793 [Richard Twiss], *A Trip to Paris in July and August, 1792*, London.

Very new Pamphlet, 1792 *A Very new Pamphlet indeed! Being the Truth: Addressed to the People at large. Containing some Strictures on the English Jacobins, and the Evidence of Lord M'Cartney, and Others, before the House of Lords, respecting the Slave Trade*, London.

Walpole, 1775, 1792, or 1793 *The Yale Edition of Horace Walpole's Correspondence*, vols. 24 (1967), 31 (1961), 34 (1965), and 42 (1980), edited by W. S. Lewis, New Haven, Conn.

Williams, *Exhibition*, 1796 John Williams [Anthony Pasquin], *A Critical Guide to the Exhibition of the Royal Academy, for 1796*, London, [1796].

Williams, *Ireland*, 1796 John Williams [Anthony Pasquin], *An Authentic History of the Professors of Painting, Sculpture, & Architecture, who have practised in Ireland*, London.

Wollstonecraft, 1794 Mary Wollstonecraft, *An Historical and Moral View of the Origin and Progress of the French Revolution*, London.

Young, 1793 Arthur Young, *The Example of France, A Warning to Britain*, 2nd ed., London.

Zimmermann, 1781 Heinrich Zimmermann, *Zimmermann's Account of the Third Voyage of Captain Cook*, translated from the German by U. Tewsley, Wellington, 1926 (first published in Mannheim, 1781).

II. Books and Articles

Agulhon, 1981 Maurice Agulhon, *Marianne into Battle: Republican Imagery and Symbolism in France, 1789–1880*, translated from the French by Janet Lloyd, Cambridge.

Andrews, 1985 Richard Mowery Andrews, "Social Structures, Political Elites and Ideology in Revolutionary Paris, 1792–94: A Critical Evaluation of Albert Soboul's *Les Sans-Culottes Parisiens en l'An II*," *Journal of Social History* 19 (Fall): 71–112.

Angelo, 1828 Henry Angelo, *Reminiscences of Henry Angelo,* 2 vols., London.

Archer, 1979 Mildred Archer, *India and British Portraiture, 1770–1825,* London, New York, Karachi, and Delhi.

Ashton, 1996 Geoffrey Ashton, "Johan Zoffany," in *The Dictionary of Art,* ed. Jane Turner, vol. 33, 692–95, London and New York.

Bakhtin, 1968 Mikhail Bakhtin, *Rabelais and His World,* translated from the Russian by Helene Iswolsky, Cambridge, Mass., and London.

Beall, 1976 Karen F. Beall, *Kaufrufe und Strassenhändler / Cries and Itinerant Trades,* Hamburg, [1976].

Biddick, 1993 Kathleen Biddick, "Genders, Bodies, Borders: Technologies of the Visible," *Speculum: A Journal of Medieval Studies* 68 (April): 389–418.

Bindman, 1988 David Bindman, "Sans-Culottes and Swinish Multitude: The British Image of the Revolutionary Crowd," in *Kunst um 1800 und die Folgen: Werner Hofmann zu Ehren,* edited by Christian Beutler, Peter-Klaus Schuster, and Martin Warnke, 87–94, Munich.

Bindman, 1992 David Bindman, "'Revolution soup, dished up with human flesh and French Pot Herbs': Burke's *Reflections* and the Visual Culture of Late 18th Century England," in *British Art, 1740–1820: Essays in Honor of Robert R. Wark,* edited by Guilland Sutherland, 125–43, San Marino, Calif.

Boime, 1987 Albert Boime, *Art in an Age of Revolution, 1750–1800,* Chicago and London.

Bordes, 1989 Philippe Bordes, "Review of *La Révolution Française et l'Europe,*" *Burlington Magazine* 131 (June): 441–43.

Bordes and Chevalier, 1996 Philippe Bordes and Alain Chevalier, *Catalogue des Peintures, Sculptures et Dessins, Musée de la Révolution française,* Vizille.

Bordes and Michel, 1988 Philippe Bordes and Régis Michel, eds., *Aux Armes & Aux Arts! Les Arts de la Révolution, 1789–1799,* Paris.

Burley, 1989 Peter Burley, *Witness to the Revolution: American and British Commentators in France, 1788–94,* London. Primarily a selection of British and American diplomatic correspondence from Paris during this time.

Calbris, 1990 Geneviève Calbris, *The Semiotics of French Gestures,* translated by Owen Doyle, Bloomington and Indianapolis, Ind.

Clark, 1980 Stuart Clark,"Inversion, Misrule and the Meaning of Witchcraft," *Past & Present: A Journal of Historical Studies* 87 (May): 98–127.

Clay, 1948 Rotha Mary Clay, *Julius Caesar Ibbetson,* London.

Cobb, 1970 R. C. Cobb, *The Police and the People: French Popular Protest, 1789–1820,* Oxford.

Cohen, 1980 William B. Cohen, *The French Encounter with Africans: White Response to Blacks, 1530–1880,* Bloomington, Ind., and London.

Colley, 1992 Linda Colley, *Britons: Forging the Nation, 1707–1837,* New Haven, Conn., and London.

Cook, 1985 B. F. Cook, *The Townley Marbles,* London.

Crow, 1985 Thomas E. Crow, *Painters and Public Life in Eighteenth-Century Paris,* New Haven, Conn., and London.

Dabydeen, 1987 David Dabydeen, *Hogarth's Blacks: Images of Blacks in Eighteenth-Century English Art,* Athens, Ga.

Davis, 1975 Natalie Zemon Davis, *Society and Culture in Early Modern France: Eight Essays,* Stanford, Calif.

Dayes, 1805 Edward Dayes, *The Works of the Late Edward Dayes,* London.

Deuchar, 1988 Stephen Deuchar, *Sporting Art in Eighteenth-Century England: A Social and Political History,* New Haven, Conn., and London.

Dickinson, 1985 H. T. Dickinson, *British Radicalism and the French Revolution, 1789–1815,* Oxford.

Donald, 1996 Diana Donald, *The Age of Caricature: Satirical Prints in the Reign of George III,* New Haven, Conn., and London.

Dozier, 1983 Robert R. Dozier, *For King, Constitution, and Country: The English Loyalists and the French Revolution,* Lexington, Ky.

Edwards, 1808 Edward Edwards, *Anecdotes of Painters who have resided or been born in England,* London.

Ehrmann, 1972 Jean Ehrmann, "Tableaux de Massacres au XVIe siècle," *Bulletin de la Société de l'Histoire du Protestantisme Français* 118 (July–September): 445–55.

Evans, 1982 Dorinda Evans, *Mather Brown: Early American Artist in England,* Middletown, Conn.

Felsenstein, 1995 Frank Felsenstein, *Anti-Semitic Stereotypes: A Paradigm of Otherness in English Popular Culture, 1660–1830,* Baltimore and London.

Fruchtman, 1983 Jack Fruchtman, Jr., *The Apocalyptic Politics of Richard Price and Joseph Priestley: A Study in Late Eighteenth-Century English Republican Millennialism,* Transactions of the American Philosophical Society, vol. 73, part 4, Philadelphia.

Fuchs, 1921 Eduard Fuchs, *Die Juden in der Karikatur,* Munich.

Furet and Ozouf, 1989 *A Critical Dictionary of the French Revolution,* edited by François Furet and Mona Ozouf, Cambridge, Mass., and London.

Garrett, 1975 Clarke Garrett, *Respectable Folly: Millenarians and the French Revolution in France and England,* Baltimore and London.

George, 1938 or 1942 Mary Dorothy George, *Catalogue of Political and Personal Satires Preserved in the Department of Prints and Drawings in the British Museum,* vols. 6 (1784–92) and 7 (1793–1800) [London].

Gilchrist and Murray, 1971 J. Gilchrist and W. J. Murray, *The Press in the French Revolution,* New York.

Gillie, 1971 R. Bruce Gillie, "Endemic Goiter," *Scientific American* 224 (June): 92–101.

Goodwin, 1979 Albert Goodwin, *The Friends of Liberty: The English Democratic Movement in the Age of the French Revolution,* Cambridge, Mass.

Graham, 1977 Ruth Graham, "Loaves and Liberty: Women in the French Revolu-

tion," in *Becoming Visible: Women in European History*, edited by Renate Bridenthal and Claudia Koonz, 236–54, Boston.

Grego, 1880 Joseph Grego, *Rowlandson the Caricaturist: A Selection from His Works*, 2 vols. Reprint, New York, [1970].

Gutwirth, 1992 Madelyn Gutwirth, *The Twilight of the Goddesses: Women and Representation in the French Revolutionary Era*, New Brunswick, N.J.

Habermas, 1989 Jürgen Habermas, *The Structural Transformation of the Public Sphere: An Inquiry into a Category of Bourgeois Society*, translated from the German by Thomas Burger with Frederick Lawrence, Cambridge, Mass.

Harris, 1981 Jennifer Harris, "The Red Cap of Liberty: A Study of Dress Worn by French Revolutionary Partisans, 1789–94," *Eighteenth-Century Studies* 14 (Spring): 283–312.

Haskell and Penny, 1981 Francis Haskell and Nicholas Penny, *Taste and the Antique: The Lure of Classical Sculpture, 1500–1900*, New Haven, Conn., and London.

Hertz, 1983 Neil Hertz, "Medusa's Head: Male Hysteria under Political Pressure," *Representations* 1 (Fall): 27–54.

Hibbert, 1958 Christopher Hibbert, *King Mob: The Story of Lord George Gordon and the Riots of 1780*. Reprint, New York, 1989.

Hill, 1965 Christopher Hill, "The Many-Headed Monster in Late Tudor and Early Stuart Political Thinking," in *From the Renaissance to the Counter-Reformation: Essays in Honor of Garrett Mattingly*, edited by C. H. Carter, 296–324, New York.

Hindley, 1884 Charles Hindley, *A History of the Cries of London, Ancient and Modern*, 2nd ed., London.

Hole, 1983 Robert Hole, "British Counter-revolutionary Popular Propaganda in the 1790's," in *Britain and Revolutionary France: Conflict, Subversion, and Propaganda*, edited by Colin Jones, Exeter Studies in History No. 5, 53–69, Exeter.

Hollstein, 1989 *Hollstein's Dutch and Flemish Etchings, Engravings, and Woodcuts, ca. 1450–1700*, compiled by Ger Luijten and Christiaan Schuckman and edited by D. De Hoop Scheffer, Roosendaal.

Hsia, 1988 R. Po-Chia Hsia, *The Myth of Ritual Murder: Jews and Magic in Reformation Germany*, New Haven, Conn., and London.

Hufton, 1971 Olwen H. Hufton, "Women in Revolution, 1789–1796," *Past & Present: A Journal of Historical Studies* 53 (November): 90–108.

Hufton, 1992 Olwen H. Hufton, *Women and the Limits of Citizenship in the French Revolution*, Toronto.

Hunt, 1983 Lynn Hunt, "Hercules and the Radical Image in the French Revolution," *Representations* 1 (Spring): 95–117.

Hunt, 1992 Lynn Hunt, *The Family Romance of the French Revolution*, Berkeley and Los Angeles.

Janes, 1991 Regina Janes, "Beheadings," *Representations* 35 (Summer): 21–51.

Joppien and Smith, 1988 Rüdiger Joppien and Bernard Smith, *The Art of Captain Cook's Voyages*, vol. 3, catalogue, and vol. 3, text, New Haven, Conn., and London.

Kampmann, 1995 Dorothea Kampmann, *Rheinische Monstranzen: Goldschmiedear-beiten des 17. und 18. Jahrhunderts,* Rheinbach-Merzbach.

Korshak, 1987 Yvonne Korshak, "The Liberty Cap as a Revolutionary Symbol in America and France," *Smithsonian Studies in American Art* 1 (Fall): 53–69.

Kromm, 1987 Jane Kromm, "'Marianne' and the Madwomen," *Art Journal* 46 (Winter): 299–304.

Lafaurie, 1981 Jean Lafaurie, *Les Assignats et les papiers: Monnaies emis par l'état au XVIIIe siècle,* Paris.

Landes, 1988 Joan B. Landes, *Women and the Public Sphere in the Age of the French Revolution,* Ithaca, N.Y., and London.

Langlois, 1988 Claude Langlois, *La Caricature contre-revolutionnaire,* [Paris].

Lavin, 1967 Marilyn Aronberg Lavin, "The Altar of Corpus Domini in Urbino: Paolo Uccello, Joos Van Ghent, Piero della Francesca," *Art Bulletin* 49 (March): 1–24.

Leith, 1965 James A. Leith, *The Idea of Art as Propaganda in France, 1750–1799,* [Toronto]. Reprint, 1969.

Leith, 1991 James A. Leith, *Space and Revolution: Projects for Monuments, Squares, and Public Buildings in France, 1789–1799,* Montreal and Kingston.

Lévêque, 1987 Jean-Jacques Lévêque, *L'Art et la Révolution française, 1789–1804,* Neuchâtel, Switzerland.

Levy and Applewhite, 1980 Darline Gay Levy and Harriet B. Applewhite, "Women of the Popular Classes in Revolutionary Paris, 1789–1795," in *Women, War, and Revolution,* edited by Carol R. Berkin and Clara M. Lovett, 9–35, New York and London.

Levy and Applewhite, 1990 Darline G. Levy and Harriet B. Applewhite, "Women, Radicalization, and the Fall of the French Monarchy," in *Women and Politics in the Age of the Democratic Revolution,* edited by Harriet B. Applewhite and Dar-line G. Levy, 81–107, Ann Arbor, Mich.

Levy, Johnson, and Applewhite, 1973 Darline Gay Levy, Mary Durham Johnson, and Harriet Branson Applewhite, "Women: The Failure of Liberation," in *The French Revolution: Conflicting Interpretations,* 3rd ed. edited by Frank A. Kafker and James M. Laux. Reprint, 261–66, Malabar, Fla., 1983.

Lock, 1985 F. P. Lock, *Burke's Reflections on the Revolution in France,* London.

Lucas, 1994 Colin Lucas, "Revolutionary Violence, the People, and the Terror," in *The Terror,* vol. 4 of *The French Revolution and the Creation of Modern Political Culture,* edited by Keith Michael Baker, 57–79, Oxford.

Lyons and Petrucelli, 1978 Albert S. Lyons and R. Joseph Petrucelli, *Medicine: An Il-lustrated History,* New York.

Manners and Williamson, 1920 Lady Victoria Manners and Dr. G. C. Williamson, *John Zoffany, R.A.: His Life and Works, 1735–1810,* London and New York.

Mathiez, 1931 Albert Mathiez, *Le Dix Août,* [Paris].

McNairn, 1997 Alan McNairn, *Behold the Hero: General Wolfe and the Arts in the Eighteenth Century,* Montreal & Kingston, London, and Buffalo.

Millar, 1966 Oliver Millar, *Zoffany and His Tribuna*, London.

Mitchell, 1944 Charles Mitchell, "Zoffany's *Death of Captain Cook*," *Burlington Magazine* 84 (March): 56–62.

Nichols, 1812 John Nichols, *Literary Anecdotes of the Eighteenth Century*, vol. 1, London, 1812.

Outram, 1989 Dorinda Outram, *The Body and the French Revolution: Sex, Class, and Political Culture*, New Haven, Conn., and London.

Ozouf, 1988 Mona Ozouf, *Festivals and the French Revolution*, translated by Alan Sheridan, Cambridge, Mass., and London.

Ozouf, 1994 Mona Ozouf, "The Terror after the Terror: An Immediate History," in *The Terror*, vol. 4 of *The French Revolution and the Creation of Modern Political Culture*, edited by Keith Michael Baker, 3–18, Oxford.

Papendiek, 1887 Charlotte Louise Henrietta Papendiek, *Court and Private Life in the Time of Queen Charlotte: Being the Journals of Mrs. Papendiek, Assistant Keeper of the Wardrobe and Reader to Her Majesty*, 2 vols., edited by Mrs. Vernon Delves Broughton, London.

Paulson, 1971 Ronald Paulson, *Hogarth: His Life, Art, and Times*, 2 vols., New Haven, Conn., and London.

Paulson, 1975 Ronald Paulson, *Emblem and Expression: Meaning in English Art of the Eighteenth Century*, Cambridge, Mass.

Paulson, 1983 Ronald Paulson, *Representations of Revolution (1789–1820)*, New Haven, Conn., and London.

Philp, 1991 *The French Revolution and British Popular Politics*, edited by Mark Philp, Cambridge.

Postle, 1991 Martin Postle, "The St. Martin's Lane Academy," *Apollo* 132 (July): 33–38.

Pressly, 1981 William L. Pressly, *The Life and Art of James Barry*, New Haven, Conn., and London.

Pressly, 1987 William L. Pressly, "Genius Unveiled: The Self-Portraits of Johan Zoffany," *Art Bulletin* 69 (March): 88–101.

Pressly, 1995 William L. Pressly, "Johan Zoffany as 'David, the Anointed One,'" *Apollo* 141 (March): 49–55.

Randolph, 1971 Mary Claire Randolph, "The Medical Concept in English Renaissance Satiric Theory," in *Satire: Modern Essays in Criticism*, edited by Ronald Paulson, 135–70, Englewood Cliffs, N.J.

Reinhard, 1969 Marcel Reinhard, *La Chute de la royauté: 10 Août 1792*, [Paris].

Ribeiro, 1988 Aileen Ribeiro, *Fashion in the French Revolution*, New York.

Rigaud, 1854 Stephen Francis Dutilh Rigaud, "Facts and Recollections of the XVIIIth Century in a Memoir of John Francis Rigaud Esq. R.A. . . . with Poetical Remains of Mrs. Mary Rigaud by their Son Stephen Francis Dutilh Rigaud," abridged and edited with an introduction and notes by William L. Pressly, *Journal of the Walpole Society* 50 (1984): 1–164, 317–41.

Robinson, 1996 Nicholas K. Robinson, *Edmund Burke: A Life in Caricature*, New Haven, Conn., and London.

Rose, 1983 R. B. Rose, *The Making of the "Sans-Culottes": Democratic Ideas and Institutions in Paris, 1789–92,* Manchester.

Roworth, 1993 Wendy Wassyng Roworth, "The Evolution of History Painting: Masaniello's Revolt and Other Disasters in Seventeenth-Century Naples," *Art Bulletin* 75 (June): 219–34.

Rudé, 1964 George Rudé, *The Crowd in History: A Study of Popular Disturbances in France and England, 1730–1848,* New York, London, and Sydney.

Schama, 1989 Simon Schama, *Citizens: A Chronicle of the French Revolution,* New York.

Schofield, 1986 Thomas Philip Schofield, "Conservative Political Thought in Britain in Response to the French Revolution," *Historical Journal* 29: 601–22.

Shyllon, 1977 Folarin Shyllon, *Black People in Britain, 1555–1833,* London, New York, and Ibadan.

Sitwell, 1936 Sacheverell Sitwell, *Conversation Pieces: A Survey of English Domestic Portraits and Their Painters,* London.

Sloan, 1995 Kim Sloan, "William Artaud: History Painter and 'Violent Democrat,'" *Burlington Magazine* 137 (February): 76–85.

Smith, 1979 Bernard Smith, "Cook's Posthumous Reputation," in *Captain James Cook and His Times,* edited by Robin Fisher and Hugh Johnson, 159–85, Seattle.

Soboul, 1988 Albert Soboul, *Understanding the French Revolution,* New York.

Sokolnikova, 1932 Galina Osipovna Sokolnikova, *Nine Women Drawn from the Epoch of the French Revolution,* translated by H. C. Stevens. Reprint, Freeport, N.Y.

Sonenscher, 1984 Michael Sonenscher, "The *Sans-culottes* of the Year II: Rethinking the Language of Labour in Revolutionary France," *Social History* 9 (October): 301–28.

Stuebe, 1979 Isabel Combs Stuebe, *The Life and Works of William Hodges,* New York and London.

Sunderland, 1988 John Sunderland, *John Hamilton Mortimer: His Life and Works,* vol. 52 of *Journal of the Walpole Society.*

Sutherland, 1985 D. M. G. Sutherland, *France, 1789–1815: Revolution and Counter-revolution,* London.

Tulard, 1989 Jean Tulard, *La Révolution française à Paris à travers les collections du Musée Carnavalet,* [Paris, 1989].

Waterhouse, 1981 Ellis Waterhouse, *The Dictionary of British 18th Century Painters in Oils and Crayons,* Woodbridge, Suffolk.

Watson, 1960 J. Steven Watson, *The Reign of George III, 1760–1815,* vol. 12 of *The Oxford History of England,* Oxford.

Webster, 1970 Mary Webster, *Francis Wheatley,* London.

Webster, 1975 Mary Webster, "The Eighteenth Century," in *The Genius of British Painting,* edited by David Piper, 145–97, New York.

Werkmeister, 1967 Lycyle Werkmeister, *A Newspaper History of England, 1792–1793,* Lincoln, Neb.

Wessely, 1886 J. E. Wessely, *Verzeichniss seiner Radirungen und Schabkunstblätter,* Hamburg.

Wilkins, 1960 Lawson Wilkins, "The Thyroid Gland," *Scientific American* 202 (March): 119–29.

Williams, 1969 Gwyn A. Williams, *Artisans and Sans-Culottes: Popular Movements in France and Britain during the French Revolution,* New York.

Wind, 1938–39 Edgar Wind, "The Revolution of History Painting," *Journal of the Warburg Institute* 2:116–27.

Wyss, 1996 Edith H. Wyss, *The Myth of Apollo and Marsyas in the Art of the Italian Renaissance,* Newark, Del., and London.

Zantop, 1992 Susanne Zantop, "Crossing the Border: The French Revolution in the German Literary Imagination," in *Representing the French Revolution: Literature, Historiography, and Art,* edited by James A. W. Heffernan, 213–33, Hanover, N.H., and London.

III. Exhibition Catalogues

Amherst, 1989 Mead Art Museum, Amherst College, *Representing Revolution: French and British Images, 1789–1804.*

Hamburg, 1989 Hamburger Kunsthalle, *Europa 1789,* Werner Hofmann, editor in chief.

London, 1977 National Portrait Gallery, *Johan Zoffany, 1733–1810,* catalogue by Mary Webster.

London, 1989 British Museum, *The Shadow of the Guillotine: Britain and the French Revolution,* catalogue by David Bindman.

Los Angeles, 1988 Grunwald Center for the Graphic Arts, Wight Art Gallery, University of California, *French Caricature and the French Revolution, 1789–1799.*

New York, 1987–88 New York Public Library; the Indiana University Art Museum, Bloomington; and the Chicago Historical Society, *William Wordsworth and the Age of English Romanticism.*

New York, Colnaghi, 1989 Colnaghi, *1789: French Art during the Revolution.*

New York, Library, 1989 The New York Public Library, *Revolution in Print: The Press in France, 1775–1800,* edited by Robert Darnton and Daniel Roche, University of California Press, Berkeley.

Paris, 1977 Musée Carnavalet, *L'Art de l'estampe et la Révolution française.*

Paris, 1982 Musée Carnavalet, *La Révolution française / le premier Empire.*

Paris, 1989 Galeries Nationales du Grand Palais, 20th exhibition of the Council of Europe, *La Révolution française et l'Europe, 1789–1799*: vol. 1, *L'Europe à la veille de la Révolution;* vol. 2, *L'Evénement révolutionaire;* vol. 3, *La Révolution créatrice.*

Québec, 1989 Musée du Québec; Montréal Museum of Fine Arts; Art Gallery of Ontario, Toronto; Winnipeg Art Gallery, *Images of the French Revolution*, catalogue by Claudette Hould.

San Antonio, 1983 San Antonio Museum of Art, *Revealed Religion: Benjamin West's Commissions for Windsor Castle and Fonthill Abbey,* catalogue by Nancy L. Pressly.

San Diego, 1992 San Diego Museum of Art, *The Great Age of Sail: Treasures from the National Maritime Museum, Greenwich, England.*

Stanford, 1970 Stanford Art Gallery, Stanford University; San Francisco, California Palace of the Legion of Honor, *Street Criers and Itinerant Tradesmen in European Prints,* catalogue by Dwight Miller.

Washington, 1985 National Gallery of Art, Washington, D.C., *The Treasure Houses of Britain.*

IV. Videodisc

Videodisc, 1990 *Images of the French Revolution,* General Director: Laure Beaumont-Maillet, a copublication of the Bibliothèque Nationale, Paris, and Pergamon Press, London and Oxford. Accompanied by a catalogue in 3 volumes, Paris.

INDEX

Note: Page numbers in italics refer to illustration captions.

Designer: Steve Renick
Indexer: Carol Roberts
Compositor: Integrated Composition Systems
Text: Adobe Garamond
Display: Caslon Antique
Printer: Malloy Lithographing
Binder: John H. Dekker and Sons